CELTIC KNOTS

In 1974, the author discovered the triple-grid basis of Celtic knotwork, as presented in this book. He began teaching this method in 1977, first in Europe, and, from 1979 onwards, in North America. Aidan Meehan is the author of an eight-volume *Celtic Design* series and *Celtic Patterns Painting Book*, *Celtic Alphabets*, *Celtic Borders*, *The Book of Kells Painting Book* and *The Lindisfarne Painting Book*, all published by Thames & Hudson.

CELTIC KNOTS

Mastering the Traditional Patterns

A step-by-step guide

Aidan Meehan

with 2843 illustrations

Thames & Hudson

Dedicated to Susan Yee

First published in the United Kingdom in 2003 by
Thames & Hudson Ltd, 181 A High Holborn, London WC1V 7QX

www.thamesandhudson.com

artwork and typography copyright © 2003 Aidan Meehan

British Library Cataloguing-in-Publication Data
A catalogue record for this book is available from the British Library

ISBN 0-500-51126-8

Printed and bound in Singapore

CELTIC KNOTS

About this Course

You do not need to use a special pen for this course, a fine-point marker is suitable.

The material in this book was designed to last twenty weeks, one unit a week. Absorb the material from one unit before going on to the next. Each unit requires that the material from the previous units has been worked through. The exercises included at the end of each unit are given to test your understanding of that unit, before going on to the next one.

The first eight units cover the principles of knot design, principles that apply to all knot design, while showing how to make a large number of patterns generated from the most simple Celtic knot.

The next ten units introduce border designs, still based on the simplest knot. These can be laid out on a quarter-inch square grid, or a 5mm grid, and will fit a standard letter-sized page, suitable for stationery, for example. In these units, you are introduced to freehand methods of dividing, by eye, any length into whatever number of spaces is required by a particular knot. Many examples are given for filling a border, using a wide range of patterns. You are shown how to divide any strip of border into symmetrical arrangements of the basic pattern, joined in groups of two or three units, allowing you to lay out a border strip of any length symmetrically and spontaneously.

In the last two units of the book, we turn briefly to knots with odd numbers of cords, such as three- and five-cord braids, while adapting the principles of knot design from the four-cord patterns of the earlier part of the book to them. Given these principles, you can invent your own knots and apply them as panels or borders, or take any classical knot through its paces by applying the same methods outlined here.

a

b

c

d

The Cord-count Paradox

Formal knot design uses three kinds of square dot grid, nested inside each other. The three grids are shown here as line instead of dot, to make them easier to pick out. The woven lines are called "cords", as represented by broken arrows in figs i–ii.

Plaits and knots may be defined by cord count, as in "a four-cord plait", or by cell count: for example, fig. ii, f is a 3 x 2 diamond grid unit, based on a 3 x 2 square grid (that is, three cells across, two down).

One problem with thinking of knots as cords is that a knot might look like a single thread, but could be any number of implied "cords", spliced together: fig. ii, d is six cords in a vertical plait.

The actual number of cords is determined by the number of cells to a side of the primary grid. For every square cell across or down, there are two cords. A horizontal grid, three spaces across and one down (3 x 1), yields a two-cord twist, three units wide. But the same pattern can be described as a six-cord pattern running up and down.

Extend the grid vertically to see this ambiguity of cord count more clearly: in a grid three cells across and two cells down (3 x 2), there are four cords from side to side, fig. i, d. But from top to bottom there are six cords, fig. ii, d. The pattern is a four-cord or six-cord plait, both at the same time.

Knots are plaits with breaks, so this cord-count paradox applies to them as well. The cord count varies according to how you read the knot - vertical, horizontal; spliced or unspliced - so it makes more sense to define a knot by the underlying grid, especially since the grid is not only an aid in drafting, it is the essential basis of the knot itself. For this reason, I find it convenient to classify the knot by the number of spaces across by the number of units down, on its primary, square grid.

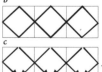

a

b

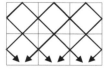

c

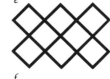

d

e

From Plait to Knot

A plaitwork pattern is interrupted by internal breaklines placed on the primary or secondary dot grid, to produce a knotwork pattern.

Knots can be drawn freehand, so mathematical precision is not essential to their construction. In this course, I use a square grid as the most convenient primary grid for knot design, but the grid unit need not be exactly square.

The dot grid may be laid out by eye, or drawn over squared grid paper. The grid determines the general form of the knot, whether a geometrical grid, a freehand sketch, or fitted to an odd shape.

f

Two Cords per Square Cell Rule

The number of cords in the knot is determined by the number of cells along an edge of the grid. If you join the midpoints of the squares, you break the grid from the middle of the first cell to the middle of the last cell, with a gap at either end, fig. iii, e. A path appears above the breakline, turns through the gap at one end, back along the bottom edge, and turns again to make a flattened loop, resembling two cords with ends joined.

Every square has room for only two pathways - or "cords"- to pass through.

The two cords per cell rule is useful. According to this rule, a four-cord braid running horizontally will require a grid of two rows of squares, as each row of squares allows two cords. The number of cords is determined by the number of squares. These square cells are the primary dot grid. The primary grid defines the cord count of the pattern.

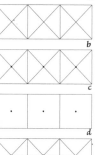

The Secondary Grid

The secondary grid is obtained by placing a mid-point in each square cell of the grid. The secondary grid, in a single row of squares, consists of a single row of dots. In fig. iii, we joined this row of dots to define a breakline on the secondary grid.

In fig. ii, we can see how a row of squares is the primary grid layout for a two-cord plait.

Fig. iii exploits the secondary grid of the same single row of squares to define a secondary line that splits the path of the twist across the middle, converting it to a looped path.

Fig. iv expands the single-row primary grid to a 3 x 2 grid: three squares across, two rows down.

The 3 x 2 primary grid has six square cells. Each cell has a midpoint, located at the intersection of the diagonals of the square.

The midpoints of the 3 x 2 primary grid form the two adjacent square cells of the 3 x 2 secondary grid, shown here in dotted line.

Note how naturally the primary grid generates the secondary grid: the four corners of a square simultaneously define the midpoint, not only the sides of the square.

The primary grid gives rise to the secondary grid. In turn, the secondary grid divides the sides of the primary grid, so that the midpoints of the sides of the primary square may be said to arise out of the interaction of the primary and secondary grid. The result is a diamond pattern that defines the intersections of the plaitwork pattern. I call this the tertiary grid. We will return to the difference between these three grids repeatedly, so if you do not fully get it now, do not worry. You will understand it very well after studying a few more units.

Every square has a midpoint. In a square grid, there is a pattern of midpoints, by definition. The line of the plait navigates around and between the dots of the primary and secondary grids.

As you can see in fig. iv, the secondary grid divides the sides of each primary grid cell, except along the outer edge. The six midpoints define two secondary grid squares, the sides of which cross the internal sides of the primary grid and divide them.

This generates a third grid, the tertiary grid, best described as a diamond pattern made of the midpoints of the sides of the primary square.

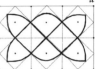

Just as the primary grid produces a secondary grid, the secondary grid intersects its parent grid to generate a third grid. The tertiary grid consists of a central diamond in each primary grid cell, fig. v, a.

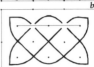

There are no midpoints outside the box containing the primary grid: the secondary grid intersects the primary on the internal sides only. Because there are no available tertiary grid points on the outside edge or corners, the knotline may not pass through the outside edge, as a rule.

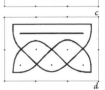

If we place a break, as in fig. v, c, it stops off two tertiary points, causing arches below the break, and a straight bar above it.

Not all breaklines produce acceptable knots: in fig. v, d the path has broken into a D-ring and a twisted loop. Loops that are too obvious spoil the knot. Technically, this may be a knotwork pattern, but aesthetically, it is not a satisfactory Celtic knot, because it has broken down too much.

The Secret of the Scribes

So this is the secret of Celtic knot design in a nutshell: when you divide a surface into squares, a second grid is generated automatically, which, intersecting the first, in turn gives rise to a third, and the path of the knot follows this tertiary grid of diamond cells.

The point where the diamond cell divides the sides of the square cell is precisely the point you need to locate the cross-over when you go to weave the path of the knot.

The path of a plait follows the tertiary grid except at the outer edge, or at an internal breakline. When the diamond path is interrupted in this way, it passes through the next available point on the tertiary grid, bending in a curve rather than at the tip of the diamond cell.

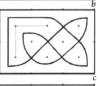

The path turns once at a vertical or horizontal break. The path skips two tertiary points at a corner, because both a vertical and a horizontal break converge in a corner, thereby making the tertiary grid points on the outer edge unavailable. That is the logical explanation for the arches on the outer edges and on either side of the breaklines. In that sense, the outer boundary is also a breakline surrounding the plait, which would otherwise extend diagonally to infinity.

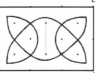

An internal breakline has the same effect on the tertiary grid as just described on the outer boundary. Normally, two or more midpoints are joined together to form a breakline on the secondary grid. A breakline interferes with the diamond grid, effectively eliminating one or more intersection points on it, causing a turn in the path.

When you block a point on the diamond grid by running a breakline line through it, you change the path of the tertiary grid from a simple plait line into the midline of a knot. The knot that follows will hide the tertiary grid. The secret of the diamond - or tertiary - grid has been hidden for a thousand years, so while it may not be self-evident to you at first glance, it will become clear with a little practice.

Unit 1: Plaits and the Foundation Knot

This is the first of twenty units. Practise each unit, one unit a week, and you will master Celtic knots design within five months.

Each unit may take several hours to do. You will need one session to go through the lesson, one to practise the material, and one to work through the exercises at the end of each unit. Try to do one unit per week. If you break in the middle of the course, go over the last unit you did before going on. If you try to spend twenty minutes each day on the course, you will find that works best. I recommend setting up a desk or table dedicated to Celtic knot design.

Knotwork comes from plaitwork, and both are based on the three levels of a dot grid of square cells: the squares are the first grid; the diagonals are the second grid; and the diamonds dividing the sides of the square are the third grid. The path of the plait or knot follows this third grid: *the tertiary dot grid defines the path.*

The square dot grid gives rise to the diagonal dot grid. This secondary grid cuts the sides of the squares, producing the diamond dot grid. We can refer to these three grids as primary, secondary and tertiary grids.

Since it is hard at first to distinguish the three dot grids from the overall, combined grid of dots, it may help to begin with the linear equivalents of each of the three dot grid cells, namely, the square, the saltire and the losenge.

As John Romilly Allen pointed out, these are the age-old elements of primitive geometric patterns. Losenge and saltire both derive from the chevron.

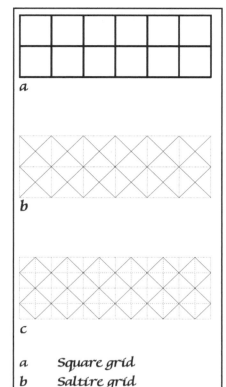

a Square grid
b Saltire grid
c Losenge grid

To start, let us draw the three grids in lines, instead of dots, because this is easier to see. Later, we will imagine the lines, in order to distinguish the three levels on a dot grid.

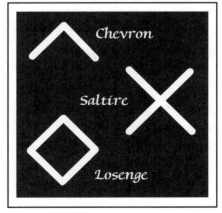

Saltire and losenge are chevron-based units of primitive geometric patterns. Both may be derived from a chevron or a square. A saltire consists of the two diagonals of the square, or two chevron arrowheads placed point to point; the losenge is a diamond-shaped, rotated square, or two opposed chevrons joined together.

Some terms of reference

The primary, secondary and tertiary dot-grid cells used in all knotwork patterns correspond to the square, saltire and losenge, which are the three building blocks of primitive geometric patterns, *fig. 1b.*

fig. 1c: 1 x 1 grids

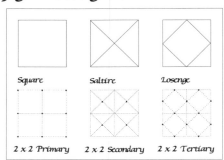

These simple cell shapes correspond to the cells of the three levels of the dot grid used to build plaitwork patterns. The sides of a square describe a 1 x 1 square grid. The diagonals of a square describe a 1 x 1 saltire grid. The midpoints of the sides of a square describe the single diamond cell of a 1 x 1 losenge grid.

The 2 x 2 primary dot grid is based on four square cells. The 2 x 2 secondary dot grid is based on four saltire cells. The 2 x 2 tertiary dot grid is based on four losenge cells. These grids are illustrated with lines here, but in building plaits or knot patterns, we use dot grids, where the dots mark the intersection points of the lines of each grid. Thus, the corner points of a square constitute a 1 x 1 primary dot grid. The 2 x 2 primary dot grid is the parent grid of the 2 x 2 secondary and tertiary dot grids.

fig. 1d: 2 x 1 grids

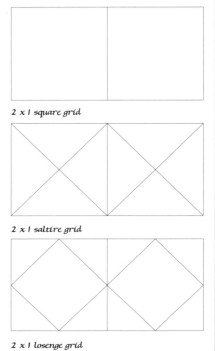

A 2 x 1 primary grid is a row of two square cells; the 2 x 1 secondary grid is two saltire cells across; two losenges side by side is a tertiary grid. The three dot grids combine to double the order of the parent grid.

A 1 x 1 primary dot grid combined with a 1 x 1 secondary dot grid and a 1 x 1 tertiary dot grid produces a 2 x 2 primary dot grid, *fig. 1f.* You can use this trick to subdivide a rectangle.

fig. 1f: 1 x 1 dot grids combined

fig. 1e: 4 x 2 grids

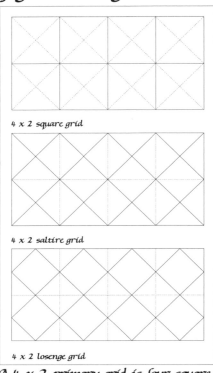

A 4 x 2 primary grid is four square cells across, and two squares down.

A 4 x 2 secondary grid is two rows of four saltire cells, one on top of the other.

A 4 x 2 tertiary grid is four columns with two losenges in each column, one on top of the other.

Can you see the 2 x 1 secondary and tertiary grids inside the 4 x 2 saltire grid, above?

The Two-by-two Plait

The 2 x 2 plait is based on the 2 x 2 primary dot grid, *fig. 2, step 4*. It was known as King Solomon's Knot in medieval Europe. In the 2 x 2 primary grid there are two square spaces across the top and two spaces down the side. Each of these squares is a primary grid cell. In *fig. 1*, we saw the secondary and tertiary grids in line-drawn form, as saltire and losenge. From now on we will identify the three levels in dot form only.

fig. 2 : The 2 x 2 plait

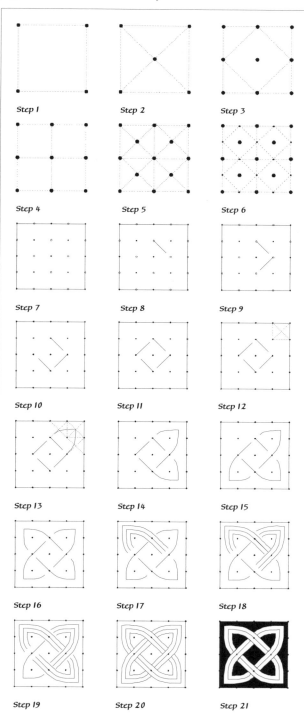

1 begin with a square of four dots
2 mark the midpoint of the square
3 divide the sides of the square
4 the 2x2 primary grid of dots
5 add a secondary, diagonal dot grid
6 add a tertiary, diamond dot grid
7 start with the central diamond
8 draw three-quarters of a side of the diamond
9 draw three-quarters of the second side
10 draw three-quarters of the third side
11 draw three-quarters of the fourth side
12 aim for the middle of the dotted "X" as here
13 draw the line from the diamond below
14 repeat from the next side of the diamond
15 repeat
16 four corners complete the line of the plait

Steps 17-19
Outline the midline of the plait with the sides of the band, keeping the same distance on either side of the midline throughout.

Step 20
Close any gaps between the end of each strand and the band that crosses over it.

Step 21
Fill the background. Notice that all the tertiary grid dots have been swallowed up by the midline of the woven band, and that the primary and secondary dots have all been covered by the surrounding frame or the filled-in background.

fig. 3a: Weaving the 4 x 2 plait midline

Step 1:
4 x 2 square grid, as shown by the unbroken lines: corners of squares locate primary grid dots.

Step 2:
4 x 2 saltire grid: diagonal crossings locate secondary grid dots.

Step 3:
the sides of the square cells are divided by imaginary lines passing through the secondary grid dots.

Step 4:
the tertiary grid is defined as diamonds connecting the midpoints of the sides of the squares.

Step 5:
the points of the diamonds are tertiary grid dots. The sides of the bounding rectangle cancel tertiary dots on the outer edges.

Step 6:
starting halfway along the side of the corner diamond, pass through the first tertiary-grid dot and stop short of the next tertiary dot.

Steps 7– 18:
continue weaving the tertiary grid, bending away from the outer edge points. Note two straight-line segments in the final two steps.

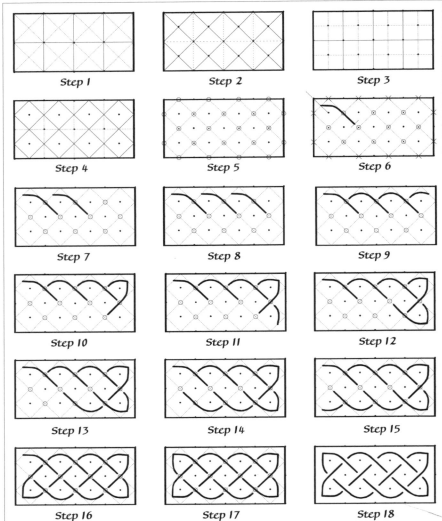

Step 1 Step 2 Step 3
Step 4 Step 5 Step 6
Step 7 Step 8 Step 9
Step 10 Step 11 Step 12
Step 13 Step 14 Step 15
Step 16 Step 17 Step 18

fig. 3b: Weaving the 4 x 2 plait band

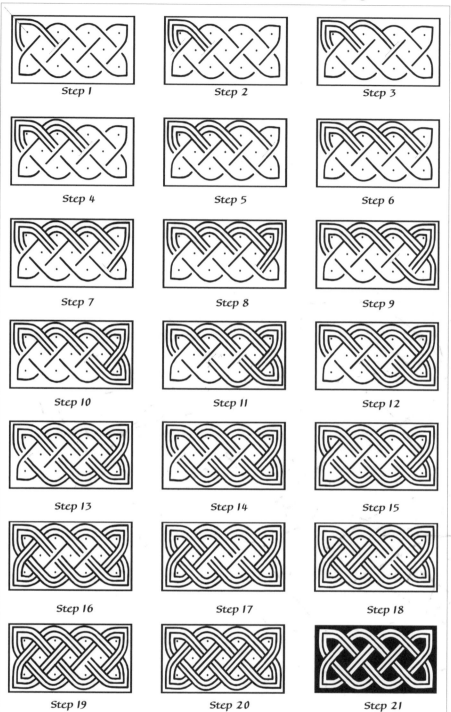

Step 1, Step 2, Step 3
Step 4, Step 5, Step 6
Step 7, Step 8, Step 9
Step 10, Step 11, Step 12
Step 13, Step 14, Step 15
Step 16, Step 17, Step 18
Step 19, Step 20, Step 21

Step 1:
wrap an outline around the outside of the top left corner elbow.

Step 2:
repeat outline inside the same segment.

Step 3:
add outline to the outside of the first, upper edge bend.

Step 4:
add an outline to the inside of the same segment.

Steps 5 and 6:
outline the next edge segment.

Steps 7 and 8:
outline the top right corner elbow.

Steps 9 to 16:
outline the edge and corner segments to the lower left corner.

Steps 17 and 18:
outline the straight, internal segment.

Steps 19 and 20:
repeat for the second straight segment.

Step 21:
fill the background to complete the 4 x 2 plait.

fig. 4a: 4 x 4 dot grid patterns

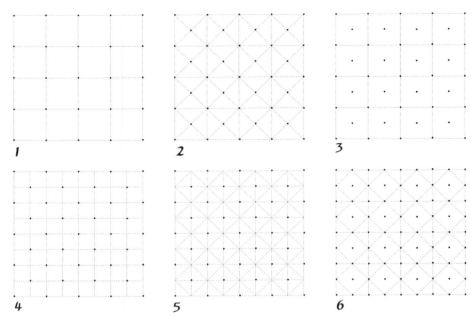

1

2

3

4

5

6

Fig. 4a, 1: the 4 x 4 square grid. This is the primary dot grid.

Fig. 4a, 2: the 4 x 4 saltire grid. The diagonals of each primary cell cross at the midpoint of the square.

Fig. 4a, 3: the 4 x 4 secondary dot grid is made of dots placed on the midpoints.

Fig. 4a, 4: horizontal and vertical lines drawn through the midpoints cut the sides of the squares.

Fig. 4a, 5: the 4 x 4 losenge grid. The points of the diamond connect the midpoints of adjacent sides of the squares. This losenge grid is the skeleton of a 4 x 4 plait.

Fig. 4a, 6: the 4 x 4 tertiary dot grid.

This figure is an exercise to train your eye to be able to pick out more than one thing at a time, to perceive secondary and tertiary relationships within the overall array. You can see the same pattern in more than only one way. For instance, in *fig. 4a, 5*, you can see a combination of 4 x 4 primary, secondary and tertiary grids all in one, or you can view it as an 8 x 8 primary grid.

Geometric patterns often present two views equally to the eye, at the same time. The Greek term for this is *synopsis*. You have to develop this "synoptic" vision, in order to "read" knots.

As you have seen, the 4 x 4 losenge grid is the midline of a plaitwork band.

This suggests that plaitwork patterns may actually have been derived from the primitive geometric pattern of a net of diamond cells, rather than the imitation of wickerwork, as might be thought otherwise.

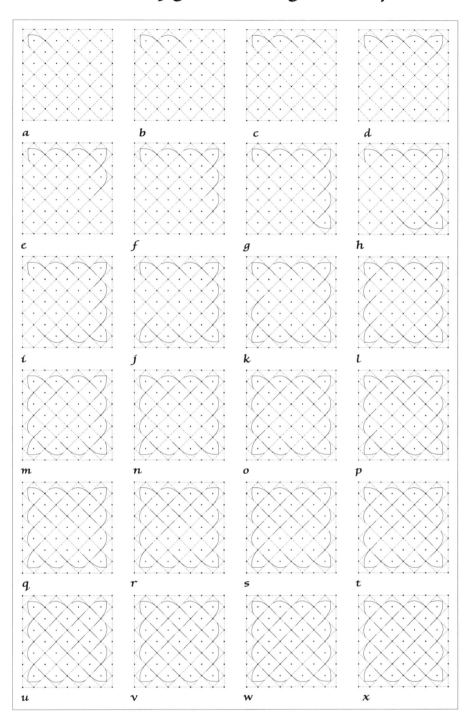

Just as two 2 x 2 grids make a 4 x 2 grid when joined side by side, grid modules can be stacked one on top of the other, so that two 4 x 2 blocks make a 4 x 4 square dot grid, *figs* 4a and 4b.

Or two 4 x 2 grids can be joined side by side to make a 8 x 2 plait, *fig. 5*.

fig. 5: The 2 x 8 plait

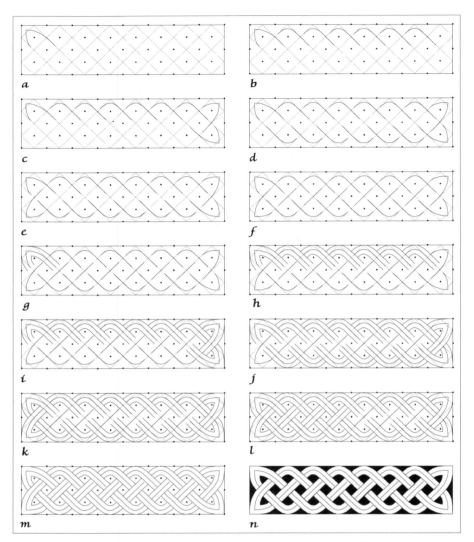

In this unit, we have seen several simple plaits beginning with King Solomon's Knot, the minimal plait, based on a square dot grid, two across by two down, *fig. 2*.

The plaitwork band contains three types of segment: a corner segment, an edge bend segment and a straight segment. Solomon's Knot contains only four corner segments.

With this building block, we built a plait four cells wide and two deep, *fig. 3*. The 4x2 plait contains two bends on the top and bottom edges, two straight segments and four corner segments.

fig. 6 : The Foundation Knot

So far, all these patterns produce separate circuits: the 2 x 2 plait, the 4 x 2 plait and the 8 x 2 plait have two circuits. The 4 x 4 plait has four circuits. This is perfectly acceptable: there is absolutely no rule that says all knots – or plaits – must be continuous.

However, we can make a continuous path out of the 2 x 2 plait pattern, by placing a breakline on the secondary grid, causing its path to turn.

Here is the construction of the basic knot, which I call the Foundation Knot.

Significantly, this is the only viable breakline that can be applied to the 2 x 2 grid. Note also that the 2 x 2 is the smallest square plait possible: the next smaller square is a single cell, which is too small.

Because the simplest knot has only one breakline solution, it makes the ideal model with which to demonstrate the principles of knotwork design.

If we can learn how to make an unlimited number of designs from such a minimal foundation, then we will be able to generate endless variations from more complex, versatile modules, such as the 3 x 2 grid, which has many more than one single breakline solution, as we shall see later on. But for the first eight units, we shall stick with this basic knot.

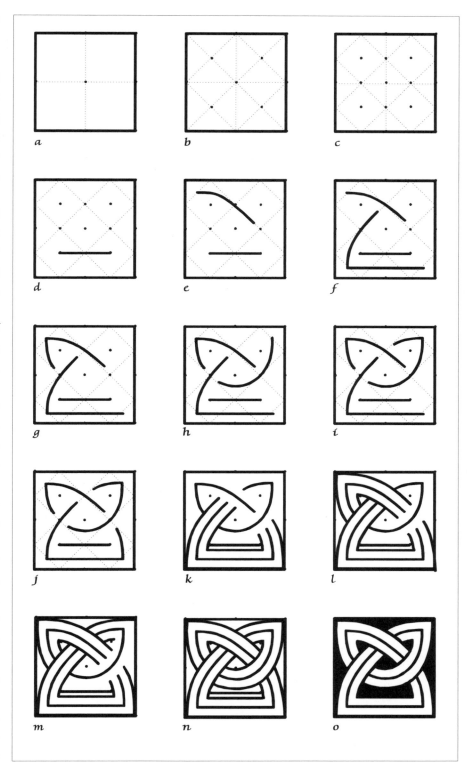

EXERCISES

1 Draw a 2 x 2 square dot grid.

2 Draw a 2 x 2 diagonal dot grid.

3 Draw a 2 x 2 diamond dot grid.

4 Draw a 2 x 2 combination grid, square, diagonal and diamond, omitting the points along the outside on the diamond grid.

5 Draw a 4 x 2 plait pattern.

6 Draw a 4 x 4 plait pattern.

7 Draw the Foundation Knot directly, free-hand, that is, without a preliminary pencil sketch or tracing, and without referring to the instructions (you may have to practise it from fig. 6 a few times to master the steps of the construction).

These exercises are in the order in which the examples appear in the book.

If you find any difficulty with exercises 1–4 above, revise figs 1 and 2.

If you have trouble with exercise 5, revise fig. 3. Draw the 4 x 2 plait from memory: if you cannot, do it over until you know it by heart.

If you cannot do exercise 6 without referring to the book, then turn to fig. 4, and repeat the drawing until you can.

Be sure, above all, that you have fig. 5 off by heart, and that you can do all these exercises to your own satisfaction before proceeding to Unit 2.

Unit 2: Four variations and sixteen permutations

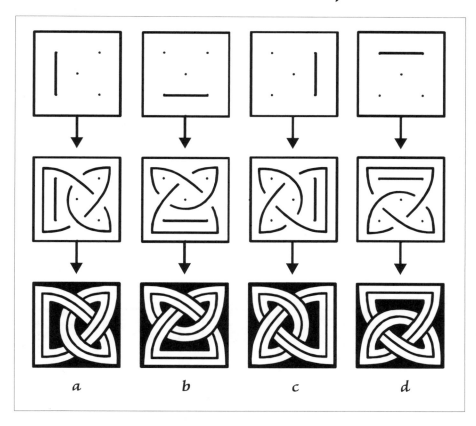

a　　　b　　　c　　　d

In the last unit, in fig. 6, we saw the effect of a breakline joining two points on the diagonal grid. This converted the 2 x 2 plait, or King Solomon's Knot, fig. 2, into the basic 2 x 2 knot, or Foundation Knot.

The first name is taken from medieval tradition, the second is one I made up, for the purpose of this course, because this knot will be the foundation on which the first lessons will be built.

By the way, there is no special significance in the names of knots, they are purely mathematical figures, but some people prefer to name them.

As you have seen, the Foundation Knot has only one breakline on the secondary grid, which happens to be the only acceptable breakline possible on the 2 x 2 grid. However, the breakline can be placed in four positions, as in *fig. 7*.

The structure of the knot remains the same in all four positions. Arranged in sequence, the four resulting knots look as if they are the same one, just rotated through four quarter turns.

But to distinguish them, for practical purposes, I will refer to the four breakline positions of the basic knot as breakline positions *a, b, c, d*, as here: you can see why, in the next figure.

fig. 8:
Foundation Knot pairs:
sixteen permutations

[A], [C], [F], [H], [I], [K], [N], [P]
are symmetrical.

[B], [D], [E], [G], [J], [L], [M], [O]
are non-symmetrical.

[C], [F], [I], [P]
are symmetrical on a vertical axis: the pattern on the right-hand side folds over onto the pattern on the other side.

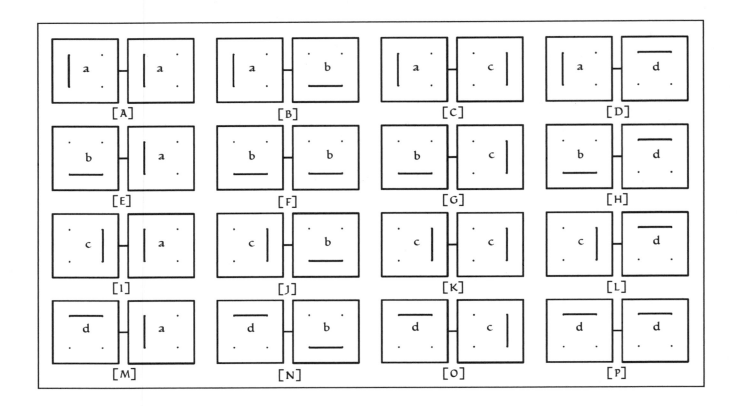

Having turned around the single knot on all four sides, as it were, and drawn it in four different positions, let us take two of these and combine them.

We can take any one of the first four permutations, *fig. 7 a, b, c or d*, and pair it with any other one... there are sixteen possible permutations of breakline pairs in this arrangement of two 2 x 2 square grids placed side by side.

[A], [C], [T], [K]

are symmetrical on a horizontal axis. The pattern on the upper half folds onto the pattern in the lower half.

[C], [H], [T], [N]

are symmetrical on a diagonal or rotating axis: if turned over, the pattern of one side will fall on that of the other half.

[C], [T]

are symmetrical on all three axes.

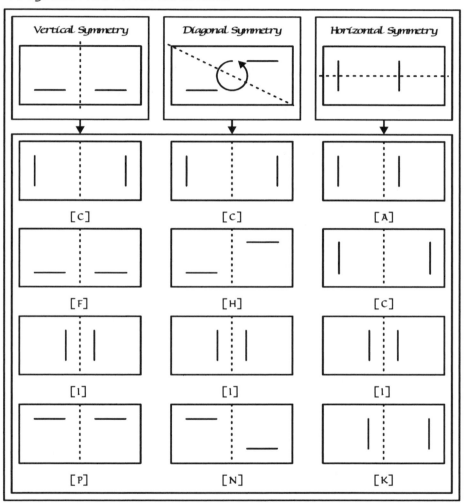

fig. 10:
4 x 2 primary, secondary and tertiary grids combined

We are used to thinking of grids as made of lines, and that is how I introduced the three grids in *Unit 1*, so that you could compare them.

But in Celtic knot design, the grids used are made of dots, not lines, so we will be dealing with primary, secondary and tertiary dot grids, rather than ruled-line grids.

Fig. 10 shows the three grids in 4 x 2 format (that is, four spaces across and two spaces down).

Study the three types of the 4 x 2 grid, and then try to pick out each when all three are combined in the compound grid, *fig. 10d*.

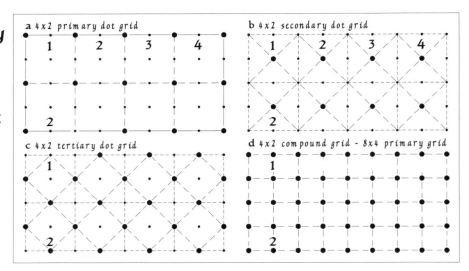

Here the implied lines are shown in broken dashes between the dots. As you can see, the primary dot grid defines the corners of four square cells across, and two squares down.

The corners automatically relate diagonally, as well as horizontally and vertically: the diagonals cross in the middle of each square. Because of this, we can see that the primary grid produces a series of diagonal crosses, or saltires, defining the midpoints of the square, primary cells. These midpoints are a separate grid from the primary grid, and so we can term them the secondary grid. This secondary 4 x 2 grid consists of fewer cells than its primary parent – the dots of the 4 x 2 grid contain only a single row of three cells across.

The sides of the cells of the secondary grid cut through the sides of the primary grid, and this sets up another series of dots: the tertiary grid diamond cells connect the midpoints of the sides of the primary squares.

The combination of all three grids produces a second generation primary grid with double the original order of cells:
(4 x 2 primary + 4 x 2 secondary + 4 x 2 tertiary) = (8 x 4 primary).

I encourage you to try laying out the grid in a different order - perhaps you will find another order that works better for you than the one I have given here. Fig. 11 gives one order of freehand construction which I have found to be comfortable: by applying this order, inaccuracies are more evenly spread throughout the whole grid.

The grid construction is all important when you are creating a freehand knot design. The harmony and regularity of the finished knot depends on how carefully and regularly the dot grid has been done. To get the best result, try it this way. Let the grid unfold as if from a seed. Point, line, line division; primary, secondary, tertiary. You may find a different order works for you, but try to keep the same order each time, in order to develop maximum control.

Steps of grid construction:

1. The starting point is the top left-hand corner.

2. The line is the width of the grid along the top edge.

3. The division of this line gives the side of a square.

4. Drop the side of the square from each end of the line, and join the lower points to complete the 2 x 1 rectangle.

5. Divide the rectangle to make two primary cells.

6. Two central points define the 2 x 1 secondary grid.

7. 2 x 1 tertiary, plus primary and secondary = 4 x 2 primary.

8. 4 x 2 secondary dot grid.

9. 4 x 2 all three dot grids combined.

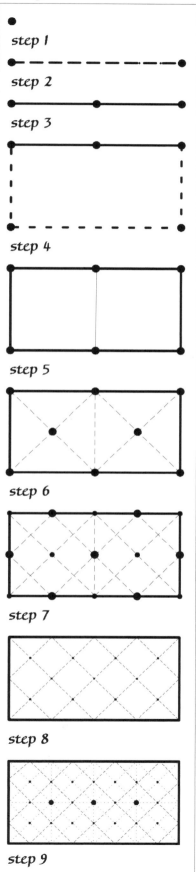

fig. 11: Freehand dot-grid construction

step 1

step 2

step 3

step 4

step 5

step 6

step 7

step 8

step 9

fig. 12 :
Primary grid
breaklines on a 4 x 2
grid

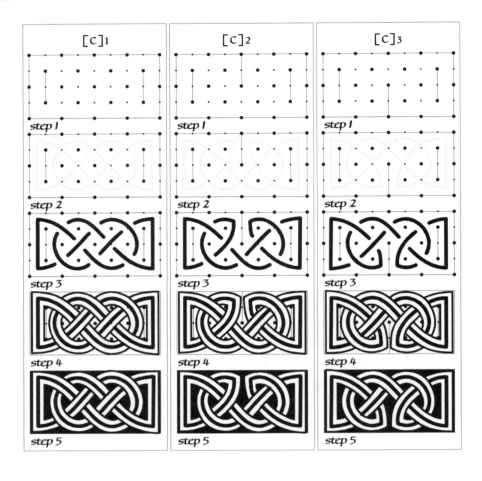

The primary grid breakline makes all the difference between the knot in fig. 12 [C] 1, step 5, and the knot in fig.12 [C]2, step 5.

In fig. 12 [C]2, the breakline is on the upper edge of the primary dot grid.

In fig. 12 [C]3, the breakline is on the lower edge of the primary dot grid.

As we have seen, putting a breakline on the secondary grid controls the structure of the knot. But what about a primary dot grid breakline?

In this particular instance, the appearance of the knot remains the same whether the primary grid breakline is on the top or the bottom, but it sometimes does make a strikingly different pattern.

Although in this case the knot appears to be the same one turned over, technically these are two distinct knots because the breakline patterns are different.

In this figure, the various stages which complete the knot have been shown. In the following figures, only skeletal, midline diagrams are given, so you can complete the knots by drawing over the dashed lines with a pencil while sweetening the curves, as in *step 2*; weave the line and - when you are sure that it is correct - draw with ink over the pencil line, as in *step 3*. Then outline, *step 4*, and fill, *step 5*.

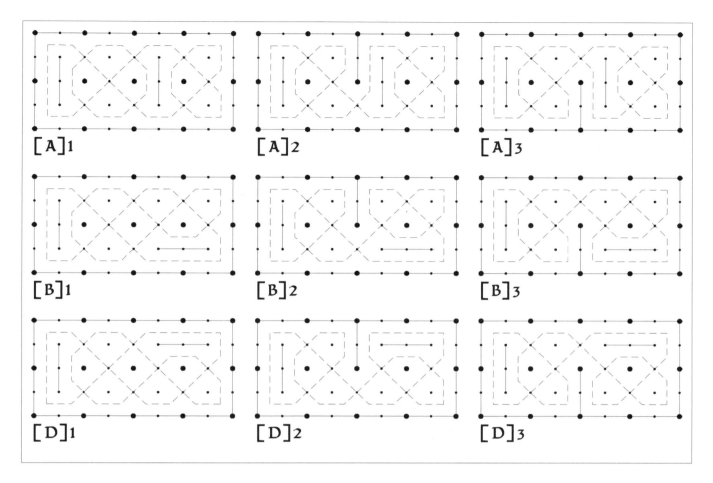

In *fig. 12*, the primary grid breakline on the top or the bottom does not change the structure of the knot. It seems to be the same, just rotated. But the position of the primary grid break can make a difference, compare fig. 13[D]2 and fig. 13[D]3.

In *fig. 12*, the four stages of the construction are shown to complete the knot. The first row gives the dot grid and breaklines, with the corresponding path of the knot shown in dotted lines, as if pencilled in. The second row shows the centre line of the knot, drawn in a heavier pen line. In the third row, the centre line is outlined on either side. In the fourth row, the background is filled in. For a more finished look, use a medium point for the midline, and an extra fine point for the edge lines.

Fig. 13 shows thumbnail diagrams of the preliminary layout for nine knots. Redraw these knots at least twice the size they are reproduced here, and then complete. Draw a 2 x 2 primary and secondary grid. Repeat four times; place the breakline in all four positions on the secondary grid.

fig. 13 :
Freehand dot grid
construction

EXERCISES

1 Draw a 2 x 2 primary and secondary grid. Repeat four times; place the breakline in all four positions on the secondary grid.

Turn to fig. 7, and compare the results. If you have any difficulty distinguishing the primary grid from the secondary grid, or with the term "breakline", revise Unit 1. Otherwise, carry on.

2 Draw a 4 x 2 dot grid, primary, secondary and tertiary. In each half of the grid, place a breakline on the secondary grid. Arrange the breaklines so that they are symmetrical on the horizontal axis of symmetry.

For the 4 x 2 dot grid, see Unit 1, fig. 3. See fig. 8 for the placement of the breaklines in each half grid.

Fig. 9 tells you about the axes of symmetry.

3 Repeat the procedure as for Exercise 2, but place the breaklines in vertical symmetry.

4 Same again, but try diagonal symmetry this time.

5 Starting with the 4 x 2 grid, primary, secondary and tertiary, place breaklines as in fig. 12, [C] 1. Weave the line on the tertiary dot grid. Outline this with a narrow contour on either side of the midline; fill the background between the closed-off triline segments.

6 Complete the line knot weaving, outline and fill in, to finish the breakline plans you have already made in exercises 2, 3 and 4 above.

7 Of the nine line knots in fig. 13, choose one that is discontinuous and symmetrical. Take it from the dot stage through to its finished state. Use no preliminary pencilling, work direct with a black ink pen. If you make a mistake, start over, rather than correct it.

Unit 3: Forty-eight pairs

In the last unit we rotated the Foundation Knot to give us four units, *fig. 7a, b, c, d.* Each unit is a 2 x 2 dot grid with a single, secondary grid breakline placed in one of four positions. Then we made a permutation chart of these four units, and labelled the resulting 16 knots with letters in brackets, *fig. 8.*

Remember, each of these four possible positions of the Foundation Knot secondary grid breakline positions fits a 2 x 2 square. Each dual unit combination will fit a 4 x 2 grid, four spaces across by two spaces down. The basic knot pairs are shown in *fig. 8.* We can also describe the contents of the same figure as a permutation chart, as here, on the right.

In the previous unit, we covered breakline plans [A], [B], [C], [D]. This unit covers the other twelve combinations, namely [E] to [P].

These symmetrical, continuous knots are a ready-made stock of single decorative motifs. Copy them onto the practice sheet on page 34, and keep them for reference. Practise them all regularly until you have them off by heart. One way to do this is to use them to decorate items such as labels, envelopes, bookmarks, letterheads, notecards, greeting cards, or anything you can imagine.

To make the permutation chart, four letters a, b, c, d are paired to make sixteen permutations, labelled with bracketed capitals for quick reference: [A] - [P].

Bracketed capitals indicate a pair of two 2 x 2 grids with breakline positions a, b, c, d, as in fig. 8.

Permutation Chart

01:	a+a	=	[A]
02:	a+b	=	[B]
03:	a+c	=	[C]
04:	a+d	=	[D]
05:	b+a	=	[E]
06:	b+b	=	[F]
07:	b+c	=	[G]
08:	b+d	=	[H]
09:	c+a	=	[I]
10:	c+b	=	[J]
11:	c+c	=	[K]
12:	c+d	=	[L]
13:	d+a	=	[M]
14:	d+b	=	[N]
15:	d+c	=	[O]
16:	d+d	=	[P]

fig. 14:
Secondary break
patterns [E], [F], [G]
with primary
breaklines on the top
and bottom edges

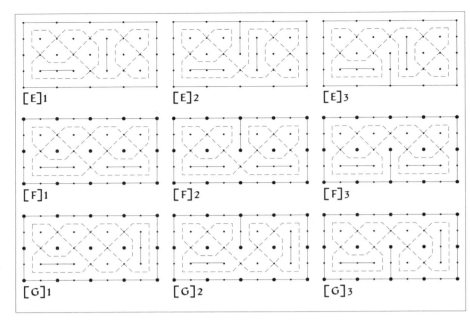

[E]1 [E]2 [E]3

[F]1 [F]2 [F]3

[G]1 [G]2 [G]3

Here, I have placed tertiary
grid dots along the outer edge,
so that you can see them. In
drawing the knot, however, the
tertiary grid dots should be
omitted along the outer edge,
or drawn in pencil only, and
erased afterwards.

Fig. 14 shows the primary breaklines 1, 2, 3 in each of the three
secondary grid combinations [E], [F], [G].

Fig. 14 [E] 1 is not continuous. The loop on the left is too obvious,
which may make this design no good as a stand-alone knot. [E] 2 and
[E] 3 are both continuous, and quite different from each other.
All three are not symmetrical, and therefore not very good as single
ornaments. However, they may have ornamental possibilities when
expanded into strips or panels, as we shall find out how to do later
on. So don't discard these just yet.

Fig. 14 [F] 1, [F] 2 and [F] 3 are all fine as single ornaments, with
symmetrical secondary breaklines on the vertical axis.

Fig. 14 [G] 1 is discontinuous, while [G] 2 and [G] 3 are continuous.
Although all three are asymmetrical, [G] 3 is a passable single unit.

For symmetry and continuity, [F] 2 and [F] 3 are the best options
to include in your collection of 4 x 2 knots, along with [C] 1, [C] 2,
[C] 3, fig. 12, and [A] 1, fig. 13.

Exercise:
draw a 4 x 2 dot grid,
and copy in the
breaklines for a knot.
Weave the midline of
the path, outline it on
either side, and fill in
the background.

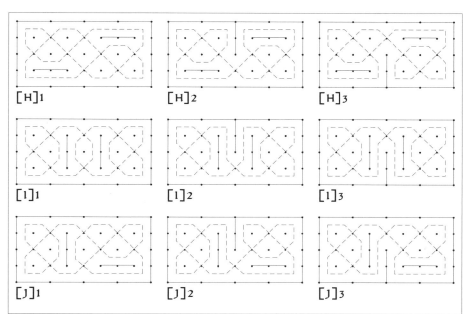

fig. 15:
Secondary break patterns
[H], [I], [J] with
primary breaklines on the
top and bottom edges

[H]1 is symmetrical, and a good single knot, even though it is not continuous. [H]2 and [H]3 are continuous and structurally different.

[I]1 is symmetrical. The single crossover in the middle of [I]2 and [I]3 breaks up the band too much, which is why the preferred treatment in such cases is a box break on the secondary grid: when two breaklines occur parallel to each other and are separated by one space only on the secondary grid, you can make a box out of the two breaklines. Then the path of the knot runs around the box, instead of being squeezed between the breaklines on the secondary grid. I leave it to you whether you include knot [I]1 in your selection.

Knots [I]2 and [I]3 are identical, symmetrical and continuous. They do not occur as single knots in traditional sources, perhaps because the breakline configuration breaks up the rhythm of the knot too much.

Knots [J]1, [J]2 and [J]3 are all asymmetrical, related to [E]1, [E]2 and [E]3.

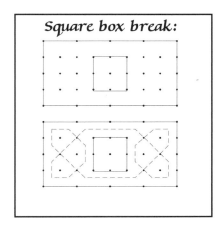

Square box break:

fig. 16:
Secondary break
patterns
[K] , [L] , [M]
with primary
breaklines
on the top and bottom
edges

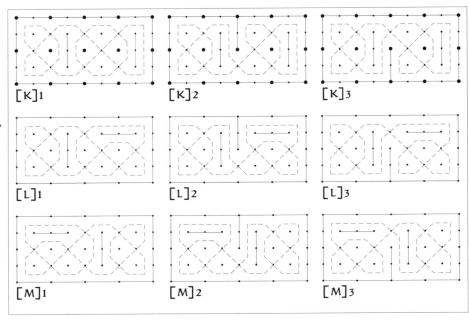

When using tracing paper to mirror an image, you must reverse the weaving from one half of the pattern to the other, to avoid crossing over-over or under-under between one knot and its mirror image. In Celtic knotwork, this is taboo: there is absolutely no exception to this rule.

Fig. 16, [K] 1 is discontinuous, and symmetrical on the horizontal axis. Fig. 16, [K] 2 and fig. 16, [K] 3 are both continuous and asymmetrical.

Compare knot [K] with knot [A] from fig. 13. [A] 1 is identical to [K] 1, except it is rotated through 180°. [A] 2 is a rotation of [K] 3, and [A] 3 is [K] 2 rotated.

When a knot is rotated, the weaving remains the same. This means that [A] and [K] may be paired off end to end in an 8 x 2 strip, or stacked one on top of another in a 4 x 4 panel.

Because the weaving keeps crossing over-under in the same direction, it is possible to connect these units to make larger units, as we shall see. We can play with these possibilities later on.

[A] 1 is also a mirror image of [K] 1. The axis of symmetry is vertical, along the short side.

Similarly [A] 2 mirrors [K] 2, and [A] 3 mirrors [K] 3.

In these three corresponding pairs, [A] 1 : [K] 1, [A] 2 : [K] 2, [A] 3 : [K] 3, the direction of weaving is reversed between any knot and its mirror image.

fig. 17:
Secondary break patterns
[N], [O], [P] with
primary breaklines on
the top and bottom edges

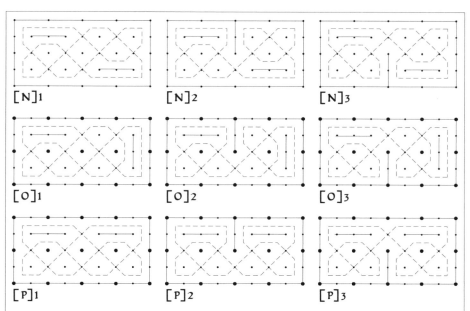

Fig. 17 [N] 1 is discontinuous, and symmetrical about the axis of rotation. This is also called "diagonal symmetry".

[N] 2 and [N] 3 are continuous, asymmetrical and structurally identical.

[N] 1 and [H] 1 are mirror images, so far as the breaklines go, but the direction of weaving in one is reversed in the other.

[0] 1 is discontinuous and asymmetrical. [0] 2 and [0] 3 are continuous, asymmetrical and different in structure. [0] and [B] are rotations of each other, with identical weaving.

[P] 1 is discontinuous. Compare with [F] 1. They are identical 180° rotations of one another.

Since some of these breakline plans are mirror images, why not just do one knot, and then trace its mirror image, and join them up? Because, if the weaving remained the same, the two knots could not be joined together without breaking the over-under order of the weaving.

If you just trace a knot, flip it over, place the reflection next to its parent, then join them together, you will end up with a strand that must pass over-over in the middle, between the mirrored halves.

EXERCISES

1 Here is a practice sheet of thirty 4 x 2 rectangles, showing primary, secondary and tertiary grid dots. If you can only see primary grids, eight units across and four down, then you need to revise the material on the three grids from the previous two units.

2 Review the knots you have completed from figs 12 and 13.

3 Select a knot that is symmetrical and continuous.

4 Fill in the primary and secondary grid breaklines and then the knot.

5 Do the same with figs 14–17.

Unit 4: The midline method

So far we have completed a survey of forty-eight knots on a 4 x 2 grid. Fig. 18 presents a chart of all forty-eight variations in terms of their breakline patterns.

As mentioned before, some of the knots would make good decorations on their own, and may be picked with consideration as to both continuity and symmetry.

In fig. 19 the eight inherently symmetrical combinations are paired.

In fig. 20 these 4 x 2 combinations are in turn treated as units, and paired up side by side and stacked one on top of the other.

Fig. 21 shows 15 variations on [A]+[K], giving the breakline diagrams.

Fig. 22 gives the line of the knots corresponding to these diagrams.

Fig. 23 introduces a new technique for drawing knots, by meandering around the dots on a secondary dot grid. This is the secondary grid method, suitable for drawing Celtic knots freehand on a small scale. The tertiary grid, triline treatment is more often seen in monumental sculpture, for instance, than miniature paintings.

In learning to design knotwork patterns, it is important, initially, to see that the patterns are derived directly from the tertiary grid, and to practise knots using the tertiary grid. However, instead of drawing the tertiary grid, it may simply be visualized instead, and the path of the knot may be drawn directly, alternately passing through and skipping over the place where you can visualize the intersection point to be located, that is, midway between the primary and secondary dots.

fig. 18:
Forty-eight 4 x 2
permutations

[A]1 [A]2 [A]3

[B]1 [B]2 [B]3

[C]1 [C]2 [C]3

[D]1 [D]2 [D]3

[E]1 [E]2 [E]3

[F]1 [F]2 [F]3

[G]1 [G]2 [G]3

[H]1 [H]2 [H]3

[I]1 [I]2 [I]3

[J]1 [J]2 [J]3

[K]1 [K]2 [K]3

[L]1 [L]2 [L]3

[M]1 [M]2 [M]3

[N]1 [N]2 [N]3

[O]1 [O]2 [O]3

[P]1 [P]2 [P]3

Knots [A], [C], [F], [H], [I], [K], [N], [P] have internal symmetry.

[A] and [K] are symmetrical on a horizontal axis.

[F] and [P] are symmetrical on a vertical axis.

[H] and [N] are symmetrical in rotation about the three axes passing through the centre of each knot.

[C] and [I] are symmetrical on all three axes.

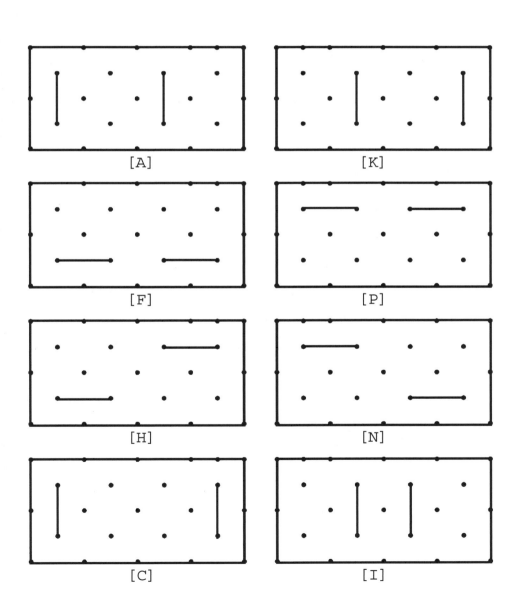

fig. 20:
[A] and [K]
symmetrical pairs

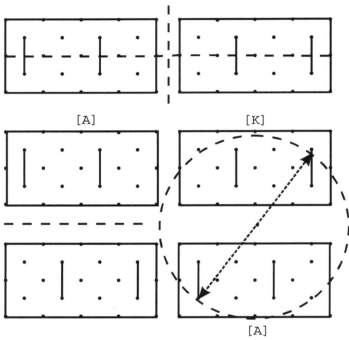

Comparing [A] with [K], we can see that they are symmetrical mirror images of each other when placed side by side. This mirror symmetry reflects on the vertical axis.

If the knots [F] and [P] are placed one on top of the other, they will reflect, mirror fashion, either side of the horizontal axis.

[A] and [K], stacked on top of each other, are not mirror images. This means they are not symmetrical to each other along the horizontal axis. However, they are symmetrical to each other on the rotating axis, the imaginary line passing from your eye through the centre of the stacked pair.

If rotated around this point, the breakline pattern of [A], on top, would correspond to the breakline pattern of [K] below, and the reverse would also be true. [A] and [K], in other words, look better when placed side by side, while [F] and [P] are better one on top of each other.

In placing pairs together, all three types of symmetry should be tried, side by side, or stacked. For now, let's see how to combine two such knots side by side, to make a 4 x 2 strip. We will look at stacked arrangements later on.

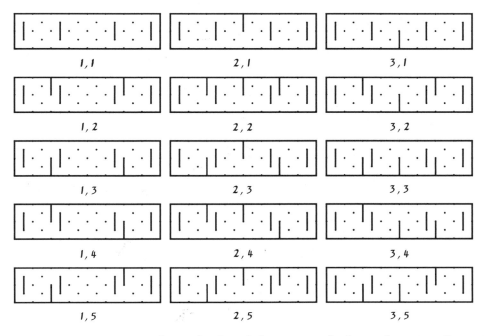

An 8 x 2 primary grid can be divided into a side-by-side pair of 4 x 2 units. The division may be left undefined, or defined by a breakline placed on the primary grid.

The primary grid breaklines may be placed in either of two positions: above or below the centre of the vertical axis dividing the pair.

Two 4 x 2s may be joined together in three ways: the three variants of [A] and [K] from fig. 18 can be joined thus:

[A] 1 + [K] 1
[A] 2 + [K] 2
[A] 3 + [K] 3

In addition, they can be joined as in [A] 1 + [K] 2 and [A] 2 + [K] 1. This makes five variations defined by breaklines on the secondary grid.

Each of these may be set out on the primary grid breaklines belonging to the 4 x 2 grid, to give us fifteen 8 x 2 permutations of [A] + [K].

fig. 22 :
[A] and [K] midline knots

When practising, lay out the knots both larger and smaller. Find a scale that works for you, that lets you draw cleanly and clearly.

1,1 2,1 3,1

1,2 2,2 3,2

1,3 2,3 3,3

1,4 2,4 3,4

1,5 2,5 3,5

The fifteen permutations, [A] + [K] in 8 x 2 format: drawn here using the primary and secondary grids only.

When you practise drawing the line of the knots, from this point on, you can try using the midline knot method, which saves time when trying out a breakline plan. This is also good practice for drawing freehand knots based on the midline alone. You can find many examples in the manuscripts, sometimes drawn with a fine line, sometimes with a dotted line in red ink.

If you find it too awkward to visualize the tertiary dot positions in order to pass through or leave a gap on either side of the intersection point, you can trace the path of the line in pencil first, and then weave over it. But if you keep trying to draw without the midline, it will pay off: you will then be able to weave the knot free hand, directly onto the primary and secondary dot grid.

If you like a particular design, you can finish it, and add it to your sketchbook collection.

Use the designs from the previous figure to practise this new, faster technique of drawing the MIDLINE of the knot: try it in as many different ways as possible. You can draw it upside down, back to front, any way you like:

fig. 23a

fig. 23b

fig. 23c:

Practise drawing the line of the knot only, with just the primary and secondary grids, as here.

EXERCISES

1 Note that in fig. 19 the dot grids are primary and secondary only. Draw the grid for [A], omitting the tertiary grid; pencil lightly the path of the knot; draw this with a pen line, weaving.

2 Repeat the last exercise, but now draw the line directly, without pencilling. Practise this with any of your favourite knots.

3 Further practice at freehand weaving is provided in fig. 23. Copy this, without using a pencil. Compare your result with the drawing in fig. 22, 1, 1.

4 From fig. 21, select any two breakline diagrams. Weave the line of the knot, freehand. Compare your result with the corresponding drawing in fig. 22.

5 Transfer the breaklines of fig. 21 onto the chart of dots on this page, and draw in the lines, weaving them directly. When you are satisfied that you have mastered the method of weaving without tertiary grid dots, and without using a pencil, then fill and complete your knots.

6 Of the 8 x 2 knots, as before, make selections according to your own taste, make a repertory sheet of your personal favourites from this unit. Label them depending on continuity or discontinuity, symmetry or assymetry.

7 When you have selected your favourites, practise them freehand and then come up with ways to apply them on every impressionable surface that you can see!

Knots look great drawn big. A single knot can even be painted to fill a whole sheet of paper, like a painting. You can use pen and ink, big markers, or tempera and paint brush. You should experiment with scale, and with different media.

Unit 5: Four-unit border strips, 30 variations

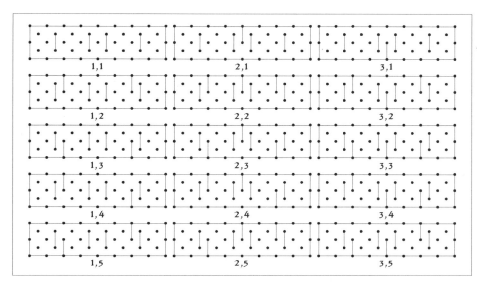

In the last unit, we found fifteen ways to vary the [A]+[K] combination. Another set of fifteen variations can be discovered by reversing the two 4 x 2 modules, from [A]+[K] to [K]+[A].

fig. 25:
[K]+[A] knot midlines

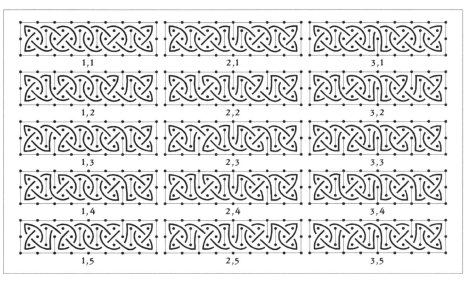

Here you can see the lines woven on the breakline arrangements as in fig. 24. You can complete the knots by outlining the midlines here, and filling in the background. But first, complete the line knots in fig. 24, and then compare the results with these, fig. 25. Compare these knots with those in fig. 31, 1-5, to see how different they are, having reversed modules in each set.

fig. 26:
Rotation, mirror image and weaving reversal [A], [K], [C] and [I]

In [A] and [K], the breaklines are mirrored. But when the line is woven, starting in the same position in each, and weaving in the same direction, the knots are 180° rotations, not mirror images.

[C] and [I] reproduce exactly when rotated, yet when mirrored, their weaving is reversed.

Weaving reverses when knots are flipped vertically or horizontally. Rotation does not affect the direction of the weave.

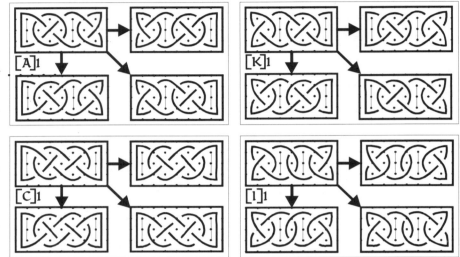

fig. 27:
Rotation, mirroring and reversal of weaving [F] and [P]

[F] and [P] are rotations, not mirror images of each other when woven, although their breaklines mirror each other.

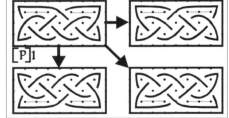

fig. 28:
Rotation, mirroring and reversal of weaving [H] and [N]

[H] and [N] breaklines are mirror images also, but do not mirror when woven. Nor do they reproduce each other when rotated, although each reproduces itself when rotated.

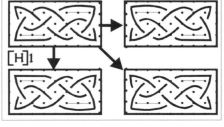
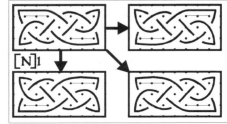

fig. 29 :
Variations [F] + [P]

The columns give the primary break permutations, for the 8 x 2 grid, as in fig. 21. The first five rows include the breaklines for 4 x 2s. The first five rows are [F]+[P]. The next five are [P]+[F].

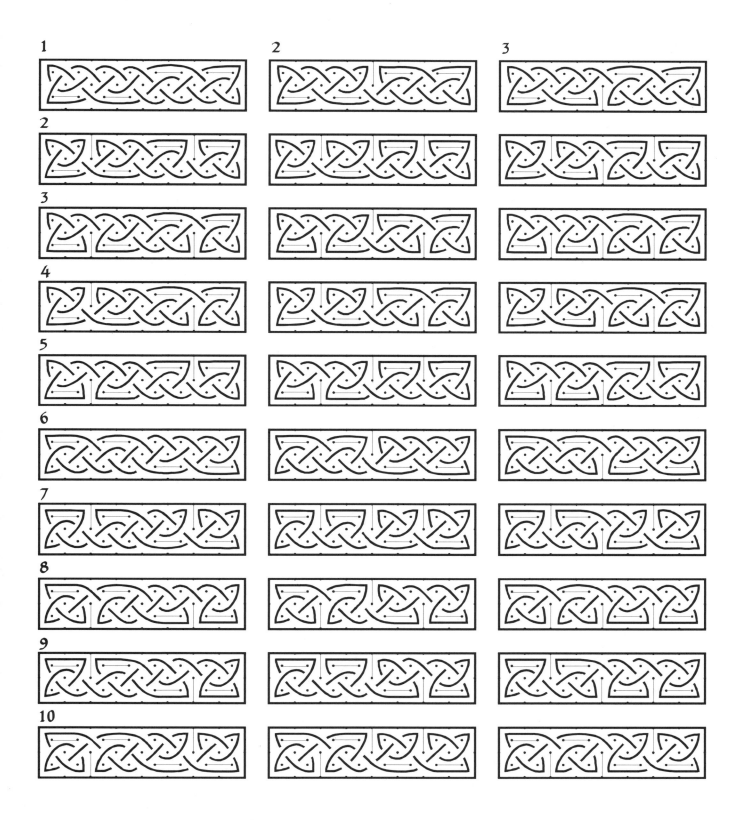

fig. 30:
Variations [H] + [N]

Thirty variations of [H]+[N]. The columns give the three primary break divisions of the 8 x 2 : column 1 has none; column 2 has one primary break on the top edge; column 3 has the break on the lower edge. Rows 1-5 show [H]+[N]. Rows 6-10 show [N]+[H].

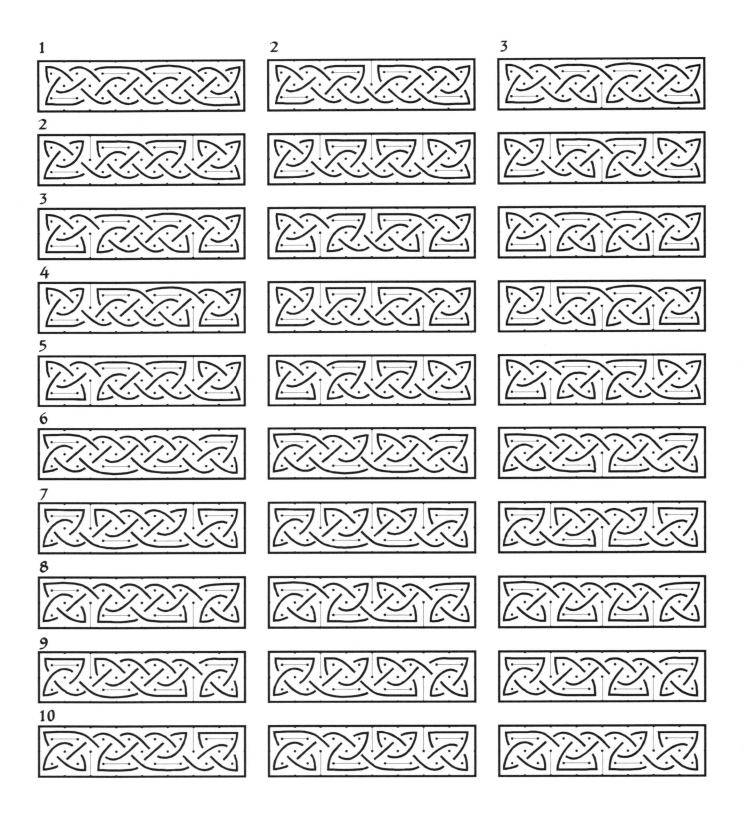

Variations [A] + [K] and [K] + [A]

Thirty variations of [A] and [K]. Rows one to five show the combinations of modules [A]+[K]. Rows six to ten show combinations [K]+[A]. These knots reproduce themselves when they are rotated. The other symmetrical knots [C], [F], [H], [T], [N], or [P] may also be repeated in pairs: [C]+[C], [F]+[F], etc.

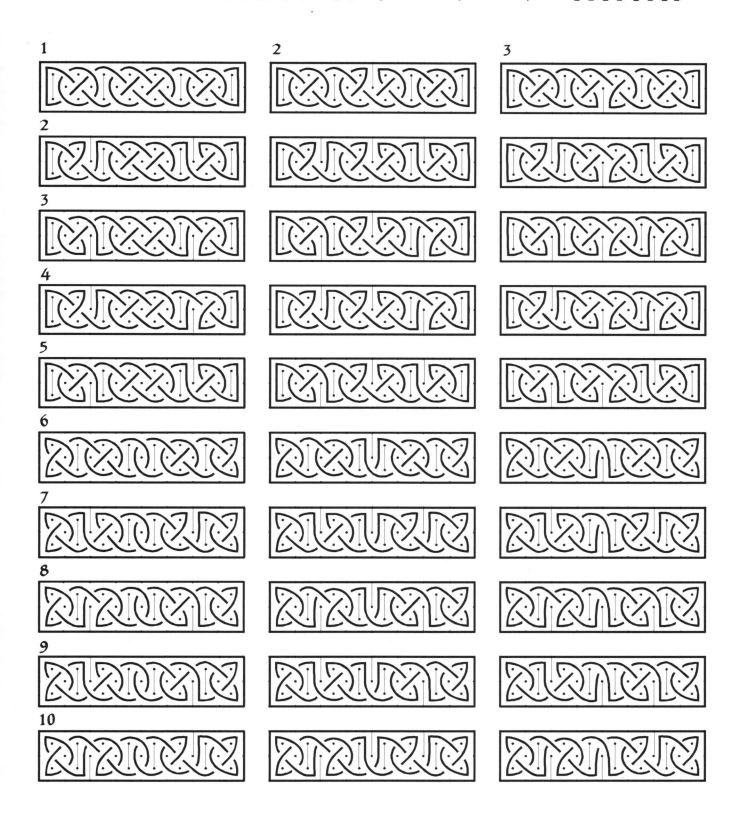

fig. 32a:
Variations [C] and [I]

Thirty permutations of [C] and [I] in 8 x 2 format. The first five rows show combinations of [C] + [I]. The last five rows show combinations of [I] + [C].

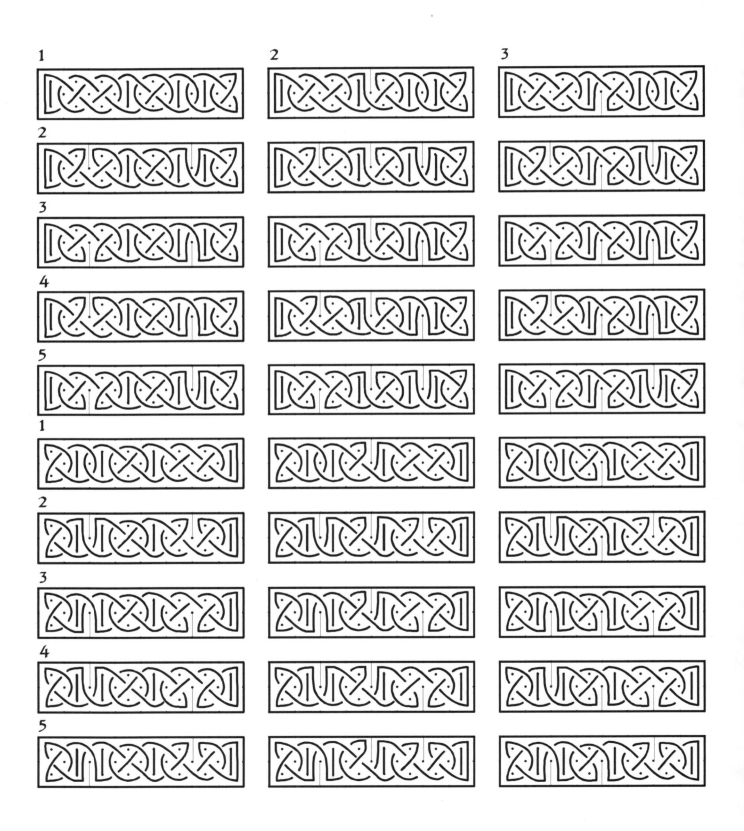

Here are thirty primary grid breaks for two 2 x 8 strips (fifteen in the upper half, fifteen below).
You can make copies of this sheet and fill in the copies.

1

2

3

2

3

4

5

1

2

3

4

5

1

2

3

2

3

4

5

EXERCISES

1 Draw the line knots onto the grids of fig. 24. Compare your results with the line knots in fig. 25.

If you get any wrong, you can redo them using the practice sheet on the previous page, fig. 32b.

2 From fig. 25, draw up one knot into its finished state. Base your drawing on a large-scale primary grid, using the width of your thumb as the width of a square.

3 Pick out which patterns in fig. 25 are symmetrical in all three axes, and which are continuous.

4 In figs 29-32, pick out those that are symmetrical on the vertical axis, symmetrical on the horizontal axis, and symmetrical on the diagonal, or rotational axis.

5 In figs 25, 29, 30, 31 and 32, pick out patterns that are both symmetrical and discontinuous.

6 Complete one knot from each of figs 29-32: convert the knotline into a woven band containing a midline, and fill in the background.

7 Select from this unit the knots that please you most, and learn them off by heart. Add them to your own repertory sheets.

8 From fig. 32a, select a row of knots; redraw them with the weaving reversed.

If you do not understand what reverse weaving looks like, compare any adjacent pair of knots in fig. 26.

Look at the top left corner segment, in one knot, and compare it with the same segment in the knot beside it. Where one goes over, the other goes under, reversing the weave.

Unit 6: Symmetrical pairs, 120 variations

In this unit, we find fifteen ways to vary a symmetrical unit, when the same unit is repeated. Here, the first fifteen combinations are [F]+[F], followed by [P]+[P].

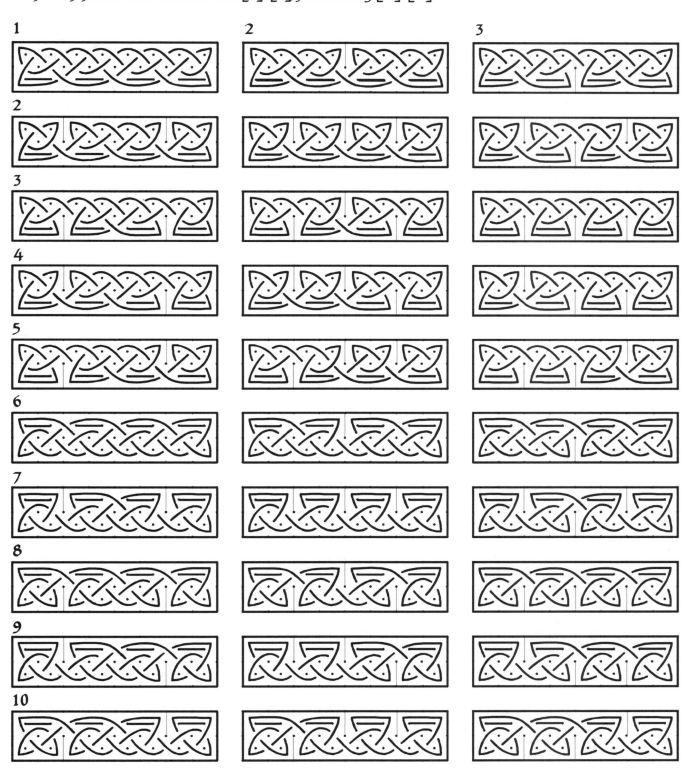

fig. 34:
[1] and [N] breaks

The first fifteen combinations are [1]+[1]; the second fifteen combinations are [N]+[N].

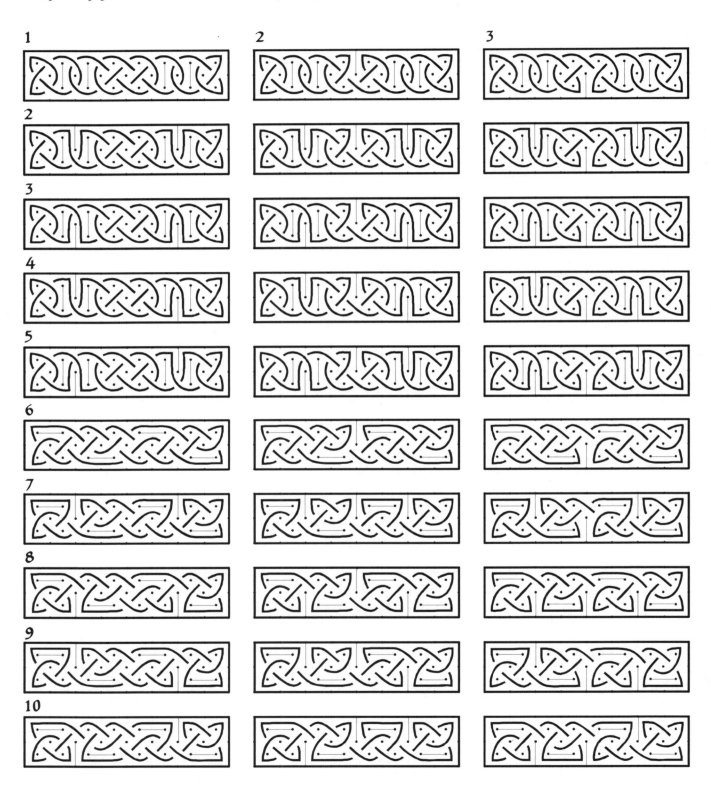

So far we have looked at symmetrical knots only, [A], [C], [F], [H], [I], [K], [N], [P]. [C] and [I] each have fifteen permutations, [C]+[C], [I]+[I].

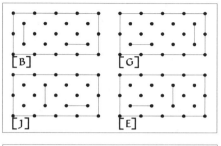

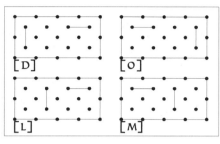

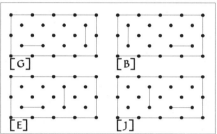

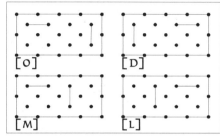

Note: adjacent breaklines may produce a kink in the path. Although a knot with such a sharp turn may be technically correct, it breaks up the visual rhythm of the knot too much, and should generally be avoided.

Having said that, we will allow the unavoidable sharp turn caused by adjacent breaklines on the primary and secondary grid, for the purpose of this course is to explore all the designs possible. You never know: a design that might look ugly on its own sometimes looks much better when stacked or mirrored.

Also, links that are too short may be avoided as a rule, on purely aesthetic considerations. Links are not necessarily wrong, so long as the link is not so short that it sticks out, or is repeated too close together – links are often found in traditional sources, even in the best work. Such aesthetic considerations should be taken as guidelines only, not hard rules.

Less symmetrical knots have more variety when combined.

[A] and [K] have thirty permutations: 15 [A]+[K] + 15 [K]+[A] (figs 22 and 25). [F] and [P] (fig. 29) and [H] and [N] (fig. 30) have thirty permutations too.

[C] and [I], symmetrical on all three axes, have the least permutations.

[A] and [K], with symmetry on one axis, have twice as many as [C] and [I]. [A] + [A], and [K] + [K] have fifteen permutations each, besides the thirty of [A] + [K] and [K] + [A].

Likewise, [F] + [P] and [P] + [F] have sixty possible combinations, and the same for [H] + [N] and [N] + [H].

In fig. 35, we look at [B], [D], [E], [G], [J], [L], [M], [O].
These may be paired side by side:
[B]+[G], [D]+[O], fig. 36 and [J]+[E], [L]+[M], fig. 37;
likewise, in reverse:
[O]+[D], [G]+[B], fig. 38 and [E]+[J], [M]+[L], fig. 39.

These asymmetrical 4 x 2 modules yield symmetrical 8 x 2 combinations when paired.

fig. 36:
[B]+[G], [D]+[O] variations

The first five rows are [B]+[G]. The next five are [D]+[O].

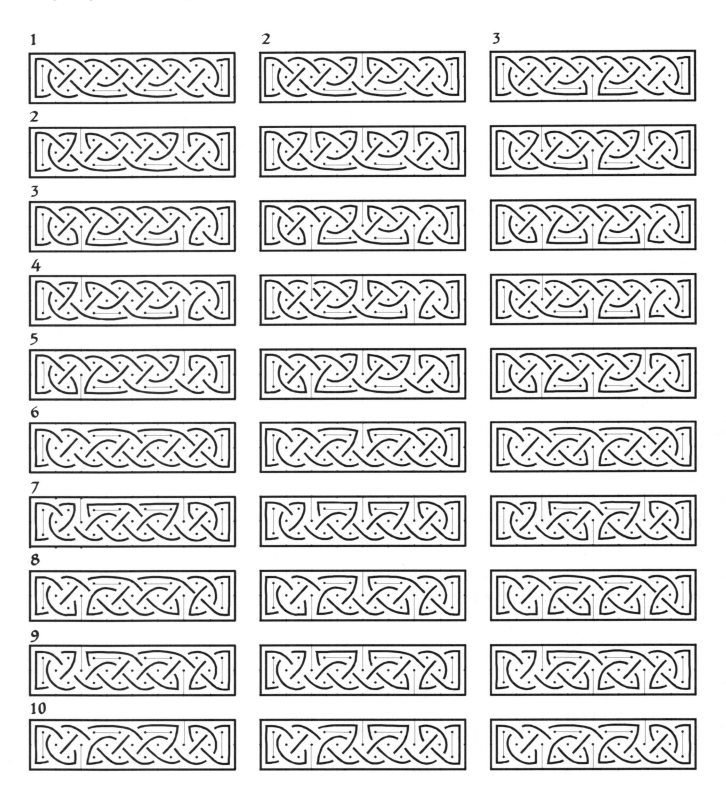

The first five rows are [J]+[E]. The next five are [L]+[M].

1

2

3

1

2

3

4

5

6

7

8

9

10

fig. 38
[O]+[D] [G]+[B]
variations

The first five rows are [O]+[D]. *The next five are* [G]+[B].

1

2

3

4

5

6

7

8

9

10

fig. 39
[E]+[J], [M]+[L]
variations

The first five rows are [E]+[J]. The next five are [M]+[L].

1

2

3

4

5

6

7

8

9

10

EXERCISES

1 From figs 33 and 34, select knots that are continuous and symmetrical, and label them accordingly. Draw up three.

Transfer these to your personal sketchbook of knots, learn them by heart, and apply them.

2 Figs 36-39: classify according to continuity and symmetry.

Select from those that look the most pleasing to your eye, copy them into your sketchbook.

3 Select knots that are continuous and symmetrical from fig. 36. Notice that the knots are not woven. Select one and draw it woven.

4 Repeat the knot you have just drawn, but with reverse weaving.

5 Draw figs 36, 1- 1; 4-2; 7-3 to their finished states.

6 Draw figs 37, 2 -1; 5-2; 8-3 to their finished states.

7 Draw figs 38, 1-3; 3-1; 6-2 to their finished states.

Unit 7:
Permutation charts for 1920 knotwork panels

In the last four figures, figs 36, 37, 38 and 39, arrangements taken
from rows 1, 2, 3 and 6, 7, 8 are symmetrical on the vertical axis,
giving seventy-two symmetrical units in all, quite a large selection.

As already noticed, asymmetrical knots have more forms of
complementary pairing than the symmetrical ones. Figs 36-39 are
pairs of regular reflections of the 4 x 2 breakline patterns. Now,
the eight asymmetrical units may also be paired in repeat, fig. 40a.

In addition, there are three asymmetrical pairs that acquire
diagonal symmetry when combined,
fig. 40b [D]+[G], [L]+[E], [B]+[O],
and also when they are paired in reverse order,
[O]+[B], [G]+[D], [E]+[L].

Fig. 40b, [J]+[M] and [M]+[J], may appear to be regular repeating
units, judging from the secondary breakline pattern. But, when
woven, they turn out to be quite irregular. The same applies to the
pairs in fig. 40c.

fig. 40a Eight asymmetrical units, each repeated twice

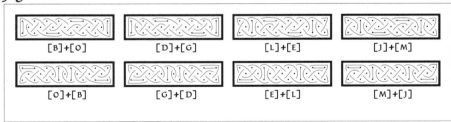

fig. 40b

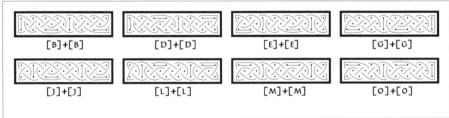

fig. 40c

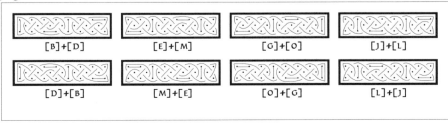

fig. 41:
Asymmetrical permutations

[B], [D], [E], [G], [J], [L], [M], [O]:
The eight asymmetrical knots may be paired in 64 permutations.

These permutation charts provide us with a choice of 128 pairs of the basic 4 x 2 modules that may be combined in an 8 x 2 format.

BB	BD	BE	BG	BJ	BL	BM	BO
DB	DD	DE	DG	DJ	DL	DM	DO
EB	ED	EE	EG	EJ	EL	EM	EO
GB	GD	GE	GG	GJ	GL	GM	GO
JB	JD	JE	JG	JJ	JL	JM	JO
LB	LD	LE	LG	LJ	LL	LM	LO
MB	MD	ME	MG	MJ	ML	MM	MO
OB	OD	OE	OG	OJ	OL	OM	OO

fig. 42:
Symmetrical permutations

[A], [C], [F], [H], [I], [K], [N], [P]
Eight symmetrical knots paired in 64 permutations.

Each of these pairs may be applied to any of the fifteen primary breakline variations provided in fig. 43, raising the number of variations to 1920 possible combinations that can be laid out on the 8 x 2 format, (15 x 64 = 960; 960 x 2 = 1920).

AA	AC	AF	AH	AI	AK	AN	AP
CA	CC	CF	CH	CI	CK	CN	CP
FA	FC	FF	FH	FI	FK	FN	FP
HA	HC	HF	HH	HI	HK	HN	HP
IA	IC	IF	IH	II	IK	IN	IP
KA	KC	KF	KH	KI	KK	KN	KP
NA	NC	NF	NH	NI	NK	NN	NP
PA	PC	PF	PH	PI	PK	PN	PP

fig. 43 :
Primary breakline variations in 8 x 2 format

1

2

3

2

3

4

5

fig. 44:
Primary and secondary 8 x 4 dot grid

Two 8 x 2 dot grids may be
stacked vertically to fill an 8 x 4
dot grid, as shown.

fig. 45:
8 x 2 primary breaks
in 8 x 4 format

Here are fifteen primary breakline patterns for the 8 x 2 rectangle, fig. 43, as applied in 8 x 4 format.

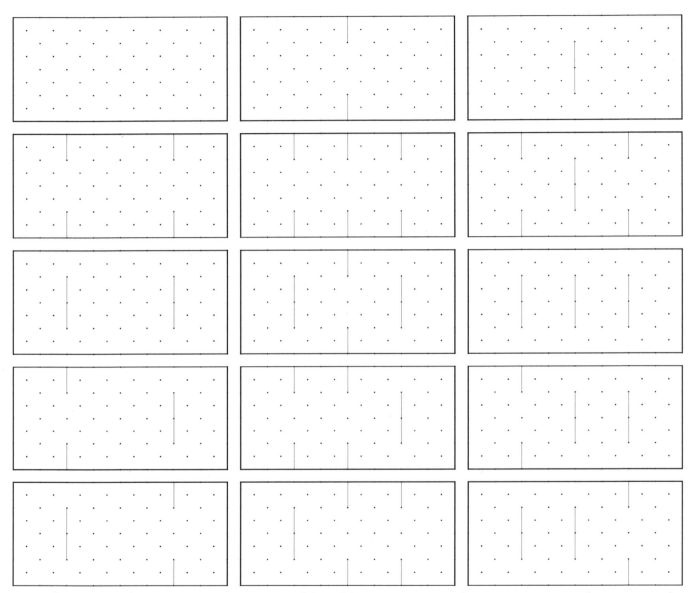

As we have seen, there are 450 primary grid breakline variations that we can use in the 8 x 4 grid. On any one of these, we can place any of the 128 permutations from figs 41 and 42, and any of the same in the lower half, to obtain 450 x 128 x 128 = 7,372,800 variations in the 8 x 4 format.

Further, by applying each of the patterns so obtained to the thirty breakline variations shown in fig. 46, the choices expand to 221,184,000.

This chart shows the primary grid breaklines that may be used between upper and lower 8 x 2 halves.

Any of the 8 x 2s that we have seen so far may be stacked one on top of the other.
The primary grid breaklines shown here may be used to connect the upper with the lower half.

EXERCISES

1 Draw up the knots in fig. 40.

2 Take the primary grid breaks from fig. 43, and the secondary grid breaks from fig. 40 [D]+[G] and draw fifteen variations.

See how [E]+[E], [J]+[J], [L]+[L], [M]+[N] all have a kite-shaped circuit that is broken off from the rest of the knot. This should be avoided as much as a glaring kink in the path.

In [B]+[B] there is a broken circuit, but it crosses over itself, to form a figure 8; this is acceptable. The simple ring, as a rule, is to be avoided. The exception to this rule is the circle centred around a single diagonal cross, as in fig. 25, 1, 1. But this design is so symmetrical, and is so like the geometrical symbol of the cross inside the circle, that it appeals to the mind as well as the eye. This pattern is acceptable, and was used very often in carved stone and metal work. It works well in repeat, forming a chain, so its very widespread usage indicates that there is no sort of traditional taboo against knots that are not continuous.

3 Choose any knot from the permutation chart in fig. 42. KK, for example, means [K]+[K]: you will find [K] in column 1, fig. 18 (where you will find the break variants for A-P); draw [K]+[K] in 8 x 2 format, as in fig. 43.

You may draw all fifteen possibilities. If you find one you really like, add it to your personal collection of knots.

4 Taking one knot from the previous exercise, apply it in 8 x 4 format, as in fig. 44. Now apply it to the symmetrical plans in fig. 45, that is, the first nine arrangements.

5 Of these nine arrangements, pick the one that is the most symmetrical and integrated, in your judgment. Check for symmetry on all three axes: vertical, horizontal and diagonal. The diagonal axis of symmetry is sometimes called the axis of rotational symmetry, as it seems to rotate.

Lastly, apply the knot you have selected to the most symmetrical of the plans in fig. 46.

Unit 8: 4 x 4 primary grid breaklines

By now, you can see how to create a great number of variations given a simple knot. As a matter of fact, we have been using only one all along, the single breakline variation of King Solomon's Knot, from the first unit.

Four of these basic knots, each of which is contained in a 2 x 2 dot grid, may now be arranged in a square 4 x 4 grid. Each quarter will contain the breakline for the basic knot.

We have already arranged all the possible variations of the 2 x 2 breakline as pairs in 4 x 2 rectangles, so now we need only stack these pairs one on top of each other, and connect them together in the middle to make a set of square knots, *fig. 54*.

Then we can apply each of these to the breakline variations as found in *figs 47, 48* and *49*. A chart is included, *fig. 50*, showing the sixteen units [A]-[P] arranged in pairs, one on top of each other, 256 permutations in all.

Fig. 47 gives 25 breakline divisions on the vertical and on the horizontal division.

See *fig. 51* for the application of these break patterns to a basic 4 x 2 unit, which shows how to place [A] in the upper and in the lower half of each square, and how to tie the two halves together.

fig. 48:
4 x 4 primary breaks, reduced

In the previous set, there is one vertical break in both the upper and lower half of the box, on the vertical axis. Here, there is only one break on the vertical axis.

fig. 49:
The same, reduced further

This is the same as the last figure, except that now the breaks are reduced from two to one break across the horizontal axis of the box.

fig. 50:
4 x 4 primary grid breaklines

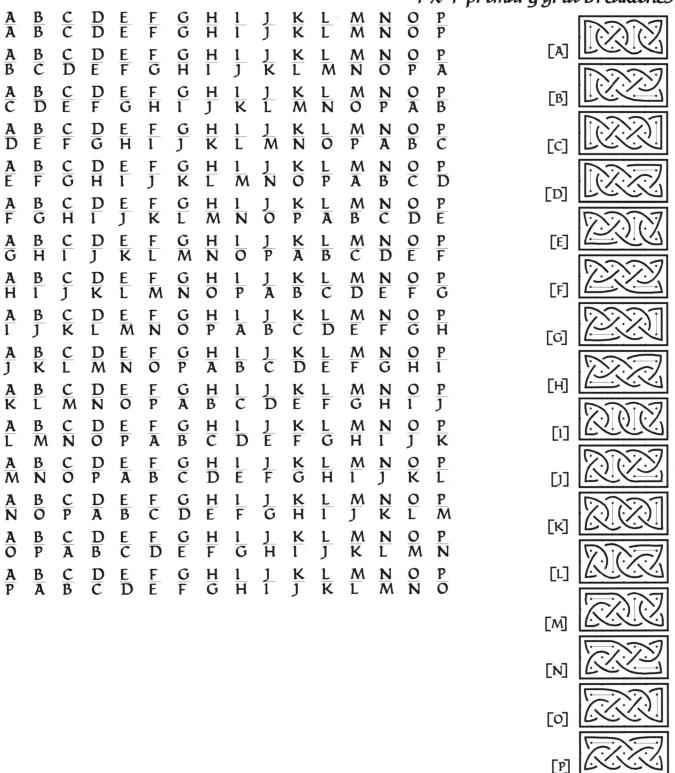

A/A	B/B	C/C	D/D	E/E	F/F	G/G	H/H	I/I	J/J	K/K	L/L	M/M	N/N	O/O	P/P
A/B	B/C	C/D	D/E	E/F	F/G	G/H	H/I	I/J	J/K	K/L	L/M	M/N	N/O	O/P	P/A
A/C	B/D	C/E	D/F	E/G	F/H	G/I	H/J	I/K	J/L	K/M	L/N	M/O	N/P	O/A	P/B
A/D	B/E	C/F	D/G	E/H	F/I	G/J	H/K	I/L	J/M	K/N	L/O	M/P	N/A	O/B	P/C
A/E	B/F	C/G	D/H	E/I	F/J	G/K	H/L	I/M	J/N	K/O	L/P	M/A	N/B	O/C	P/D
A/F	B/G	C/H	D/I	E/J	F/K	G/L	H/M	I/N	J/O	K/P	L/A	M/B	N/C	O/D	P/E
A/G	B/H	C/I	D/J	E/K	F/L	G/M	H/N	I/O	J/P	K/A	L/B	M/C	N/D	O/E	P/F
A/H	B/I	C/J	D/K	E/L	F/M	G/N	H/O	I/P	J/A	K/B	L/C	M/D	N/E	O/F	P/G
A/I	B/J	C/K	D/L	E/M	F/N	G/O	H/P	I/A	J/B	K/C	L/D	M/E	N/F	O/G	P/H
A/J	B/K	C/L	D/M	E/N	F/O	G/P	H/A	I/B	J/C	K/D	L/E	M/F	N/G	O/H	P/I
A/K	B/L	C/M	D/N	E/O	F/P	G/A	H/B	I/C	J/D	K/E	L/F	M/G	N/H	O/I	P/J
A/L	B/M	C/N	D/O	E/P	F/A	G/B	H/C	I/D	J/E	K/F	L/G	M/H	N/I	O/J	P/K
A/M	B/N	C/O	D/P	E/A	F/B	G/C	H/D	I/E	J/F	K/G	L/H	M/I	N/J	O/K	P/L
A/N	B/O	C/P	D/A	E/B	F/C	G/D	H/E	I/F	J/G	K/H	L/I	M/J	N/K	O/L	P/M
A/O	B/P	C/A	D/B	E/C	F/D	G/E	H/F	I/G	J/H	K/I	L/J	M/K	N/L	O/M	P/N
A/P	B/A	C/B	D/C	E/D	F/E	G/F	H/G	I/H	J/I	K/J	L/K	M/L	N/M	O/N	P/O

[A] [B] [C] [D] [E] [F] [G] [H] [I] [J] [K] [L] [M] [N] [O] [P]

fig. 51:
[A]:[A] x 25
all breaks

Taking the first permutation, [A] in the top half and [A] in the lower half, the two halves are joined together across the horizontal central axis.

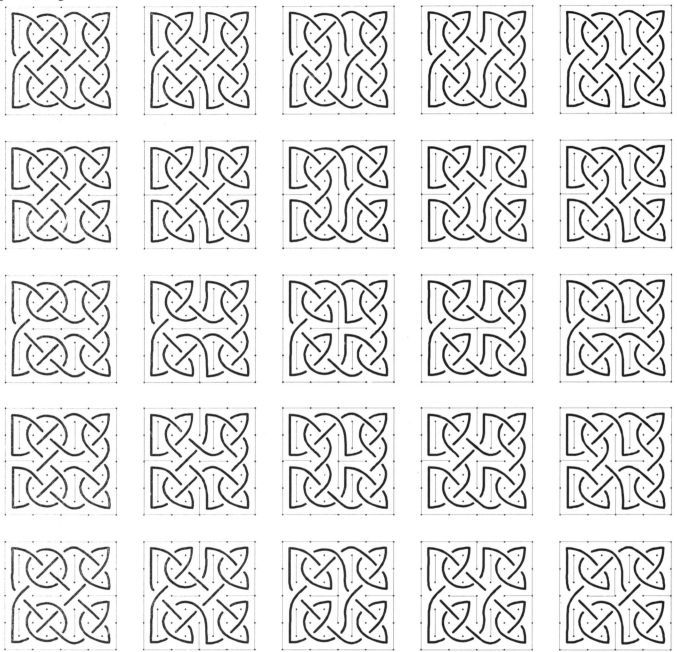

These breaklines are from the chart in fig. 47.

This is like the previous figure, only here the primary breaklines are the same as in fig. 48.

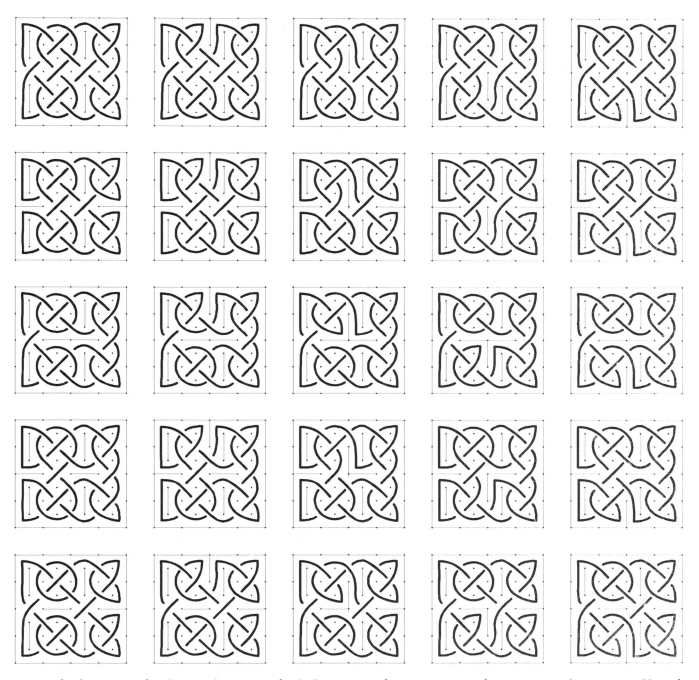

Note: the knots in the first column on the left remain the same as in the previous figure, unaffected by the reduction in the primary grid breaks that affect the other twenty designs. Therefore there are only twenty new variations in this set.

fig. 53:
[A] : [A] x 25 primary breaks reduced further

Here the primary breaklines are drawn from the chart in fig. 48. This set is the same as in the previous figure, except the first row is unaffected, leaving only twenty new variations. This brings the total variations for the [A] : [A] combination to 65. Note how the crossovers on the horizontal axis join the two halves together. Compare with [A] - [P] in the side bar, opposite, to see how the character of each unit is altered by the crossover.

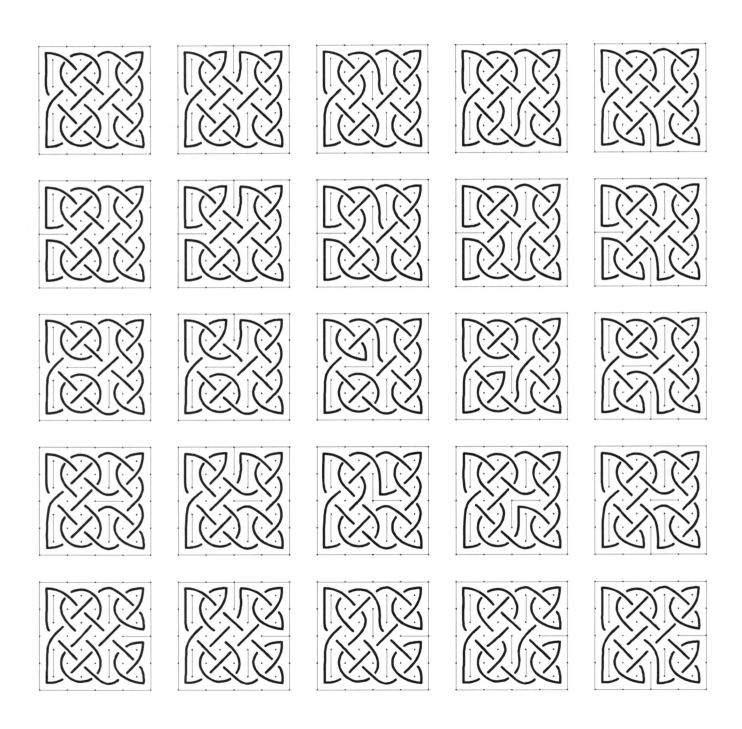

fig. 54a:
Sixteen 4 x 2 variations [A] – [P]

[A]

[B]

[C]

[D]

[E]

[F]

[G]

[H]

[I]

[J]

[K]

[L]

[M]

[N]

[O]

[P]

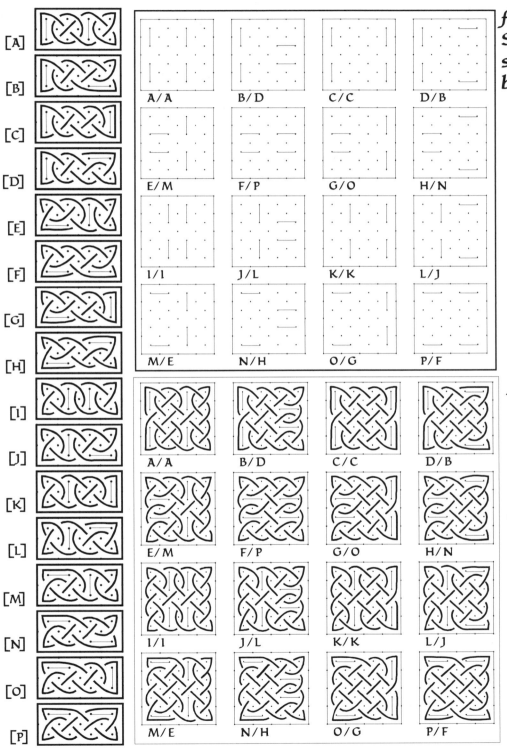

fig. 54b:
Sixteen 4 x 4 secondary breaklines

A/A B/D C/C D/B

E/M F/P G/O H/N

I/I J/L K/K L/J

M/E N/H O/G P/F

fig. 54c:
Sixteen 4 x 4 knots

These sixteen knots are made from the by now familiar sixteen 4 x 2 basic combinations, stacked one on top of each other, so that the breaklines are mirrored on the horizontal axis.

A/A B/D C/C D/B

E/M F/P G/O H/N

I/I J/L K/K L/J

M/E N/H O/G P/F

1 In fig. 47, how many symmetrical break plans and how many asymmetrical plans can you find?

2 Rearrange the four squares in the lower right corner of fig. 47, so that they form a symmetrical, 8 x 8 panel.

3 Rearrange the asymmetrical squares in related groups of two or four, 8 x 4 and 8 x 8, to form symmetrical panels.

EXERCISES

4 Do the same with fig. 48.

5 Do the same with fig. 49.

6 Select a permutation from fig. 54a other than [A], and apply it to figs 47, 48 or 49.

7 Select a symmetrical break plan from fig. 54b, and apply to a panel from figs 47, 48 or 49, which is also symmetrical.

Unit 9: Freehand border layout techniques

By now you have discovered how a great number of variations can be developed out of a single knot.

The course so far has illustrated various ways to tinker systematically with a single knot, to produce variations and even entirely new knots, as unfolded according to the principles of formal knot design, using the dot grids and breaklines.

Now we will look at the method for making a decorative border out of a knot, using direct, freehand methods. Until now, we have been using grids for practice, to save time, and to work out the design principle. Now that we have understood the principles, we may feel free to explore more freehand methods of drawing the designs, which are preferable to mechanically produced patterns, except on the rare occasion that calls for a technically precise rendering: as, for instance, producing a knot as a logo design. But for general purposes, technical and mechanical aids should be kept to a minimum.

Drawing with pen and ink should be simple and direct. With this in view, let us now consider how to carry out the few calculations needed in knot design as simply and freely as possible. Graph paper and tracing paper, preliminary pencilling and erasing afterwards should be left aside for the present. All you need for this unit is a straight edge for ruling, and a pen.

Feel free to draw lines that are not ruled. The accuracy of the construction is the important thing here, not precision. You can express yourself as uniquely in a knot drawing as in your own handwriting. What results is your own style. You may see that it needs to be improved, and this may guide your practice to refine your style further. Precision can best come about through practice, by learning to see what you need to avoid, or control with more skill. Such insights are very valuable, and they come from working as directly as possible: with blank paper, pen, hand and eye.

Some tips on drawing

When drawing freehand, gauging distances by eye, your lines will be straighter if you do not think too much about measurements. Just trust your own judgment, and do it.

In drawing lines freehand, place the pen at the starting point, then shift your gaze to your intended end point, and move the point of the pen to that location.

The trick is not to look at the pen point while it is in transit, or the pen will tend to waver.

We will now look at a few rules of thumb that will enable you to draw a border of knots freely all around a page.

So far, we have been using one knot, the Foundation Knot, based on the 2 x 2 square dot grid as a building block. The advantage of using this one knot is that we can apply all the principles needed to design knot patterns to this simplest of Celtic knots, and we are familiar with it from the beginning, so that we are free to concentrate on the practice, and, with the same unit, can perfect our skills with this particular knot. If the result is less than satisfactory, we know it is not due to the knot that we are working with, as the base knot has always been the same. Now we will branch out, and apply the by now familiar rules to a variety of different knots. I find it most convenient to classify these knots individually according to dimensions of the underlying, primary dot grid.

To simplify matters further, let us call the grid of 2 x 2 cells, one square. A 4 x 2 grid may be described as two squares. A row of four squares describes an 8 x 2 dot grid.

To draw King Solomon's Knot, we need first to draw one square. Inside this square, primary and secondary dots can be drawn, and the path of the knot put in directly, as the tertiary grid midline.

To draw a 4 x 2 knot, first lay out two squares. Here is how to do this. This procedure is the kind of rule of thumb which enables you to design really freely:

First draw a line, as wide as you want your overall design to be; divide this line by placing a dot in the middle of the line. Halving the line gives you the top edges of the two squares. Next, drop the sides at each end of the line, equal to the half width, judging by eye. Then complete the rectangle. You have now drawn the outside lines of your two squares. Each half of the enclosed area should be approximately a square. Put the 2 x 2 dot grid into each square, and proceed from there.

You can lay out four squares, eight squares and sixteen squares by drawing a baseline, dividing it in half, dividing each half, and further subdividing, then build on that.

Instead of referring to the 4 x 2 primary-grid knot, let us call it a two-square knot (remember the "square" is a 2 x 2 primary-cell unit). Lay out as many two-square knots as you want: choose from any of the 48 permutations. Each can be repeated indefinitely to produce a border; if you alternate one repeat unit with one other, this will give you 48 x 48 = 2304 different border strips.

Draw the horizontal line, divide it; divide each half; divide each quarter: you should have a line divided in eight equal spaces, or close enough. Drop the sides at each end of the whole line. Make these sides equal to the eighth part of the horizontal line; join the ends, keeping the bottom line as parallel to the top as you can, by eye. Don't be afraid to do all this without measuring - you can find a midpoint by eye with surprising accuracy. To finish, divide the bottom line into eight just as you divided the top, checking with the points on the line above to make sure the bottom dots are square.

Now you should have an eight-square layout, drawn freehand. But these divisions, 2, 4, 8, 16, 32, are only a few of the even numbers. What about 6, 10, 12?

To eyeball some of these more complex divisions, you need odd-number divisions, thirds, fifths, sevenths and so on. To divide a line in six parts, for instance, you divide in two, and then divide each half in three parts. So the third division lets you break a line into multiples of three: 3, 6, 9, 12. Some odd, some even. This gives us a lot of options.

Fig. 55 shows how to divide a three square into a single plus a double space, using the primary grid partition (fig. 55a).

In a six-square strip, you can alternate these breaks to get two different patterns: 1 square, 2 square, 1 square, 2 square (1, 2, 1, 2); or the reverse order: 2, 1, 2, 1, as illustrated in fig. 55a.

fig. 55 a-e:

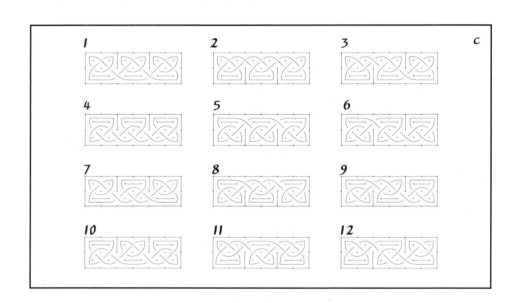

a

1+2 = 3 squares 1+2+2+1= 6 squares

2 +1 = 3 squares 2+1+2+1= 6 squares

b

2 +1+2 = 5 squares 1+1+1+1+1= 5 squares

c

1	2	3
4	5	6
7	8	9
10	11	12

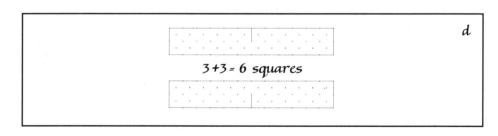

d

3 +3 = 6 squares

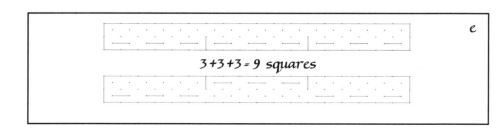

e

3+3+3 = 9 squares

Practise the sixfold division both ways: first in two, then each half in three; first in three, then each third in two. With practice, you can divide a line in six as easily and as accurately as you can divide a line in two.

Throughout all this practice, you are sharpening your sense of proportion, and this skill once developed will remain with you. You cannot develop this skill by always relying on mechanical aids such as a ruler. With mechanical means, you have to start from scratch. Eyeballing it, on the other hand, pays off in the long run, for your skill grows each time you use it. This leads to spontaneity of expression, which is so necessary if your drawing is to come alive, and, inevitably, leads to your personal style, as individual as a signature. Not having to think about it, in the moment, is the experience to aim for, making it a real pleasure.

Having mastered the 1/6 division, now you can tackle the 1/9 division with ease. Divide a line in three, and each part in three again; drop a single space length at each end and square off, *fig. 55e.*

Fig. 56 gives you 64 three-square permutations. The possibilities are astronomical.

In addition, each of these triadic knots may be superimposed on any of the nine primary breaks outlined in *fig. 57.* Two of the permutations from *fig. 56* are given in the nine variations in *fig. 58.* This gives you lots of room to practise your judgment of three-fold division. When 1/3 division comes as easily to you as 1/2 division, you are ready to eyeball the 1/5 division, as described above.

Fig. 55b is a five-square layout. To make the 1/5, first place a space in the centre of the line, so that the spaces at either end are equal, and twice the length of the centre space. Then divide the end spaces in two. This gives five spaces. Alternatively, place a point off centre, dividing the line into two parts, one twice as big as the other; divide the smaller part in half, and the larger into three, to make five in all.

fig. 56:
Permutation chart

This chart shows a matrix of cells numbered 1–64, each containing two letters drawn from a, b, c, d. The columns below are labelled 1–4 by horizontal position (left letter, middle letter). Each cell's content is given below; the first letter and second letter are recorded.

No.	Letter 1	Letter 2
1	a	a
2	a	b
3	a	c
4	a	d
5	b	a
6	b	b
7	b	c
8	b	d
9	c	a
10	c	b
11	c	c
12	c	d
13	d	a
14	d	b
15	d	c
16	d	d
17	a	a b
18	a	b b
19	a	c
20	a	d
21	b	a b
22	b	b
23	b	c
24	b	d
25	c	a b
26	c	b
27	c	c
28	c	d
29	d	a b
30	d	b
31	d	c
32	d	d
33	a	a c
34	a	b c
35	a	c c
36	a	d c
37	b	a c
38	b	b c
39	b	c c
40	b	d c
41	c	a c
42	c	b c
43	c	c c
44	c	d c
45	d	a c
46	d	b c
47	d	c c
48	d	d c
49	a	a d
50	a	b d
51	a	c d
52	a	d d
53	b	a d
54	b	b d
55	b	c d
56	b	d d
57	c	a d
58	c	b d
59	c	c d
60	c	d d
61	d	a d
62	d	b d
63	d	c d
64	d	d d

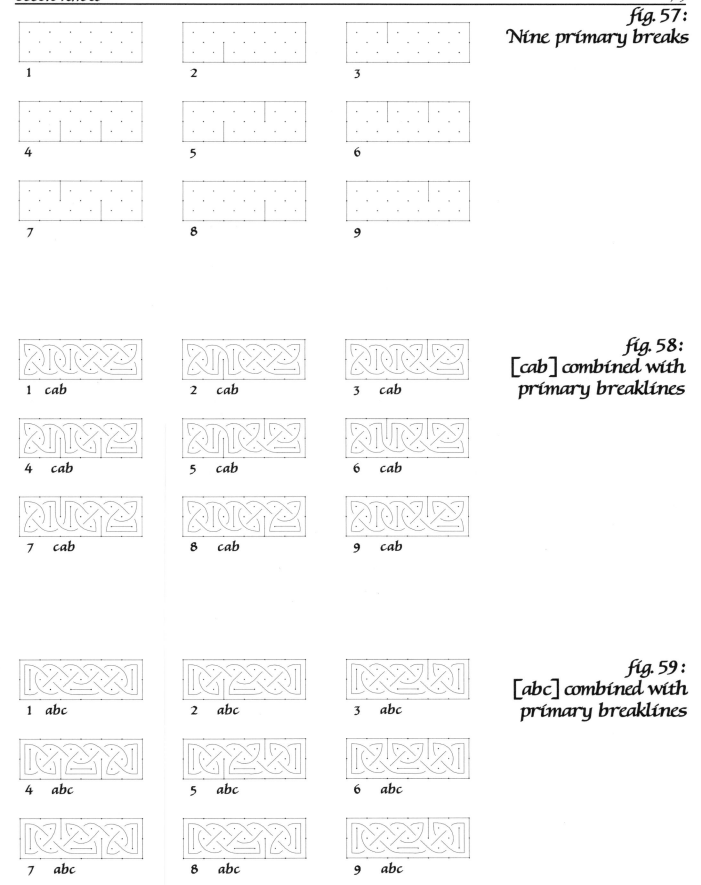

1

2

3

4

5

6

7

8

9

1 cab

2 cab

3 cab

4 cab

5 cab

6 cab

7 cab

8 cab

9 cab

1 abc

2 abc

3 abc

4 abc

5 abc

6 abc

7 abc

8 abc

9 abc

1 Calling the 2 x 2 unit one square, divide a horizontal line into four, and let this line be the long side of a strip four squares long, one square wide (four across, one down).

2 Lay out two two-square knots in the rectangle you have drawn; do it freehand.

3 Divide a line into six. On this baseline, create a rectangle one part wide, six long. Subdivide into squares, each with a 2 x 2 dot grid, secondary as well as primary. In this rectangle, apply a two-square knot, with a primary grid breakline, repeated three times.

EXERCISES

4 On a line divided into nine, construct a border strip with a three-square knot in three repeats. Select the three-square primary grid layout from fig. 57.

5 Starting with a six-part division, draw a strip containing a three-square unit, repeated twice.

6 Start with a six-part division, draw a rectangle two squares down, six across.

7 In the grid just drawn, make three divisions on the primary grid; in each, place a 2 x 2 knot, so that they form a continuous border. The path of your border strip may be continuous or not.

Unit 10: Odd-number divisions, freehand practice

Fig. 60: Once you can divide a line into fifths, you are ready to divide a line into sevenths. Place a space in the middle of the line, smaller than the sixth part, and divide the remaining spaces into three on each side. With a few tries, you will find you can get the spaces even.

Fig. 60a shows some seven-square grids. The sevenfold division may be divided in groups of three, two and single squares: 3, 1, 3; 1 (7); 2, 3, 2; 1, 2, 1, 2, 1.

In *fig. 60b*, there are grids for nine divisions. These are divided internally by primary breaklines into the following groups of squares: 3, 3, 3; 2, 2, 1, 2, 2; 1, 2, 3, 2, 1; 2, 1, 3, 1, 2; 1, 3, 1, 3, 1; 1, 1, 2, 1, 2, 1, 1.

Fig. 61: the break patterns from *fig. 60*, with lines.

Fig. 62: ten strips divided into eleven squares. To divide a line in eleven, place a small gap in the centre, so that the remainder may be divided in five on each side: 5, 1, 5. Each five-part division can then be subdivided in the same way that a line is divided into five, one space in the middle, and two equally divided spaces on either side of the central space.

Eleven-fold divisions can be arranged in groups of one, two and three squares: 1 x 11; 1, 2, 1, 3, 1, 2, 1; 2, 3, 1, 3, 2; 3, 2, 1, 2, 3; 2, 2, 3, 2, 2; 3, 1, 3, 1, 3; 1, 3, 3, 3, 1; 2, 2, 1, 1, 1, 2, 2; 1, 2, 2, 1, 2, 2, 1.

Fig. 63: as in *fig. 62*, lines added.

It is not easy to get the one-eleventh proportion right, but it will come after a bit of practice.

Assuming you can divide a line into one tenth, or one twelfth, draw three parallel lines the same length as you want to divide one eleventh on another piece of paper.

Divide the top into one tenth, and the bottom into one twelfth.

Now, take a distance smaller than the average space in the one tenth line on top, and larger than the bottom one twelfth, put it in the middle of the line you wish to divide by eleven.

Then divide both spaces remaining on either side into five parts.

The grouping will read like this: 5, 1, 5. Then break the five down, 2, 3, 1, 3, 2.

To draw a twelfth division, divide in half, then divide each half into six parts; or, divide in three first, and break each third into four parts.

fig. 60a:
Dividing in seven, breaks

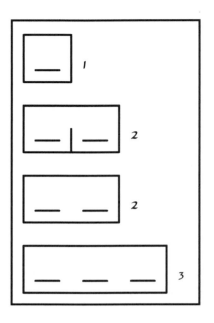

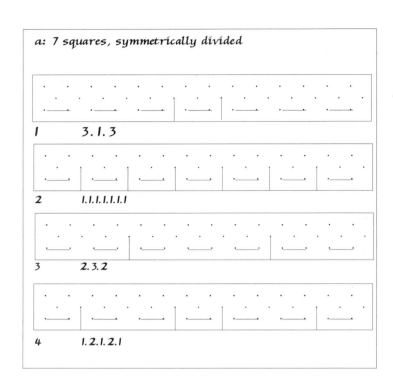

a: 7 squares, symmetrically divided

1 3.1.3

2 1.1.1.1.1.1.1

3 2.3.2

4 1.2.1.2.1

fig. 60b:
Dividing in nine, breaks

b 9 squares, symmetrically divided

1 3.3.3

2 2.2.1.2.2

3 1.2.3.2.1

4 1.3.1.3.1

5 1.1.2.1.2.1.1

a 7 squares, symmetrically divided

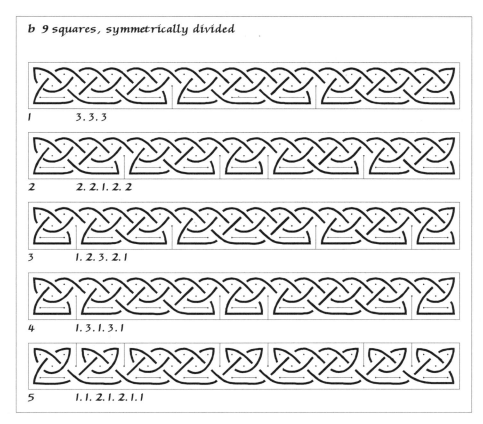

1 3.1.3

2 1.1.1.1.1.1.1

3 2.3.2

4 1.2.1.2.1

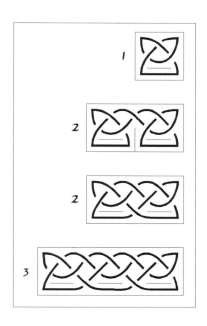

1

2

2

3

b 9 squares, symmetrically divided

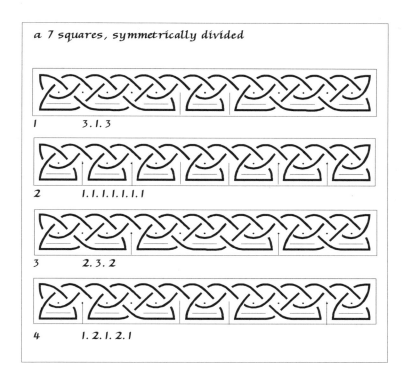

1 3.3.3

2 2.2.1.2.2

3 1.2.3.2.1

4 1.3.1.3.1

5 1.1.2.1.2.1.1

fig. 62 :
Eleven-part strips

11 squares, symmetrically divided

1 1.1.1.1.1.1.1.1.1.1.1

2 1.2.1.3.1.2.1

3 2.3.1.3.2

4 3.2.1.2.3

5 2.2.3.2.2

6 1.2.1.3.1.2.1

7 3.1.3.1.3

8 1.3.3.3.1

9 2.2.1.1.1.2.2

10 1.2.2.1.2.2.1

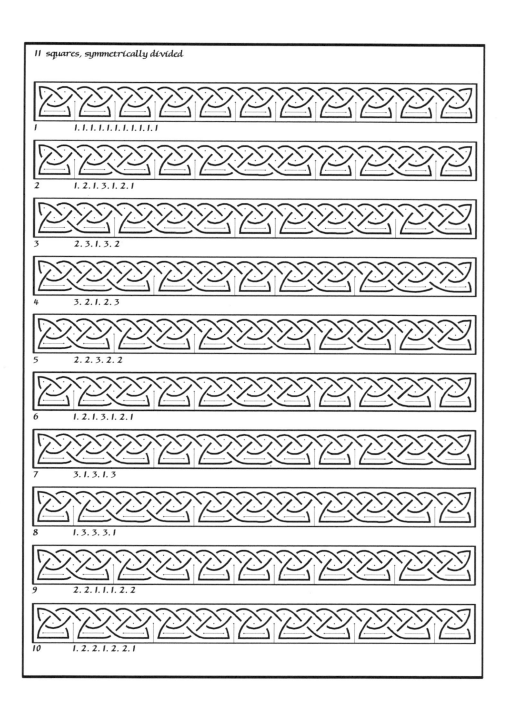

11 squares, symmetrically divided

1 1.1.1.1.1.1.1.1.1.1.1

2 1.2.1.3.1.2.1

3 2.3.1.3.2

4 3.2.1.2.3

5 2.2.3.2.2

6 1.2.1.3.1.2.1

7 3.1.3.1.3

8 1.3.3.3.1

9 2.2.1.1.1.2.2

10 1.2.2.1.2.2.1

fig. 64a: Border dot-grid layout, 15:20 proportion

(as fits on a letter-size page with a half-inch margin and a quarter-inch square grid)

fig. 64b: Five corner treatments

| a | b |
| c | d |

1 2 3 4 5

1a 2a 3a 4a 5a

1b 2b 3b 4b 5b

1c 2c 3c 4c 5c

1d 2d 3d 4d 5d

left edge

upper edge

lower edge

right edge

Figs. 65 and 66 show you several variations on a border strip thirteen squares long, followed by strips divided into fourteen, fifteen, eighteen, nineteen and twenty parts. The border pattern in *fig.* 66 is fifteen by twenty squares. The corners are filled with single units, leaving thirteen spaces on the short side, and eighteen on the long side. We can lay out repeating units symmetrically on the short side using repeating patterns which are either two or three units wide, as seen in *fig.* 66b, 3. But first, to do this spontaneously, you need to be able to divide a given length into thirteen parts. I recommend that you learn to be able to do this as follows.

To divide a line into thirteen, place a centre space in the line that is larger than a fourteenth, and smaller than a twelfth space. The method has already been described for dividing into eleven.

By the same means you can quickly estimate one seventeenth, one nineteenth, etc. On all these awkward odd number divisions, you only have to approximate the centre space, the remainder divides evenly: one divided by seventeen equals one divided by eight plus one in the middle, plus another eight. If you can make a reasonable stab at the size of the middle space, the other parts are easily divided into eight parts. Likewise, to take a very odd division, such as one divided by twenty-nine, place one in the middle that is about a thirtieth part (one third of one fifth of one half) and divide either side into fourteen parts (divide into two, then divide each half into seven).

When you have laid out the odd-number strip, always place a three-unit module in the middle, and place twos and threes symmetrically on either side of it. So now you can improvise a symmetrical border strip, break it down into ones, twos or threes, for any number of units.

This being so, you can improvise a border frame, by dividing the four sides into separate strips, as in *fig.* 64. You can then see how many squares there are in each section, and break it down into twos and threes. Then draw from your stock of knot variations for two or three squares to improvise the secondary grid breaks, and complete. An example is given in the border of *fig.* 66.

This is as far as we need to go with division of any line into any combination of two spaces and three spaces, as you now have enough experience to lay out a border strip freely, and fill it with repeating knotwork patterns, either spontaneously, or by applying patterns from the collection you have built in your sketchbook to this point.

The course continues with an in-depth look at about fifty borders, for which you now have all the design principles. For this, we need to pay special attention to how to turn a corner, called mitring, while retaining the integrity of the knot, perhaps the most challenging part of knotwork design.

fig. 65a: Border layout in groups of threes and twos

fig. 65b: Thirteen-, fourteen-, fifteen-part divisions

1	line
2	thirteen spaces
3a	thirteen squares: 2. 3. 3. 3. 2
3b	thirteen squares: 3. 2. 3. 2. 3
4a	fourteen squares: 3. 3. 2. 3. 3
4b	fourteen squares: 2. 3. 2. 2. 3. 2
4c	fourteen squares: 2. 2. 3. 3. 2. 2
4d	fourteen squares: 3. 2. 2. 2. 2. 3
5a	fifteen squares: 3. 3. 3. 3. 3
5b	fifteen squares: 2. 2. 2. 3. 2. 2. 2
5c	fifteen squares: 2. 3. 2. 3. 2. 3

fig. 66a: three- and two-square knot border

fig. 66b: Eighteen-, nineteen-, twenty-part strips

1 eighteen squares: 3. 3. 3. 3. 3. 3

2 eighteen squares: 2. 2. 2. 2. 2. 2. 2. 2. 2

3 eighteen squares: 2. 3. 3. 2. 3. 3. 2

4 eighteen squares: 3. 2. 3. 2. 3. 2. 3

5 eighteen squares: 3. 3. 2. 2. 2. 3. 3

6 eighteen squares: 2. 2. 2. 3. 3. 2. 2. 2

7 eighteen squares: 3. 2. 2. 2. 2. 2. 2. 3

8 eighteen squares: 2. 3. 2. 2. 2. 2. 3. 2

9 eighteen squares: 2. 2. 3. 2. 2. 3. 2. 2

10 nineteen squares: 2. 3. 3. 3. 3. 3. 2

11 nineteen squares: 3. 2. 3. 3. 3. 2. 3

12 nineteen squares: 3. 3. 2. 3. 2. 3. 3

13 twenty squares: 3. 3. 2. 2. 2. 2. 3. 3

14 twenty squares: 3. 2. 3. 2. 2. 3. 2. 3

15 twenty squares: 3. 2. 2. 3. 3. 2. 2. 3

16 twenty squares: 2. 2. 3. 3. 3. 3. 2. 2

17 twenty squares: 2. 3. 2. 3. 3. 2. 3. 2

18 twenty squares: 2. 3. 3. 2. 2. 3. 3. 2

EXERCISES

1 Divide a line into five.

2 In a rectangle of 5:1 proportion – five squares across, one square down – place a symmetrical arrangement of knots, namely, 1, 1, 1, 1, 1 or 2, 1, 2 or 1, 3, 1.

3 Draw a line divided into seven parts. On this, base a symmetrical design as in fig. 60a.

4 Divide a line into eleven parts. Produce a symmetrical pattern of primary grid breaklines from a strip in fig. 62, but use a different secondary breakline pattern than the one illustrated in that figure.

5 In fig. 64, mitre the border grid according to one of the five ways illustrated. Taking one side, count the number of squares in that strip, and plan out a symmetrical arrangement of one, two or three square units to fill the side.

Repeat this on the opposite side. You can place it upside down or back to front in the opposite strip relative to the original strip. When you have set out two sides, repeat the procedure for the remaining pair of opposite sides.

6 Fill in the border design in fig. 65. Compare the result with that of fig. 66. Here you have a few different ways to draw the knots. Notice that in the drawing of the ribbon the centre line has been omitted. The simplest way to do this is to draw the centre line in pencil first, then draw the segments as parallel lines, weaving, to produce the open ribbon. You should practise to learn to do this without the preliminary pencil.

Although the open path method is not as true to the principles of knot design as the method we have been following, it is a very common treatment, especially when knotwork is being drawn to a very small scale, as in illuminated manuscripts.

Unit II : Border layouts

In this unit we will explore three repeating knotwork units, *fig. 68b, knots 14, 16* and *20*, using the same frame layout, but altering the orientation of the primary and secondary breaklines. Sometimes the primary separators alternate, as in *figs 68a* and *69a*, or sometimes the orientation of the knots follows that of the primary breaklines, alternating from side to side as each corner is turned, as in *fig. 70a*. For different ways to turn the corners, you can also refer to *fig. 64*.

Notice how the knots fit the layout of the borders on the following pages, facing out where the primary breaks face out, and facing in when the primary breaks are turned inwards.

The borders around *figs 67–72* are based on one of the five ways to mitre the four sides of a knotwork border, as shown in *fig. 64, 2*.

According to this plan, the four sides fit together so that the left-hand side and the right-hand side butt between the top and the bottom. The longer sides are eighteen squares in length, where the square is the 2 x 2 dot grid module, and the top and bottom are fifteen squares. We can easily divide each side into groups of three squares: five threes across the top and six down the side. Each unit is three 2 x 2 squares, or 2 x 6.

We have sixty-four ways to arrange three 2 x 2 square units, each with only one secondary breakline, which can fall on one of four positions, a, b, c and d. These sixty-four triads are charted in *fig. 67b*.

In this unit, we will build three knotwork borders, to fit a page 15 x 18 squares. This is a standard letter-size page with a half-inch margin all around.

The border can be drawn freehand. Use the ruler to lay out a half-inch border around the page. Then, divide the top and bottom into five, and the left-hand and right-hand sides into six equal parts. Next, divide each part into three squares, and lay out the dot grid. Lastly, place the secondary dot in the middle of each square, and lay out the primary and secondary breaklines. Primary breaklines may be placed either on the outside or the inside edge of the frame. These primary breaks partition the border into 2 x 6 units, which we can fill with any of the sixty-four permutations, as shown in *figs 67b* and *68b*.

fig. 67a: Border layout, 2 x 6 knot

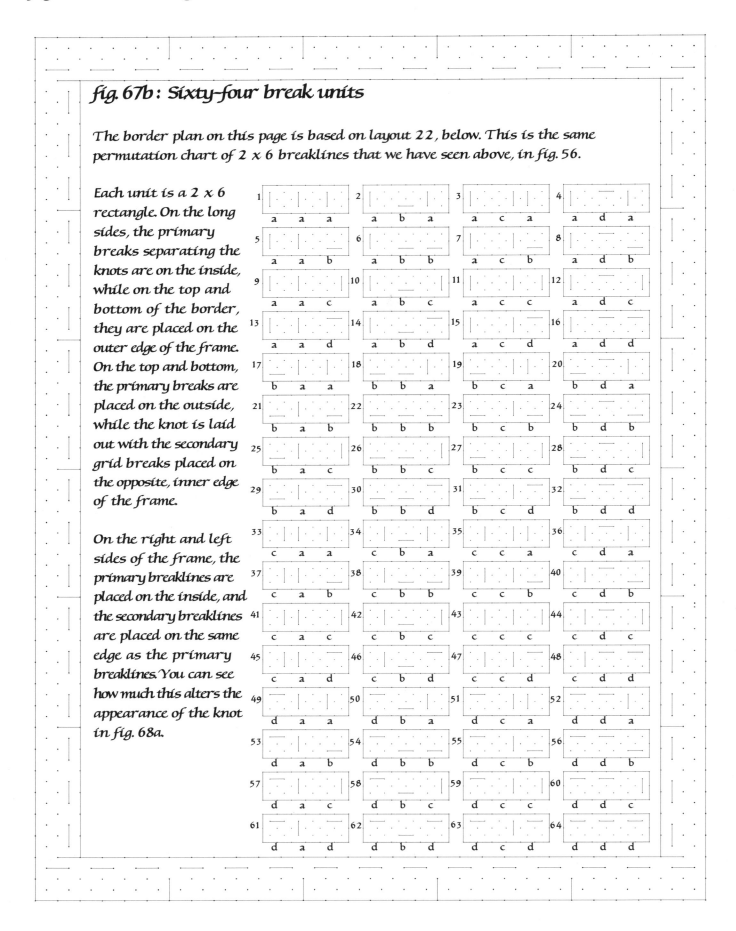

fig. 67b : Sixty-four break units

The border plan on this page is based on layout 22, below. This is the same permutation chart of 2 x 6 breaklines that we have seen above, in fig. 56.

Each unit is a 2 x 6 rectangle. On the long sides, the primary breaks separating the knots are on the inside, while on the top and bottom of the border, they are placed on the outer edge of the frame. On the top and bottom, the primary breaks are placed on the outside, while the knot is laid out with the secondary grid breaks placed on the opposite, inner edge of the frame.

On the right and left sides of the frame, the primary breaklines are placed on the inside, and the secondary breaklines are placed on the same edge as the primary breaklines. You can see how much this alters the appearance of the knot in fig. 68a.

fig. 68a: Border knotwork, 2 x 6, knot 22

fig. 68b: Sixty-four knot units

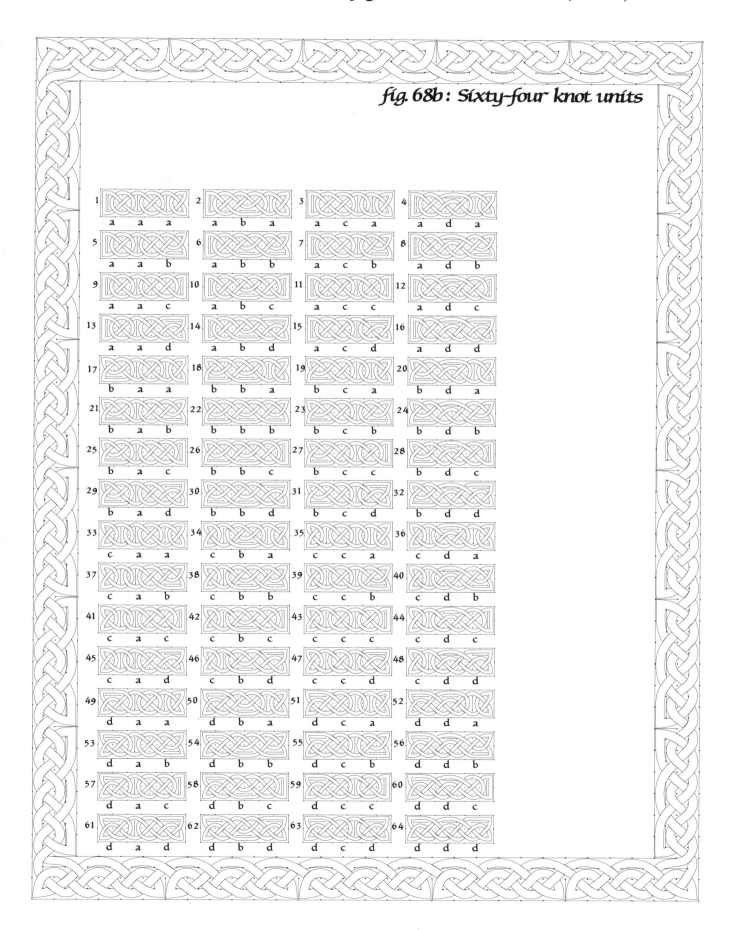

1	a a a	2	a b a	3	a c a	4	a d a
5	a a b	6	a b b	7	a c b	8	a d b
9	a a c	10	a b c	11	a c c	12	a d c
13	a a d	14	a b d	15	a c d	16	a d d
17	b a a	18	b b a	19	b c a	20	b d a
21	b a b	22	b b b	23	b c b	24	b d b
25	b a c	26	b b c	27	b c c	28	b d c
29	b a d	30	b b d	31	b c d	32	b d d
33	c a a	34	c b a	35	c c a	36	c d a
37	c a b	38	c b b	39	c c b	40	c d b
41	c a c	42	c b c	43	c c c	44	c d c
45	c a d	46	c b d	47	c c d	48	c d d
49	d a a	50	d b a	51	d c a	52	d d a
53	d a b	54	d b b	55	d c b	56	d d b
57	d a c	58	d b c	59	d c c	60	d d c
61	d a d	62	d b d	63	d c d	64	d d d

fig. 69a: Border layout, 2 x 6 break, knot 34

fig. 69b: Corner and edge units, layout

Mitre the corners of the frame by connecting two knots together according to the arrangement of the breaklines, as here.

Compare the plan for this border with that of fig. 68a. Here, the primary breaklines separating the 2 x 6 units are on the outside edge, on the left and on the right-hand side of the frame. On the top and bottom sides of the frame, the primary separators are tied to the inside edge. However, the secondary breaks are arranged consistently on all four sides. This makes a variation, as the pattern passes from one side to the next.

Two units, each one built on a 2 x 3 dot grid, may be joined as shown here, fig. 69b. The units are separated by the single break on the primary grid. This particular design has a large knot flanked by two side knots, and these side knots connect at the corner around the primary grid break separating two sides.

In the middle of each side, the two knots also connect around the primary grid break, as illustrated above by the dotted line in the upper diagram. Below this diagram, the separating breakline has been added on the primary grid. As you can see, it produces a new variation of the knot, two side knots touching point to point. Because the primary break alternates from the inner to the outer edge from side to side, this causes the combination knot to flip from outward facing to inward facing, while the main body of the knot keeps facing the same way, its longest curve always aligned on the inside edge.

In the layout for this border, the primary breakline pattern is identical to the layout for the border in fig. 68a. The secondary break pattern here is from the chart in fig. 68b, number 16.

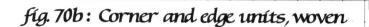

fig. 70a: Knotwork border, woven

fig. 70b: Corner and edge units, woven

Compare these woven patterns with their breakline plans in the previous figure. Here, you can see the transition from the closed corner of the stand-alone unit, top, to the crossover, in the middle of the upper edge of the frame. In this diagram, one of the crossovers is incomplete, separating the middle unit from its partner to the left. It should, of course, cross over in the same way that it is connected to the knot to the right.

Also in this diagram, you can see details of the construction of the corner mitre, the unit is rotated, and butted under the top edge, with a long strand winding from the inside edge to the outer edge.

fig. 70c: 2 x 6 unit, breakline layout for knot 36

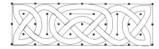

fig. 71a: Border breakline layout

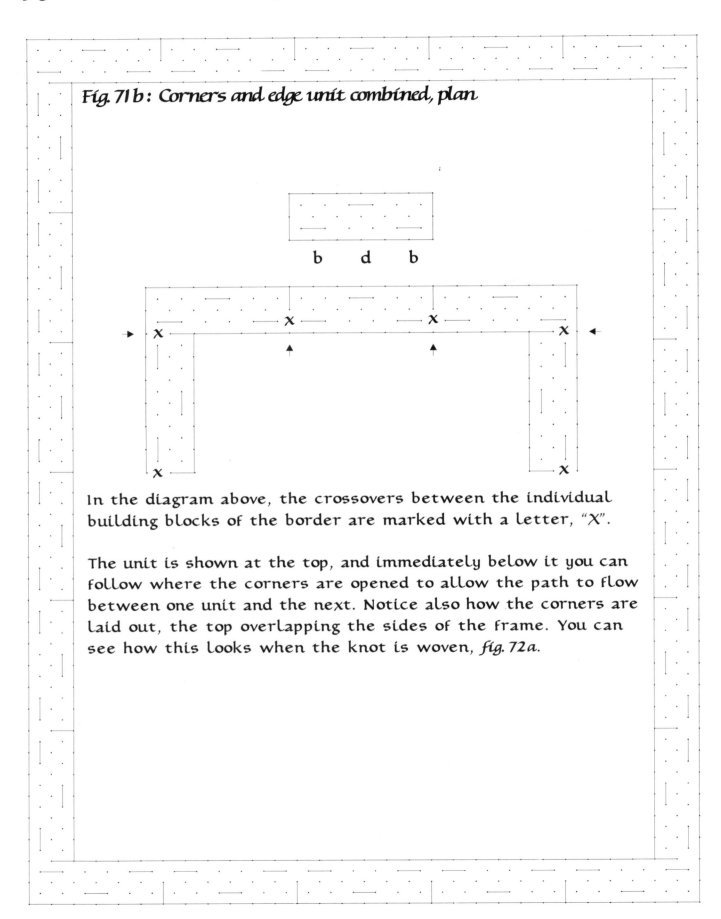

Fig. 71b: Corners and edge unit combined, plan

b d b

In the diagram above, the crossovers between the individual building blocks of the border are marked with a letter, "X".

The unit is shown at the top, and immediately below it you can follow where the corners are opened to allow the path to flow between one unit and the next. Notice also how the corners are laid out, the top overlapping the sides of the frame. You can see how this looks when the knot is woven, *fig. 72a.*

fig. 72b: Corners and edge unit combined, weaving

b d b

The top corner unit on the left is not connected to the middle unit. Compare with the single unit immediately above it. Both sides are connected in the border as completed above, fig. 72a.

This is knot number 24 from the chart of sixty-four 2 x 6 permutations in *fig. 68*. It happens also to be knot number 62, when rotated upside down.

Connect the knots together along the sides of the frame as shown in *fig. 68b*.

1	List the knots in chart 68b that are continuous.

2	List the pairs of knots in chart 68b which are exact rotations of each other.

3	Lay out a border based on fig. 68a, reproducing the dot grid and primary grid break division.

EXERCISES

4	On this grid, place a secondary grid breakline arrangement according to break unit number 62, from the chart of 2 x 6 breakline units in fig. 68b.

Unit 12 : Letter-size page borders

In this unit, we will build three knotwork borders, to fit a page 15 x 18 squares. This is a standard letter-size page proportion with a half-inch margin all around, where each square is one half inch.

The borders in this unit are based on the third method of mitring the corners of a rectangular frame of knotwork, the mitre scheme shown in *fig. 72a*, in which the four sides connect so that the longer sides sandwich the shorter sides between them. The longer sides are twenty squares in length, and the top and bottom are thirteen, taking the square to be the same width as the border. In this arrangement, the shorter sides may be divided into groupings of two or three square boxes, by placing breaklines on the primary grid, and the twos may be filled by secondary grid breaks drawn from *fig. 18*. Threes may be drawn from the chart in *fig. 67b*.

On the following pages, for instance, the secondary grid breakline pattern from *fig. 68b*, knot 36, is used for the triple unit in *fig. 72a*, while the secondary breaks from *fig. 18*, [L], [M] are used for the double units. The results are shown in *fig. 73a*, where the knots are woven and the background is ready to be filled in, as, for example, with black ink, or some other colour.

The same two units are used to demonstrate variations on this border throughout the rest of the unit. *Figs 81-84* also contain charts of further variations on the triple units. For each of the basic sixty-four permutations found in *fig. 68*, there are eight extra primary grid breaks that may be introduced, 576 possibilities to choose in all. Although only one of these 576 break patterns is used in a given border design, any of the others might be used in its place, with different results.

fig. 73a: Border layout, twos and threes

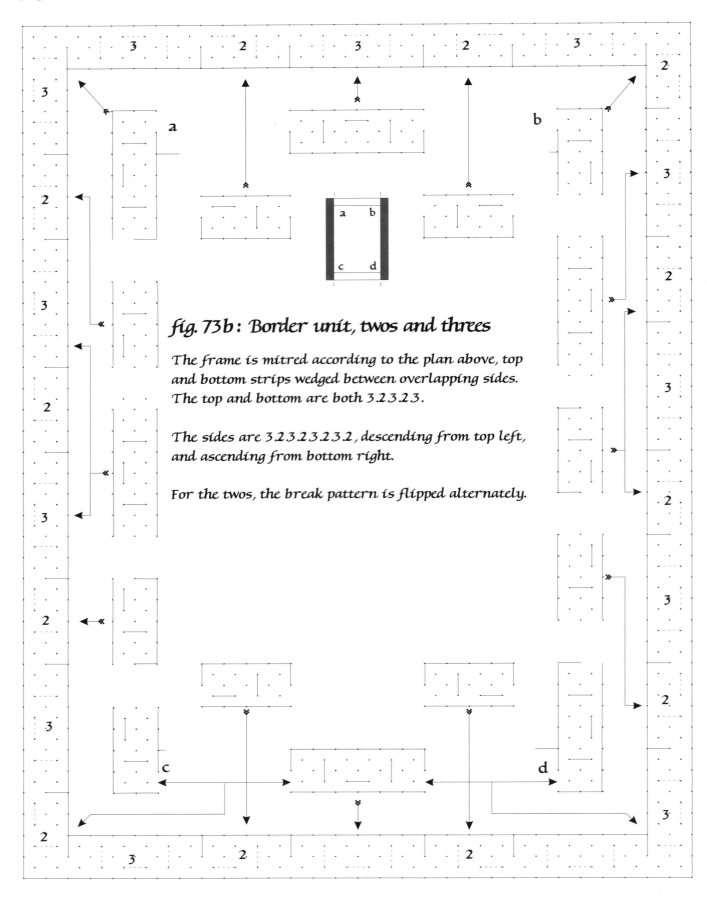

fig. 73b: Border unit, twos and threes

The frame is mitred according to the plan above, top and bottom strips wedged between overlapping sides. The top and bottom are both 3.2.3.2.3.

The sides are 3.2.3.2.3.2.3.2, descending from top left, and ascending from bottom right.

For the twos, the break pattern is flipped alternately.

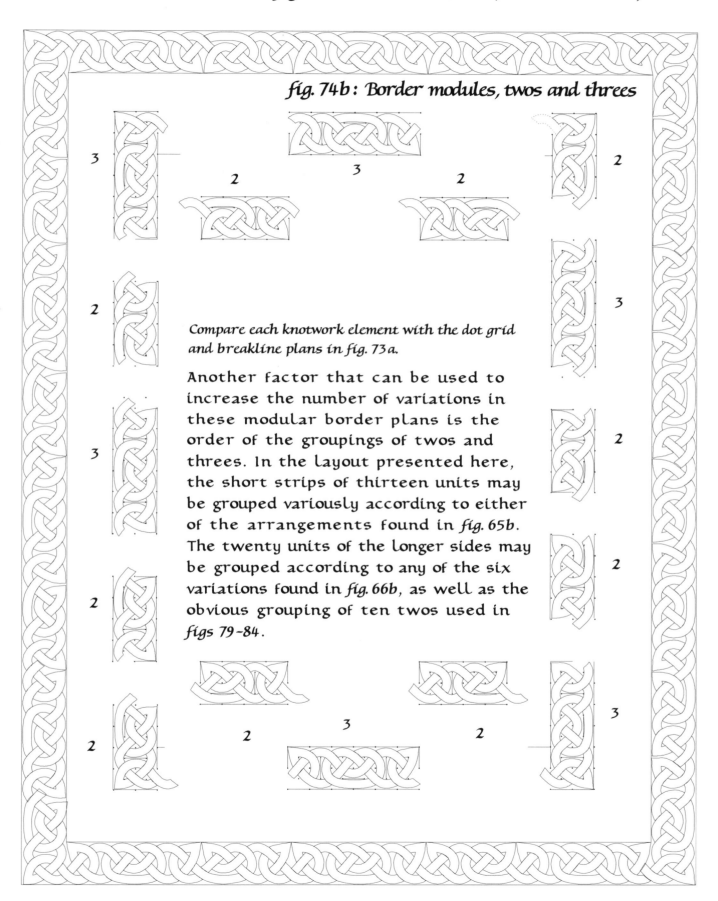

fig. 74b: Border modules, twos and threes

Compare each knotwork element with the dot grid and breakline plans in fig. 73a.

Another factor that can be used to increase the number of variations in these modular border plans is the order of the groupings of twos and threes. In the layout presented here, the short strips of thirteen units may be grouped variously according to either of the arrangements found in *fig. 65b*. The twenty units of the longer sides may be grouped according to any of the six variations found in *fig. 66b*, as well as the obvious grouping of ten twos used in *figs 79–84*.

fig. 75a: Border breakline plan

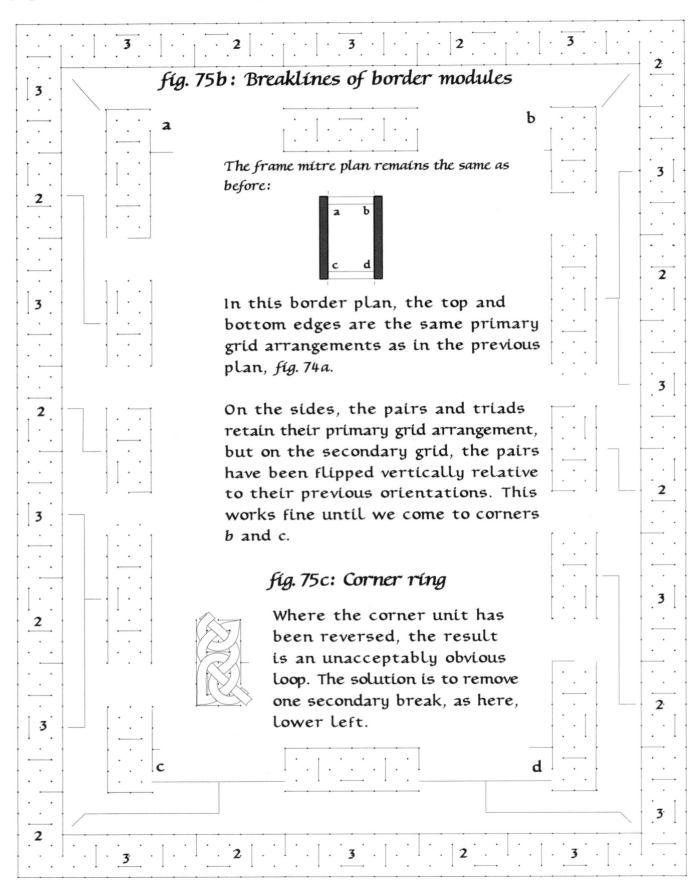

fig. 75b: Breaklines of border modules

The frame mitre plan remains the same as before:

In this border plan, the top and bottom edges are the same primary grid arrangements as in the previous plan, *fig. 74a*.

On the sides, the pairs and triads retain their primary grid arrangement, but on the secondary grid, the pairs have been flipped vertically relative to their previous orientations. This works fine until we come to corners *b* and *c*.

fig. 75c: Corner ring

Where the corner unit has been reversed, the result is an unacceptably obvious loop. The solution is to remove one secondary break, as here, lower left.

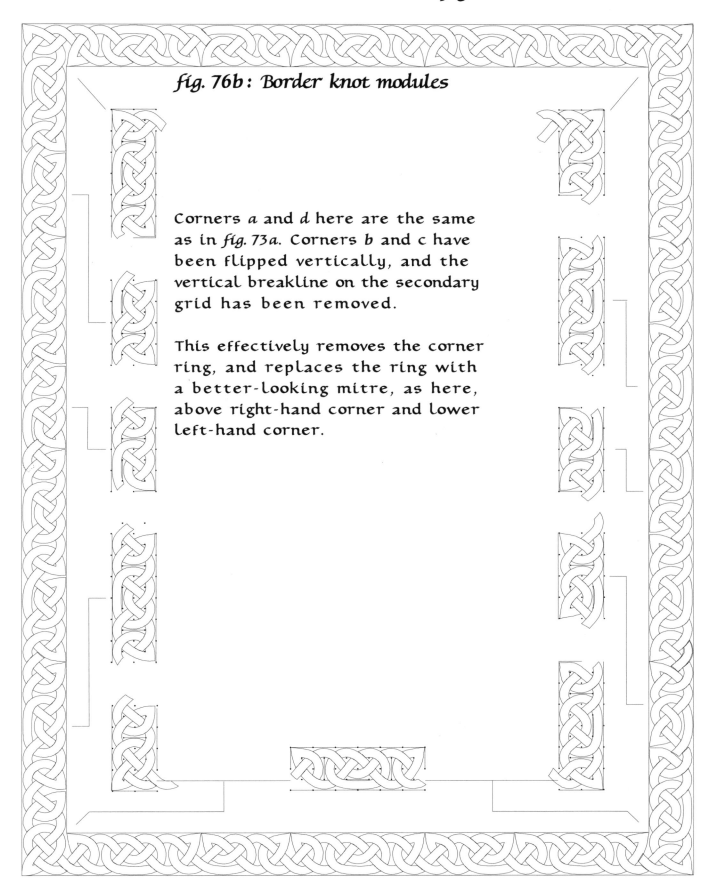

fig. 76b: Border knot modules

Corners *a* and *d* here are the same as in *fig. 73a*. Corners *b* and *c* have been flipped vertically, and the vertical breakline on the secondary grid has been removed.

This effectively removes the corner ring, and replaces the ring with a better-looking mitre, as here, above right-hand corner and lower left-hand corner.

fig. 77a: Border breakline plan

The frame mitre plan remains the same as that of the previous figure, mitre variation 3.

In this border, the same knots are used as well, except that their order has been rearranged.

Here, the order for the top and bottom strips is 2.3.3.3.2. The order for the sides is 2.3.2.3.3.2.3.2, which is a symmetrical order.

As in the previous figure, the knots at the end of each side strip need to be modified to get rid of the ring in the corner. The vertical breaks have been dropped in all four corners.

fig. 77b: Corner mitre

In this figure, the corner described is the top left-hand one. The end of a horizontal block, above, is placed against the side of an upright block, left. The blocks are the same size, but the upright has only one secondary break. The sideways block has two secondary breaks.

fig. 78b:
Mitre

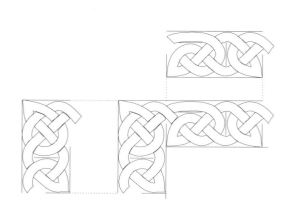

Here is the corner construction showing
its parts, and the knot woven from the
plan in *fig. 76*.

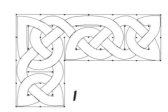

fig. 78c: Other
mitres

In this example, *fig. 78, c, 1*, the ring in the corner
- considered unsightly in Celtic knot design -
is caused by the inclusion of the vertical
secondary grid breakline, omitted in the
plan for the border, *fig. 77a*. An alternative
placement of the problem breakline, *fig. 78, c, 2*,
does nothing to improve the picture. The result
is a bent figure eight connecting both sides,
which is too obvious, and should be avoided.

fig. 79a: Border plan

The primary grid breaks are on the inner edge of the frame throughout. These divide the sides into groups of threes and twos in the following order:
top and bottom - 2.3.3.3.2
left and right - 2.2.2.2.2.2.2.2.2.2

The mitre layout is the same as the previous figure, mitre variation 3, as in fig. 64b.

The secondary grid breaklines on opposite sides mirror each other.

On the longer sides, the secondary grid breaklines alternately flip on the vertical axis, so that adjacent pairs mirror each other.

As we have seen, this secondary grid breakline pattern produces a ring in a corner, so one of the secondary breaklines has been omitted, to make the more pleasant-looking mitre of the finished border, *fig. 81a*.

fig. 79b, c: Alternative mitres

To avoid the ring, a variation of the 2x4 unit may be used, one with a central primary break. Two possibilities are given here. The results are shown in skeleton-knot form.

In the next two borders, the short strips remain the same, but the longer sides are different.

Taking the upper left- and right-hand corners, the mitre illustrated in *figs 76b* and *77a* reappears in *figs 80a* and *81a*, the same secondary grid pattern mirrored on either side, only with the weaving reversed.

In *figs 82a* and *83a* the top right corner is built upon the following mitre construction, *fig. 79b*.

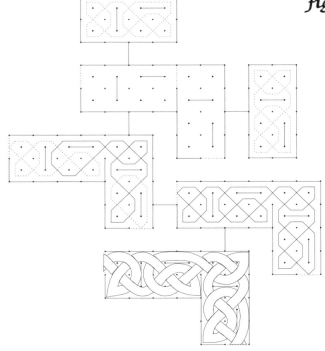

fig. 80b: Mitre construction

Here is the construction for the top right-hand corner of the frame in *fig. 83a*, above.

fig. 81a: Breakline plan for border

The mitre layout is the same as the previous figure, mitre variation 3.

The primary grid breaks are on the inner edge of the frame throughout. These divide the sides into groups of threes and twos in the following order:

top and bottom – 2.3.3.3.2
left and right – 2.2.2.2.2.2.2.2.2.2

fig. 81b: 144 three-square knots

fig. 82a: Knotwork border

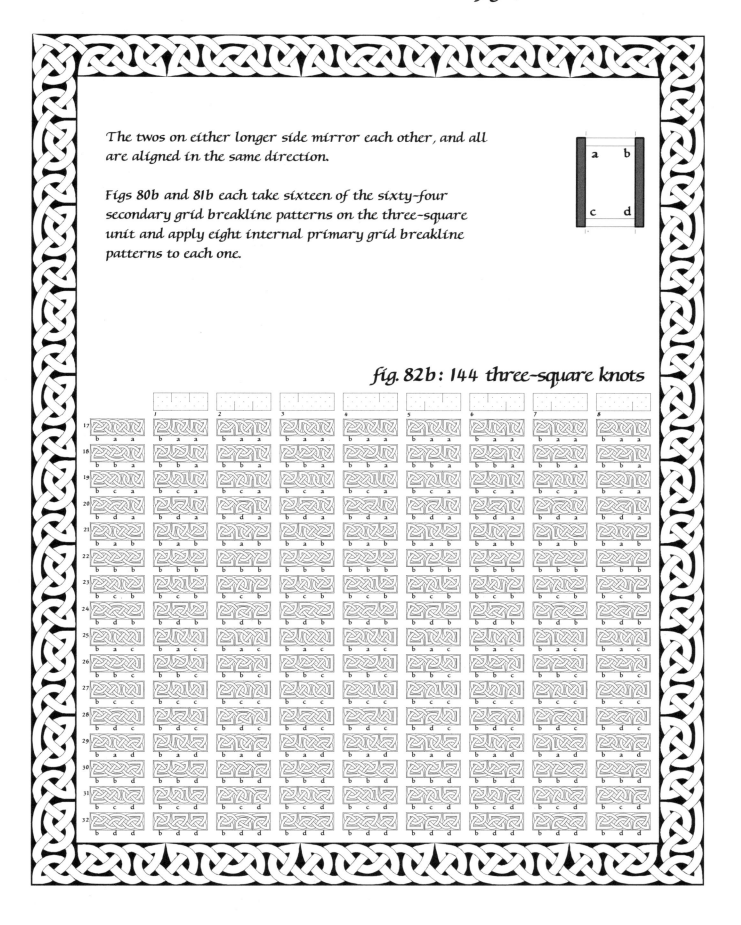

The twos on either longer side mirror each other, and all are aligned in the same direction.

Figs 80b and 81b each take sixteen of the sixty-four secondary grid breakline patterns on the three-square unit and apply eight internal primary grid breakline patterns to each one.

fig. 82b: 144 three-square knots

fig. 83a: Breakline plan

2 2 · 3 · 3 · 3 · 2 **2**

2

The primary grid breaks are on the inner edge of the
frame throughout. These divide the sides into groups
of threes and twos in the following order:

top and bottom – 2. 3. 3. 3. 2
left and right – 2. 2. 2. 2. 2. 2. 2. 2. 2. 2

The twos on the longer sides are reversed from one
side to the other so that the pattern from bottom to
top on the left-hand side is reflected from top to
bottom on the right-hand side.

fig. 83b: 144 three-square knots

2 2 · 3 · 3 · 3 · 2 **2**

fig. 84 a: Border

The mitre layout is the same as the previous figure, mitre variation 3, fig. 64 b. Opposite corners are identical rotations. The construction for corners b and c on this page is described in fig. 79 b, above.

Figs 83 b and 84 b each take sixteen of the sixty-four secondary grid breakline patterns on the three-square unit and apply eight internal primary grid breakline patterns to each one.

fig. 84 b : 144 three-square knots

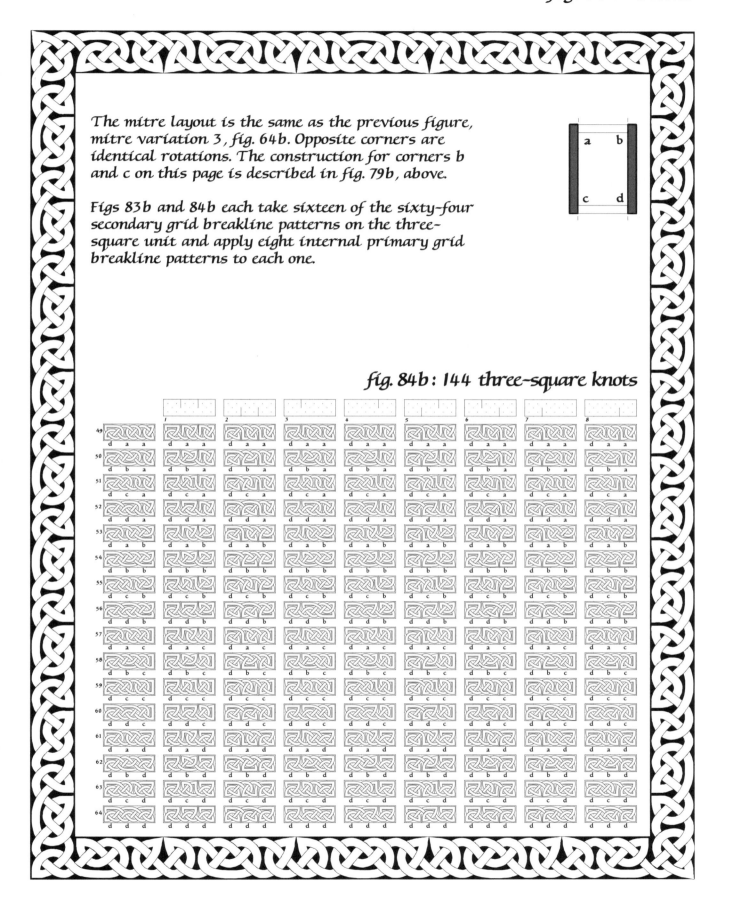

EXERCISES

1 Lay out a border of dimensions 15 x 20 squares, with primary and secondary dots.

2 Draw a solid line around the inside of the border, with pen and black ink. Take care not to smudge the inked line, while you draw another ink line around the inside edge of the frame.

3 Place a primary grid breakline from the inside edge of the frame according to the mitre method.

4 Divide the thirteen squares of the short sides into groups of twos and threes, using primary grid breaks.

5 Divide the twenty squares of the long sides into groups of twos and threes, using primary grid breaks.

6 Select a 6 x 2 secondary breakline pattern and apply to the threes.

7 Select a 2 x 4 secondary breakline and apply to the twos.

8 Pencil in the skeleton knotline of the border.

9 Weave the knot, ink up and colour in the background.

The borders in *figs 85a- 91a* are mitred as
shown in *fig. 86b*, where the shorter sides of
the frame are fitted between the longer,
over-lapping sides. Longer sides are twenty
squares long, and the top and bottom are
thirteen squares.

On this page, top and bottom are divided with
primary breaks spaced along the outer edge
in 3.2.3.2.3 order. The sides are divided into
3.2.3.2.2.3.2.3 order. The plans for this border
are in *figs 86* and *87*.

Figs 88 and 89 show a border with the same
primary grid arrangement as on this page,
but the secondary grid breaks are alternately
reversed.

In *figs 90* and *91*, the thirteen squares at the
top and bottom are also arranged in 3.2.3.2.3
order, but the sides are divided into ten
twos, filled with knots [H]1 or [N]1. These
knots have breaks that are symmetrical on
the diagonal, and work best with primary
breaks alternating on either side.

Figs 92 and 93 change to the rotary mitre. Each
side extends to one edge, *fig. 92b*. The top and
bottom are fourteen squares, grouped into
seven twos. The sides are nineteen, or eight twos
plus a three. The three is less conspicuous if
it is placed in the corner.

fig. 86a: Border breakline plan

The sides of the frame at the top and bottom are divided into squares, each square being 2 x 2 on the primary dot grid.

Primary breaklines are placed on the inner edge, thirteen squares grouped in 3.2.3.2.3 order.

The twenty squares of the longer sides are divided into groups in 3.2.3.2.2.3.2.3 order.

fig. 86b: Mitre plan, variation 3
This mitre is based on *fig. 64*, mitre variation 3.
The horizontal strip is butted against the
overlapping, longer side.

Primary break placement:

fig. 86c: No primary break

There are three ways to place the primary breakline. In the first instance, there is no break.

fig. 86d: Inner-edge break
In the second, the break is placed on the inside edge of the corner.

fig. 86e: Outer-edge break
In the third case, the break is placed on the outside edge. For this border, I used the third option.

Fig. 87b shows the construction of the upper right-hand corner, corner *b* in mitre variation 3.

The horizontal block of three squares is placed against the side of the vertical strip. The primary grid break between the two blocks is placed on the upper edge. The three horizontal breaks along the bottom of the horizontal block are the secondary grid breaks, as are the three aligned breaks up the inside of the vertical block.

The primary break defines the passage for the path between one block and the other. The dotted line shows the tertiary grid, as modified by the solid breaklines to form the straight-line skeleton of the knot. Below, the skeleton has been converted to curves, to define the midline of the path. Compare the knot plan here with the finished border, *fig. 87a*.

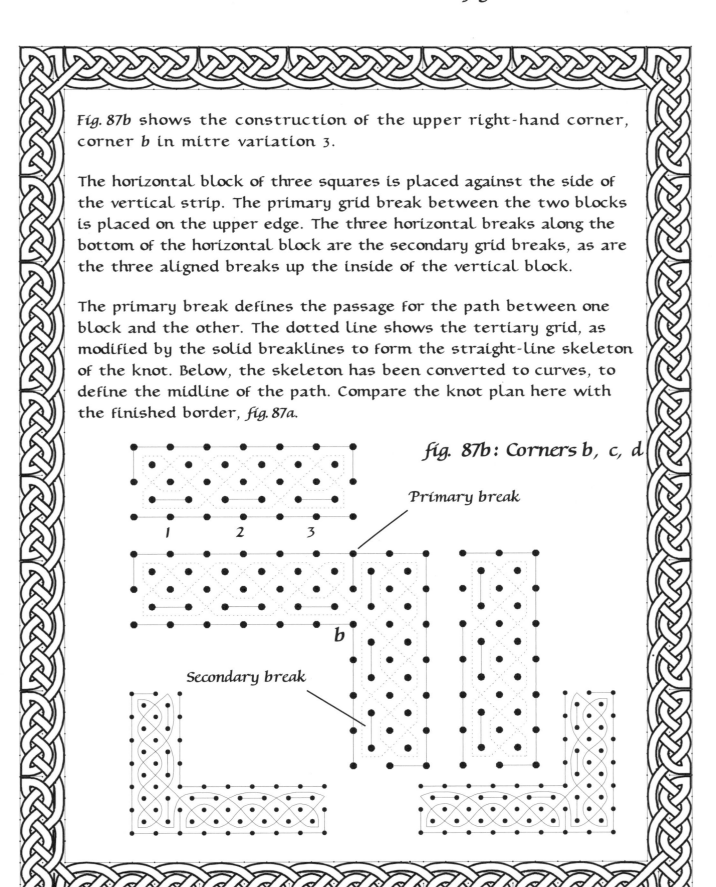

fig. 87b: Corners b, c, d

Primary break

Secondary break

fig. 88a: Border breakline plan

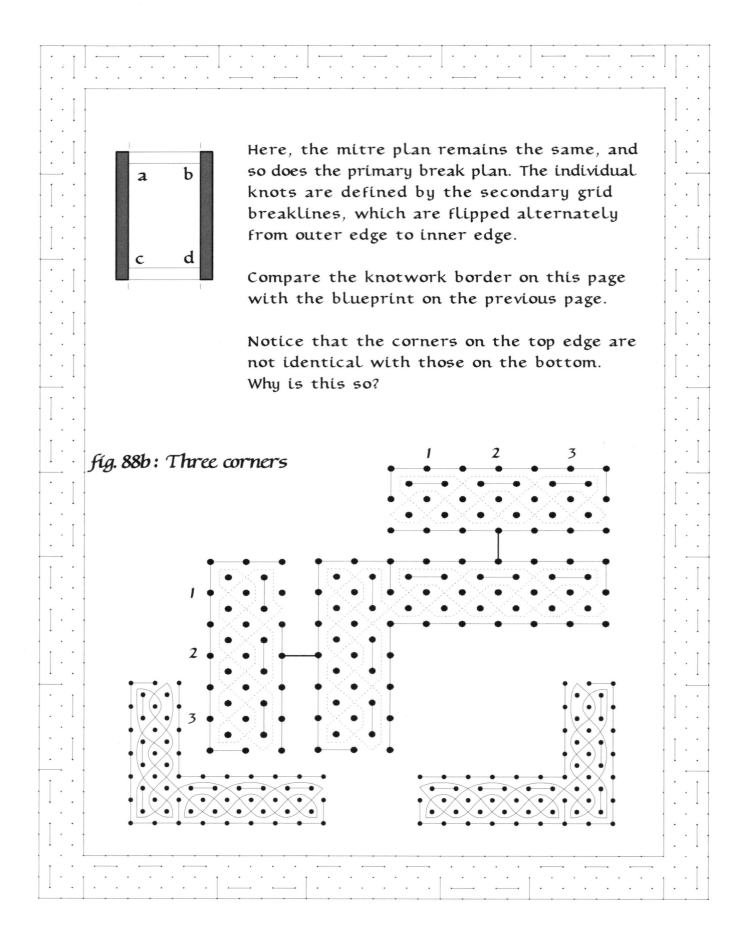

Here, the mitre plan remains the same, and so does the primary break plan. The individual knots are defined by the secondary grid breaklines, which are flipped alternately from outer edge to inner edge.

Compare the knotwork border on this page with the blueprint on the previous page.

Notice that the corners on the top edge are not identical with those on the bottom. Why is this so?

fig. 88b: Three corners

fig. 89 : Knotwork border

Although the primary breaklines are placed
consistently all around the outer edge, on all
four sides, the secondary breaklines along the
top and bottom strips are different. Along
the top, the secondary breaks for the threes
are placed along the upper edge, and the twos
have secondary breaks nearer to the inside
of the frame.

Along the bottom, the reverse is the case, the
secondary breaks are closer to the inside of
the frame in the threes, while the twos have
their breaks close to the outside. The reason
for this is that the twos and threes form a
wave, alternating secondary breaklines from
outer to inner edge, all around. But the long
sides have an even number of units, so the
direction changes from top to bottom: the top
right-hand corner, for instance, has a vertical block
aligned inwards, the bottom right-hand corner
is aligned outward. Therefore the bottom right
horizontal block flips inwards.

The flip-flop rhythm is preserved, at the expense of
overall symmetry. Absolute symmetry on all axes is
not necessary all the time, especially as here, where
the difference between the top and bottom edges
reveals the hidden rhythm of the whole. The border
is still symmetrical, although only on the vertical
axis. You often find an equivalence to symmetry
rather than an absolute adherence in patterns like
this. This is not always perversity or incompetence
on the part of the designer. Often, there is a
hidden reason for such an irregularity, as here.

fig. 90a: Border breakline plan

fig. 90b: Mitre variation 3

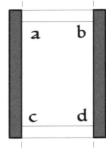

The mitre arrangement is the same as the last example, the top and bottom edges are strips of border inserted between the two, overlapping sides of the frame.

The order on the top and bottom is thirteen 2 x 2 squares on the primary dot grid gathered into groups of twos and threes, in 3.2.3.2.3 order.

The threes have secondary breaklines alternating from side to side, as, for instance, in the first horizontal block on the upper left-hand edge, along the top. The twos alternate also. Together, a pattern emerges between the primary and secondary breaks, two secondary breaks on either side of each primary break.

The longer sides break down into ten groups of two units, flip-flopped to maintain the same effect of two secondaries opposite a primary.

The result is a symmetrical border pattern, with opposite edges mirroring each other.

The segments of woven bands can be drawn in black or brown ink. If black, the result is as you see here. If you draw the knot lines in brown and then paint the background black, over the brown, the effect is closer to the painting technique of the manuscripts.

This border pattern is from the plan in *fig. 90a*. The construction shown in *fig. 91b, c, d* corresponds to the upper left corner.

fig. 91b: Corner a, module plan

On the left, a two-square block marks the end of the longer side. To its right, a three-square block marks the beginning of the short side along the top of the frame.

fig. 91c: Corner a, breakline plan

The next drawing shows the two- and the three-square unit combined. The two blocks are separated by a primary grid break on the upper edge, leaving a gap below for the path to cross between the two blocks.

fig. 91d: Corner a, woven path

In the final stage, the knot bands have been woven around the breaklines and dots in the background. Then the background marks are covered with ink, as in the border on this page.

fig. 92a: Border breakline plan

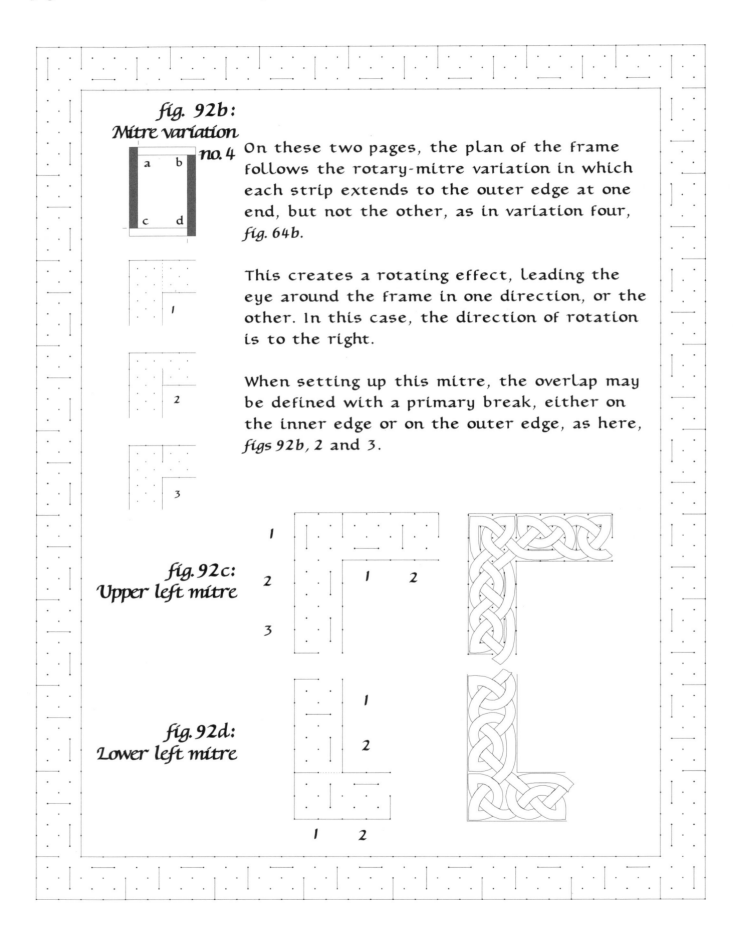

fig. 92b:
Mitre variation
no. 4

On these two pages, the plan of the frame follows the rotary-mitre variation in which each strip extends to the outer edge at one end, but not the other, as in variation four, *fig. 64b.*

This creates a rotating effect, leading the eye around the frame in one direction, or the other. In this case, the direction of rotation is to the right.

When setting up this mitre, the overlap may be defined with a primary break, either on the inner edge or on the outer edge, as here, *figs 92b, 2 and 3.*

fig. 92c:
Upper left mitre

fig. 92d:
Lower left mitre

This border is built according to the plan of *fig. 92a*. It exhibits diagonal symmetry: opposite corners are rotations of one another.

The difference between the two adjacent corners is illustrated in *figs 92 c, d*. The repeating unit is based on a 4 x 2 block, *fig. 93b*. In the lower left-hand and upper right-hand corners, the mitre is made of two of these blocks, as outlined in *fig. 92d*.

The other block is a 2 x 6 block, which is found at the top end of the left-hand side, and at the foot of the right-hand side.

Because these longer sides occupy nineteen squares (where each square is the width of the border, and the repeating unit fills two of these squares), this means we have to add an extra-long unit somewhere along each side, a three-square unit instead of the repeating two-square unit. The three-square block is picked out in *fig. 93c*.

Along the top and bottom edges, the strips are fourteen squares long, and this divides naturally into a repeat of two squares.

Alternatively, the three-square unit could have been centred in the longer side. This would have changed the mitre so that all the corners would then be a combination of twos, such as described in *fig. 92d*.

Note that in this, as in previous borders, you can choose units from the chart of 2 x 4s in *fig. 18*, or the 2 x 6s in *fig. 67*. Not all will work well together. Try out different combinations to find some that work for you.

fig. 93b:
4 x 2 unit,
upper edge

fig. 93c:
2 x 6 unit,
upper left corner

EXERCISES

1 Lay out a border, with primary and secondary dots, of dimensions 15 x 20 squares.

2 Draw a solid line around the inside of the border, with a pen and black ink. Take care not to smudge the inked line while you draw another ink line around the inside edge of the frame.

3 Place a primary grid breakline from the inside edge of the frame according to mitre method 4.

4 Divide the fourteen squares of the short sides into groups of twos and threes, using primary grid breaks.

5 Divide the nineteen squares of the long sides into groups of twos and threes, using primary grid breaks.

6 Select a 6 x 2 secondary breakline pattern and apply to the threes.

7 Select a 2 x 4 secondary breakline and apply to the twos.

8 Pencil in the skeleton knotline of the border.

9 Weave the knot in pencil, overlay the lines of the knotwork in brown ink. Fill in the background in black ink.

Unit 14: Rotary mitre and 3 x 2 plait

fig. 94: Knotwork border

Borders in this and the next three figures are mitred according to the rotary mitre, where each side extends to one edge only. Top and bottom strips are fourteen squares, left- and right-hand sides are nineteen squares.

The border is divided into threes and twos, as in *fig. 95a*, and then the threes are further divided in half, *fig. 96a*. Even without any secondary grid breaks, as here, the result is quite effective. Each three-square division contains a pair of knots, which repeat all around the border except at the corners, where the twos occur at the outer end of each side.

We will explore this new unit that has appeared when the threes are divided.

If you recall, we began with a 2 x 2 basic unit, the Foundation Knot, and we have been dealing with it throughout the course so far, whether alone or in multiple repeats forming modules of knotwork.

With the division of the three-square unit, we have a new basic unit to explore, to which all the principles that we have learned so far may be applied. The Foundation Knot is based on the simplest plait, the King Solomon's Knot. The 3 x 2 is also a plait.

fig. 95a: Border breakline plan

The top and bottom of the frame are divided into squares, each square being 2 x 2 on the primary dot grid. Primary breaklines are placed on the inner edge, fourteen squares grouped in 3.3.3.3.2 order.

The nineteen squares of the longer sides are divided into groups in 2.3.3.3.3.3.2 order.

fig. 95b: Mitre plan

This mitre is based on fig. 64b, variation 4. The horizontal strip is butted against the overlapping, longer side. For the remaining corners, the same mitre is repeated, but rotated a quarter turn to the right.

The plan that we have been using is designed to fit a letter-sized sheet of paper, so that the patterns might easily be converted into a personal stationery design, for instance.

On a standard letter-size page of 8½"x 11", a half-inch margin all around the border leaves an area of 7½"x 10", or fifteen units across by twenty units down, using half an inch as a convenient unit. The primary dot grid for the border will then correspond to a quarter-inch grid, each square of the border unit being quartered by the primary dot grid.

You may substitute metric measurements, if you prefer, making your border 15 x 20 cms, for instance: this will make a border of the same overall proportion, while using a square grid of 5 mm for your primary grid layout.

On this page, the plan for the border, *fig. 96a*, consists entirely of primary grid breaklines. Because of the mitre plan for this border, which has strips of fourteen and nineteen squares, the short sides have two squares left over at the end of the strip, where it extends to the outside of the frame. The long sides divide into five three-square blocks except for twos at either end.

As a result, the twos at the top of the right-hand side, and at the bottom of the left-hand side are boxed off by the primary grid breaks of the mitre, causing a twisted loop. Although it is hard to detect, this defect should be avoided if at all possible.

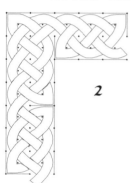

1

fig. 96b: Corner mitre

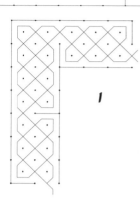

2

fig. 96c: Three-square unit, divided

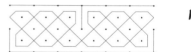

1

Border design, *fig. 95a*, shows the sides of the frame divided into threes and twos. On this page, the threes are further divided, so that each half of the triple unit forms a 3 x 2 rectangle unit on the primary grid.

Below, 2, is the woven braid derived from the skeleton tertiary grid line overhead, 1.

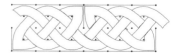

2

Mitre plan for the upper left-hand corner: the horizontal block is 3 x 2 primary grid cells placed to the right against the side of the vertical, 2 x 4 primary grid unit.

The primary grid break between the two blocks is on the inner edge of the frame.

fig. 97a: Border breakline plan

Here, the mitre plan remains the same, but the primary break plan has changed, to avoid the twisted loop in the corner, as described in the previous figure.

fig. 97b:
Twisted loops

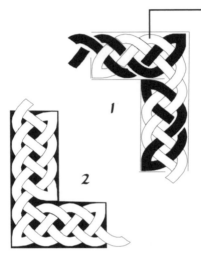

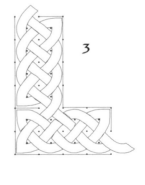

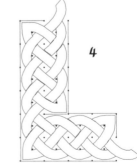

1 Twisted loops are blacked out. The one on the top is open to the left, and this is acceptable. The one below is boxed in on the inner edge of the frame, isolating the twisted loop, which is to be avoided.

2 The same problem occurs in the lower left corner of the border in fig. 93a. The loop results from two primary breaks placed on the same side, two squares apart.

3 If the mitre break is shifted over to the outer edge, this clears the loop in the vertical block. But now the bottom block is boxed in, and the dreaded butterfly loop strikes again. Besides, to be consistent, the mitre break should remain as is.

4 Here, both blocks are open on diagonally opposite corners, while maintaining the mitre plan.

As mentioned before, the first primary grid break from the bottom on the left-hand side needs to be shifted over to the outside edge of the frame, in order to avoid boxing off the first, two-square unit. The same applies in the corresponding place on the opposite side, below the corner in the upper right.

This interferes with the alternating pattern - however, this is unavoidable. If the breaks are reversed throughout the rest of the strip right to the top, then the two-square unit in the upper left would become boxed in. So, there is no alternative but to place two consecutive primary breaks on the outside, as marked with a cross on the plan for the border, *fig. 97a*.

Note that the two-square, 4 x 2 plait consists of two butterfly loops intertwined, so that if a 4 x 2 block is defined by two primary breaks on the same side, one of the butterfly loops will be bound to pop up. While the loops are acceptable in the 4 x 2 plait, they are unacceptable as part of a larger format, as there is usually no reason why they should not be avoided, if at all possible. Larger loops than this are acceptable, as they are less obvious to the eye, being spread over more of the pattern.

fig. 98b:
2 x 3 plait

The one and a half or 3 x 2 plait is a continuous band, so it may be boxed in by two primary breaks on the same side with no harm to the integrity of the knotwork. You can see just such a knotwork unit on the side of the border here, to the immediate left, corresponding to the location of the "X" marked on the plan in the previous figure.

fig. 99 : Border breakline plan

Mitre 2

The pattern that we want to use is a repeating unit based on the division of the three-square or 6 x 2 primary grid rectangle.

For this purpose, it would be most convenient if we could divide the border into units that could be grouped in threes only.

Given that the border is fifteen across and twenty down, we can choose a different mitre than the one we used for the last border, one that will break down into groups of three squares.

Handily, mitre variation number two from *fig. 64b* will do the job, as the shorter sides will be fifteen squares, and the longer sides, sandwiched between the top and bottom, will yield eighteen squares.

This mitre plan can be subdivided into five threes across and six threes down.

For now, the primary grid breaklines may be placed along the outer edge for the short sides, and along the inner edge for the long sides. Other arrangements are possible: all on the outside, or all on the inside, or alternating from one to the other. Other arrangements will produce different results.

The next step is to sub-divide the three-square groups with more primary breaklines, placed half way between the first lot, on either side. Again, the choice will affect the outcome of the pattern.

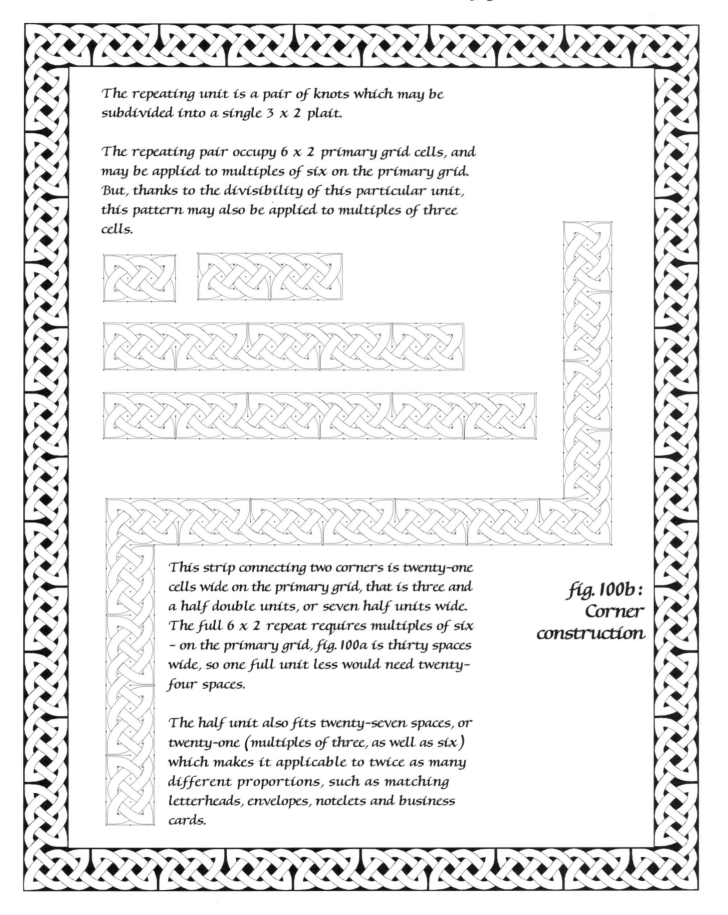

The repeating unit is a pair of knots which may be subdivided into a single 3 x 2 plait.

The repeating pair occupy 6 x 2 primary grid cells, and may be applied to multiples of six on the primary grid. But, thanks to the divisibility of this particular unit, this pattern may also be applied to multiples of three cells.

fig. 100b: Corner construction

This strip connecting two corners is twenty-one cells wide on the primary grid, that is three and a half double units, or seven half units wide. The full 6 x 2 repeat requires multiples of six – on the primary grid, fig. 100a is thirty spaces wide, so one full unit less would need twenty-four spaces.

The half unit also fits twenty-seven spaces, or twenty-one (multiples of three, as well as six) which makes it applicable to twice as many different proportions, such as matching letterheads, envelopes, notelets and business cards.

fig. 101: Border breakline plan

Mitre 2

On this page, the plan of the frame follows the same development as the previous example, with threes defined on the primary grid, except that here the primary breaklines are all set off from the inner edge of the frame, mitred henge-style according to mitre variation 2. The corner mitres are also determined by the primary breaklines on the inner edge. Also, the primary grid 3/2 divisions are aligned on the same side of the frame.

This looks like the layout for a perfectly regular knotwork pattern, but knotwork borders often contain unexpected surprises. In this case, as the completed border on the next page reveals, the corner units are different from the repeating units coming between them from one corner to the next.

How come? The cause lies in the placement of the primary grid breaks: the repeat unit is formed between two breaks on the inner edge, but the outer edge of the frame is, in effect, a primary grid break itself, and so the unit at each end of the short side is formed between two breaks that are diagonally opposed, instead of being aligned on the inside edge as elsewhere in the pattern.

The result is quite acceptable, even if unintended. The regularity of the pattern lies in the underlying breakline pattern, which should be valued as much as the resulting knot pattern, and this breakline plan is very regular. In order to achieve the effect of a perfectly regular repeating pattern, the breaklines would have to be shifted to the outside of the frame on the shorter sides.

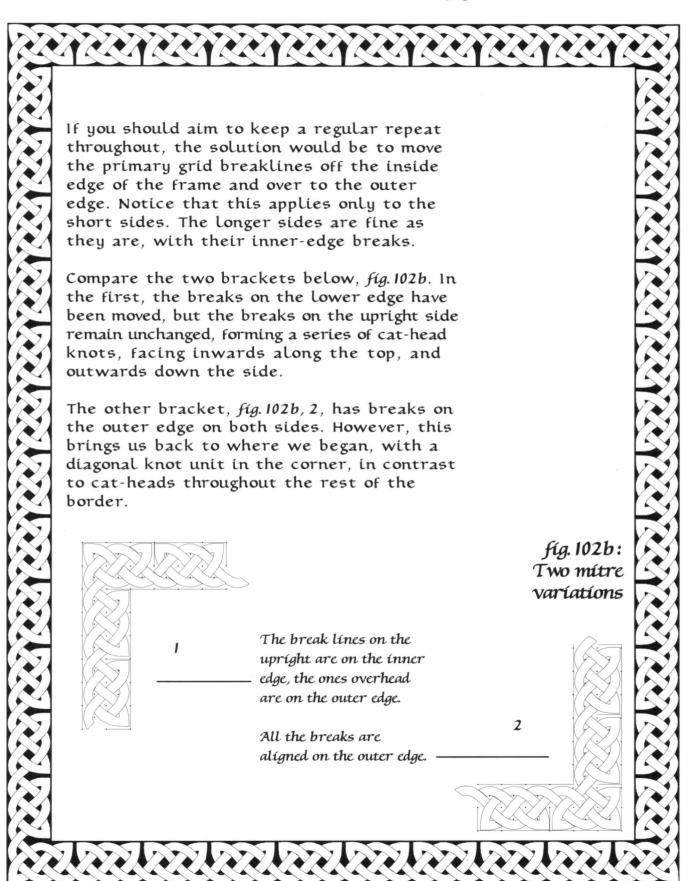

If you should aim to keep a regular repeat throughout, the solution would be to move the primary grid breaklines off the inside edge of the frame and over to the outer edge. Notice that this applies only to the short sides. The longer sides are fine as they are, with their inner-edge breaks.

Compare the two brackets below, *fig. 102b*. In the first, the breaks on the lower edge have been moved, but the breaks on the upright side remain unchanged, forming a series of cat-head knots, facing inwards along the top, and outwards down the side.

The other bracket, *fig. 102b, 2*, has breaks on the outer edge on both sides. However, this brings us back to where we began, with a diagonal knot unit in the corner, in contrast to cat-heads throughout the rest of the border.

fig. 102b: Two mitre variations

1

The break lines on the upright are on the inner edge, the ones overhead are on the outer edge.

All the breaks are aligned on the outer edge.

2

1 Lay out a border two cells wide, with a primary grid cell of either a quarter inch or 5 mm, to fit a rectangle thirty cells wide and forty cells high.

2 Draw a solid line around the inside of the border, with a pen and black ink, and another ink line around the inside edge of the frame.

EXERCISES

3 Mark the dots for the primary grid in ink, so that the dots are equal or smaller than the thickness of your pen line.

4 Place the dots for the secondary grid in the middle of each primary grid cell.

5 Place the primary breaklines for the corners according to mitre variation 2. Place the primary grid breaklines on the inner edge.

6 Divide the thirty primary cells of the short sides into groups of three spaces, using primary grid breaks on the outer edge.

7 Divide the thirty-six cells of the longer sides into groups of three, using primary grid breaks on the inner edge.

8 Pencil in the skeleton knotline of the border.

9 Weave the knot band in pencil, using the skeleton midline as a guide. Check that the weaving is correct, and make any changes that need to be made.

10 Draw over the lines of the knotwork in brown ink, using a pen. Fill in the background with black ink using a finely pointed brush.

Borders in this unit are mitred according to the henge mitre, *fig. 64, variation 2*, where top and bottom sides extend to the full width of the frame. Top and bottom strips are fourteen squares, left- and right-hand sides are nineteen squares.

The border is divided into threes and twos, as in *fig. 95a*, and then the threes are further divided in half. Even without any secondary grid breaks, as here, the result is quite effective. Each three-square division contains a pair of knots, which repeat all around the border except at the corners, where the twos occur at the outer end of each side.

We will explore this new unit that has appeared when the threes are divided. If you recall, we began with a 2 x 2 basic unit, the Foundation Knot, and we have been dealing with it throughout the book so far, whether alone or in multiple repeats forming modules of knotwork.

With the division of the three-square unit, we have a new basic unit to explore, to which all the principles we have learned so far may be applied. The Foundation Knot is based on the simplest plait, the King Solomon's Knot. The 3 x 2 is also a plait.

In this unit, we start with the construction of the border that you see on this page, *fig. 103a*.

fig. 104 : Border, breakline plan, primary

Mitre 2

The method of construction for the border on the previous page is as follows.

The outside measurement for this full-page border is thirty spaces across and forty down, on the primary grid. Using a quarter inch grid, the frame will fit a standard letter-size format, with a half inch margin all round.

The inside measurements of this border are twenty-six across and thirty-six down. The outer and inner rectangles are first ruled, and then the primary grid points are placed on each corner of the primary grid. Then, the secondary grid is drawn, consisting of points placed in the middle of each square of four dots on the primary grid.

The top and bottom sides of this frame span the outside width of thirty spaces. Primary grid breaklines are placed on the outer edge, dividing the width into five sections of six spaces. Then, primary grid breaklines are set off from the middle of each section, and drawn to the inner edge of the frame. All together, the primary breaks on both sides divide the overall width into ten sections of three primary grid spaces.

The enclosed vertical sides equal the internal height of thirty-six primary grid spaces.

This height is first divided into six six-space sections, with primary breaklines set off from the inside edge. The first and last of these breaklines also serve to establish the breakline pattern for the mitre plan, variation 2, as featured in the side bar to the left. Having done that, each six-space section is further divided by a centrally placed break set on the opposite edge of the frame, so that the sides now contain twelve sections of three spaces each.

fig. 105a: Border, breakline plan, secondary

fig. 105b: 6 x 2 knot

1

2

3

4

5

The next stage is to place the secondary breaklines midway between the primary breaklines, as illustrated in this figure. The secondary breaklines are placed three spaces apart on the secondary grid throughout.

The construction of the repeating unit, as laid out in fig. 105b, is as follows.

1 With a pencil, the straight-line skeleton is drafted.

2 Using the straight-line draft as a guide, redraw the line of the knot, converting angles to curves except at the corners and at the point where the primary break meets an edge.

3 Go over the curved line, weaving over and under as you go. If you plan to erase the midline later, keep the pencil line light. If you plan to incorporate the midline, as here, it does not matter, so long as you are reasonably accurate, because you will be drawing over the pencil line. A well-defined pencil line is a great help in drawing pen lines, as it lays a groove for the pen point to follow, smoothing the way for the nib.

4 Using the interlaced central line as a guide, draw the edges of the band on either side of it, keeping a constant distance from the middle, on each side. Draw both sides of each segment at the same time, complete one segment before proceeding to the next. Start somewhere in the middle of the border, and work towards the corners, leaving them until last.

5 When you have completed pencilling the design, ink up the outer edges of the band first. Erase any unwanted pencil marks before filling the background.

fig. 106a: Border breakline plan

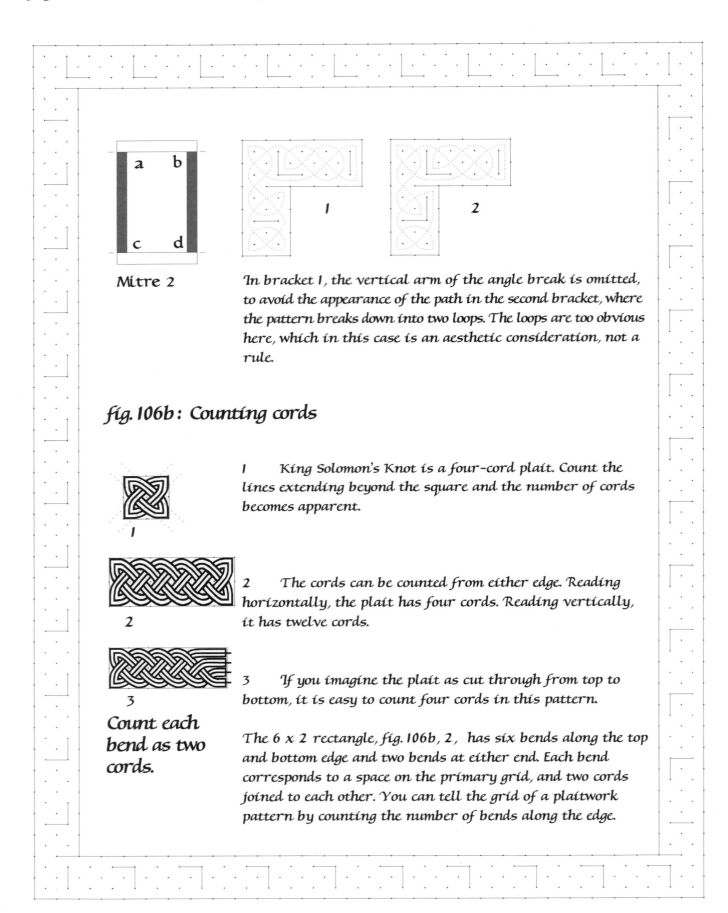

Mitre 2

In bracket 1, the vertical arm of the angle break is omitted, to avoid the appearance of the path in the second bracket, where the pattern breaks down into two loops. The loops are too obvious here, which in this case is an aesthetic consideration, not a rule.

fig. 106b: Counting cords

1 King Solomon's Knot is a four-cord plait. Count the lines extending beyond the square and the number of cords becomes apparent.

2 The cords can be counted from either edge. Reading horizontally, the plait has four cords. Reading vertically, it has twelve cords.

3 If you imagine the plait as cut through from top to bottom, it is easy to count four cords in this pattern.

Count each bend as two cords.

The 6 x 2 rectangle, fig. 106b, 2, has six bends along the top and bottom edge and two bends at either end. Each bend corresponds to a space on the primary grid, and two cords joined to each other. You can tell the grid of a plaitwork pattern by counting the number of bends along the edge.

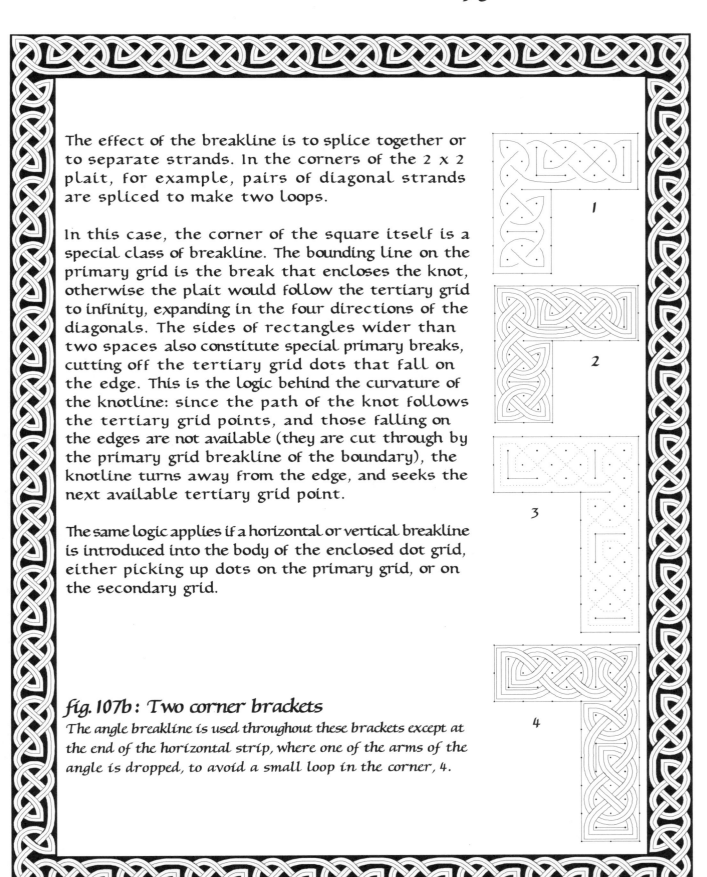

The effect of the breakline is to splice together or to separate strands. In the corners of the 2 x 2 plait, for example, pairs of diagonal strands are spliced to make two loops.

In this case, the corner of the square itself is a special class of breakline. The bounding line on the primary grid is the break that encloses the knot, otherwise the plait would follow the tertiary grid to infinity, expanding in the four directions of the diagonals. The sides of rectangles wider than two spaces also constitute special primary breaks, cutting off the tertiary grid dots that fall on the edge. This is the logic behind the curvature of the knotline: since the path of the knot follows the tertiary grid points, and those falling on the edges are not available (they are cut through by the primary grid breakline of the boundary), the knotline turns away from the edge, and seeks the next available tertiary grid point.

The same logic applies if a horizontal or vertical breakline is introduced into the body of the enclosed dot grid, either picking up dots on the primary grid, or on the secondary grid.

fig. 107b: Two corner brackets

The angle breakline is used throughout these brackets except at the end of the horizontal strip, where one of the arms of the angle is dropped, to avoid a small loop in the corner, 4.

fig. 108a: Border plans

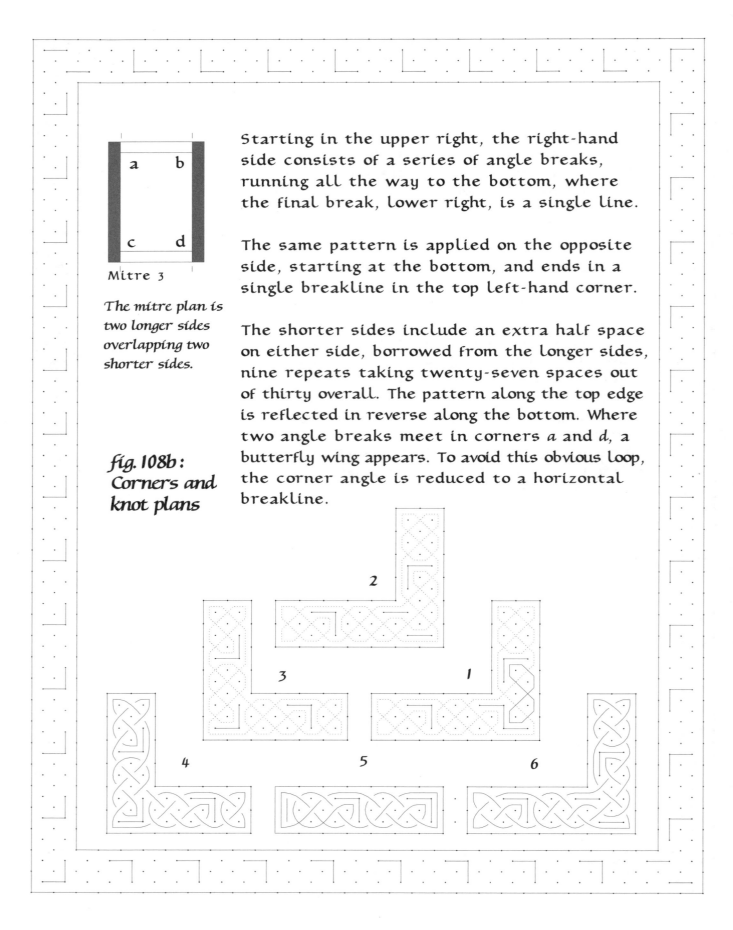

Mitre 3

The mitre plan is two longer sides overlapping two shorter sides.

fig. 108b: Corners and knot plans

Starting in the upper right, the right-hand side consists of a series of angle breaks, running all the way to the bottom, where the final break, lower right, is a single line.

The same pattern is applied on the opposite side, starting at the bottom, and ends in a single breakline in the top left-hand corner.

The shorter sides include an extra half space on either side, borrowed from the longer sides, nine repeats taking twenty-seven spaces out of thirty overall. The pattern along the top edge is reflected in reverse along the bottom. Where two angle breaks meet in corners *a* and *d*, a butterfly wing appears. To avoid this obvious loop, the corner angle is reduced to a horizontal breakline.

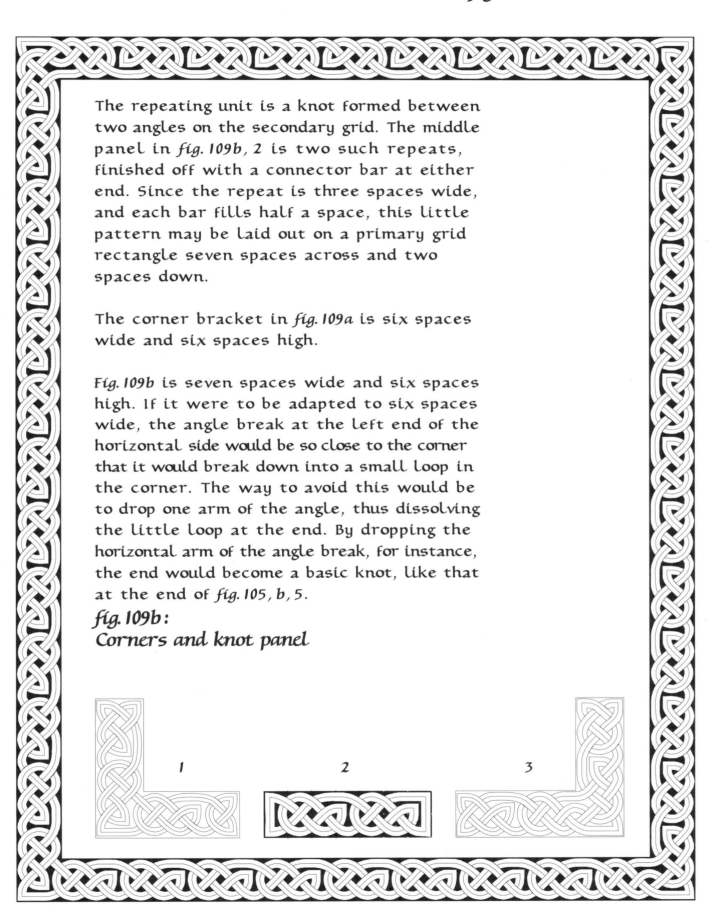

The repeating unit is a knot formed between
two angles on the secondary grid. The middle
panel in *fig. 109b, 2* is two such repeats,
finished off with a connector bar at either
end. Since the repeat is three spaces wide,
and each bar fills half a space, this little
pattern may be laid out on a primary grid
rectangle seven spaces across and two
spaces down.

The corner bracket in *fig. 109a* is six spaces
wide and six spaces high.

Fig. 109b is seven spaces wide and six spaces
high. If it were to be adapted to six spaces
wide, the angle break at the left end of the
horizontal side would be so close to the corner
that it would break down into a small loop in
the corner. The way to avoid this would be
to drop one arm of the angle, thus dissolving
the little loop at the end. By dropping the
horizontal arm of the angle break, for instance,
the end would become a basic knot, like that
at the end of *fig. 105, b, 5.*

fig. 109b:
Corners and knot panel

1 2 3

fig. 110: Border breakline plan

In this variation, the top and the bottom overlap the sides, as in mitre variation two, *fig. 64b.* Ten angles fit across the shorter sides, beginning half a space in from the edge, and ending two and a half spaces from the other end. The base of the frame is a rotation of the pattern across the top. In each case, the entire strip is filled by nine groups of three spaces, filling twenty-seven of the thirty available spaces. The remaining three spaces are taken by the bar at one end, which always counts as half a space, leaving two and a half spaces at the other end. All the breaklines on the top and bottom stretches are secondary dot grid breaklines.

On the next page, the plan shown here has been finished. The mitre plan follows the arrangement shown on the left, mitre 2.

The longer sides, *a–c* and *b–d*, are defined by primary grid breaklines at either end, forming the mitre, and contain six groups of six primary grid units, marked by breaklines on the inner edge. Inside each 2 x 6 primary grid block, the secondary angle breaks are paired centrally, three spaces apart between the horizontal arms of the angles. The result is a chain of links. The corners are diagonally symmetrical.

On the next page are corner mitre plans, extracted from the frame and changed into brackets, which can be rearranged to form a modular frame.

The modular frame consists of corner brackets, with panels or strips placed in between. The modular frame was used more often than the overall, continuous frame in manuscripts.

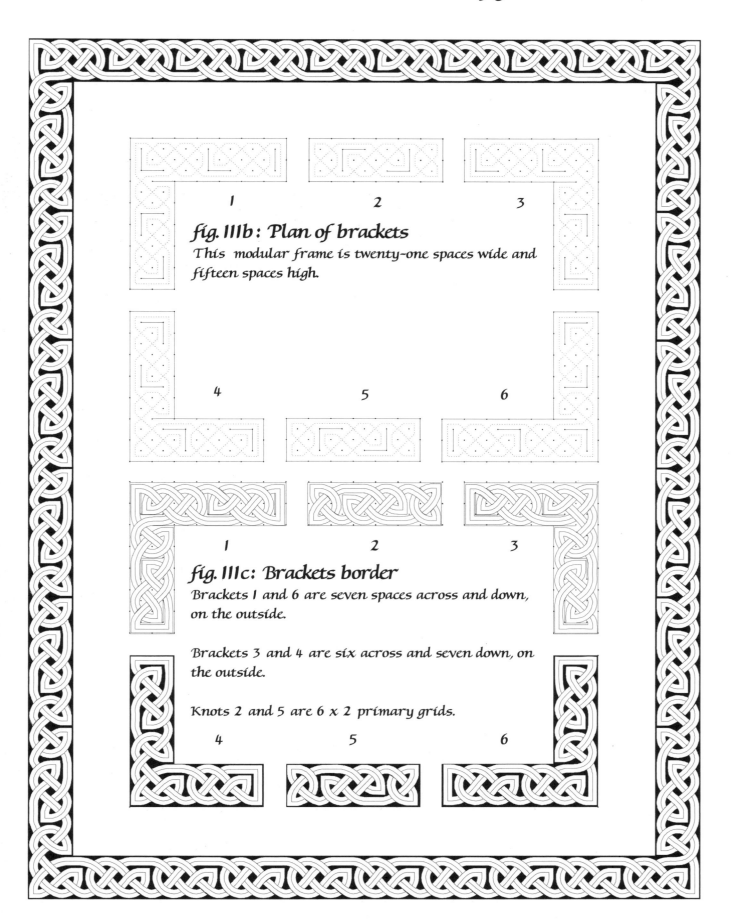

fig. 111b: Plan of brackets

This modular frame is twenty-one spaces wide and fifteen spaces high.

fig. 111c: Brackets border

Brackets 1 and 6 are seven spaces across and down, on the outside.

Brackets 3 and 4 are six across and seven down, on the outside.

Knots 2 and 5 are 6 x 2 primary grids.

EXERCISES

1 Lay out a border two cells wide, with a primary grid cell of a quarter inch or five mm, to fit a rectangle thirty cells wide and forty cells high.

2 Draw a solid line around the inside of the border, with a pen and black ink, and another ink line around the inside edge of the frame.

3 Mark the dots for the primary grid in ink, so that the dots are equal or smaller than the thickness of your pen line.

4 Place the dots for the secondary grid in the middle of each primary grid cell.

5 Apply mitre variation number 2, with primary grid breaks on the inner edge defining the four side strips.

6 Divide the sides into groups of three spaces, placing the breaks on the inside.

7 Pencil in the straight-line skeleton of the pattern.

8 Go over the angles of the skeleton, sweetening all the curves, except for the right-angled turns.

9 Weave the knot band in pencil, using the skeleton midline as a guide. Check that the weaving is correct, and make any changes that need to be made.

10 Draw over the lines of the knotwork in brown ink, using a pen.

11 Fill the background with Chinese ink using a dip pen.

Unit 16: Modular frames

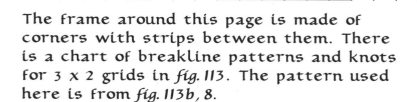

3 4

The frame around this page is made of
corners with strips between them. There
is a chart of breakline patterns and knots
for 3 x 2 grids in *fig. 113*. The pattern used
here is from *fig. 113b, 8*.

The effect depends on whether the primary
break between repeats is placed on the inner
or the outer edge. Compare separating breaks
in the lower left-hand corner, 8, with those
of the opposite corner, 6.

The separating breaklines on the primary grid
combine with angle breaks on the secondary
grid to form the pattern. As placement of
the separating breaks changes, so does the
resulting knot. On the lower arms of the corner
brackets below, angle breaks correspond,
but separating breaks sit on the outer edge of
the bracket on the left only, 8. On the right,
the separators hang from the inner edge.

The design in the upright arm of the bracket
on the right, 6, is the same as that between
the brackets, below centre, 7, rotated to the
left. The lateral border strip, 5, is the same
pattern turned the other way.

Brackets and intervening strips can be
extracted from a complete border plan
such as in *fig. 113a*. Figs *114a–120a* show
variations on the same knot. Modules may
be tied together by a surrounding fillet,
fig. 120c. This fillet is best integrated as
part of the layout from the outset.

fig. 112:
Modular frame
Corners 2 and 6 have
primary breaklines
on the inner edge;
corners 4 and 8 have
primary breaks on
the outer edge.

The 6 x 2 panels, 3
and 7 and the 2 x 12
panels, 1 and 5, have
primary breaks on the
outer edge, and the
secondary grid angle
breaklines are
rotated relative to
those in the corner
brackets.

5

6

8 7 6

2

1

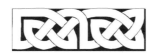

fig. 113a: Breakline plan for 3 x 2 repeat border

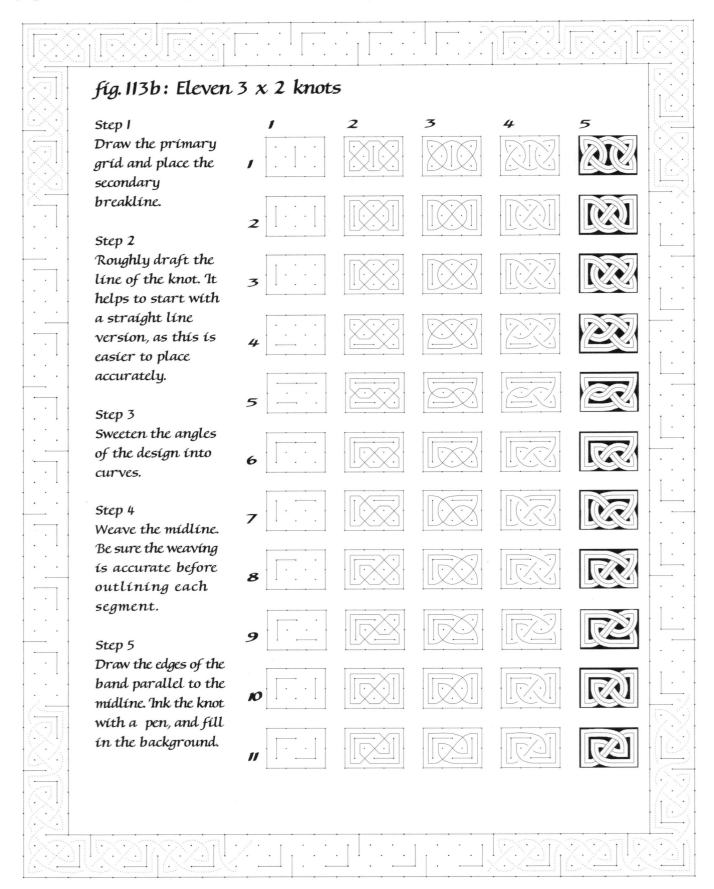

fig. 113b: Eleven 3 x 2 knots

Step 1
Draw the primary grid and place the secondary breakline.

Step 2
Roughly draft the line of the knot. It helps to start with a straight line version, as this is easier to place accurately.

Step 3
Sweeten the angles of the design into curves.

Step 4
Weave the midline. Be sure the weaving is accurate before outlining each segment.

Step 5
Draw the edges of the band parallel to the midline. Ink the knot with a pen, and fill in the background.

fig. 114a: Border, 3 x 2 repeat

fig. 114b: 3 x 2 knot and repeat

This border is based on the plan shown in fig. 113a.
The mitre plan is fig. 64, mitre 2, right.

½ 1 2 ½

a-b is 30 spaces
a-c is 36 spaces

1 2 3

Mitre 2

1 In order to repeat a knot unit, we need to count the
half spaces at either end, as well as the whole spaces.
This stand-alone unit is 2½ spaces on the primary
grid, plus the bar on the left side, which takes half a
space.

½ 1 2 3 1 2 3 1 2½

1 2 3 1 2 3 1 2 3

2 The repeating unit is three spaces on the secondary grid.
You might expect three units to fit nine spaces, as here.
However, the left-hand end unit is only 2½ spaces, as this
pattern requires a half space at the right-hand end, for
a vertical bar. To create a border of three, identical-looking
units, allow three spaces for each, and add half a space
for a vertical bar at each end, or ten spaces in all.

3

4 This is a 10 x 2 layout.

5

fig. 115: Modular frame plan

Based on the plan for the previous figure, this frame was extracted by dropping some of the repeating units at regular intervals, leaving four modules: two brackets, each repeating at opposite corners, and two intervening blocks, varying in length, with two-unit strips on the longer sides and four-unit strips on the top and the bottom.

The repeat is three spaces across and two spaces down. The unit used here is number eight from the selection in *fig. 113b*. Other units from that selection could be used in this layout. Also, some of the variations may be rotated, and flipped alternately. Or two different units might be alternated. Remember that the asymmetrical units may be rotated, and when these rotations are combined in pairs, other patterns will be produced, sometimes with unexpected results. Finally, although I have used separating breaks between the repeating units in this case, these primary grid breaks may also be omitted entirely, with interesting results.

The divisions between the units are marked with primary grid breaklines. These separators are placed on the inner edge here, but they could also be placed on the outer edge, or alternated from one side to the other. The form of the knot in the single unit is determined by the angle breaklines on the secondary grid. The appearance of the knot changes with the addition of the primary grid break, and by placing the separator on the outside instead of the inside edge, the form of the resulting knot is further changed. Given all these variables, you can see that a single layout such as the plan on this page may be reused to produce a wide variety of modular frames other than the one illustrated here and on the next page.

In the plan here, you can see the dot grid and breaklines, as well as the skeleton midline of the knot shown in dotted lines. I first drew the course of the path in straight line segments, with angles instead of curves, then the angles were smoothed, to make curved lines.

fig. 116: Modular frame

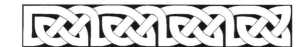

Mitre plan 2 underlies the plan for this border, as shown, right. On a quarter inch grid, this will fit a standard 8½ x 11 inch, or standard letter-size layout.

Mitre 2
a–b is 30 spaces
a–c is 36 spaces

The knotwork on the 12 x 2 panel, in the middle of the top and bottom sides, is different from that of the three panels on the left and on the right sides. What makes the difference here? The primary grid break separating the individual repeating units is placed on the inner edge throughout the frame. However, compare the angle breaks on the secondary grid.

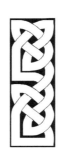

Along the left-hand and right-hand sides, the corner of the angled breakline lies closer to the inner than the outer edge of the frame. On the top and bottom, the corner of the angle is nearer to the outer edge. This variation in the orientation of the secondary breaklines changes the knotwork.

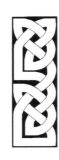

Modular frames have several advantages over continuous frames, such as the frame in *fig. 114a*. They are easier to adapt to slightly different layouts: the modular frame here could be applied to a slightly different page proportion, such as an A4 rather than the letter size for which it was designed. But, while that might be convenient, it is better to design the full frame first, then extract the corners and intervening strips from that, because this gives you a greater number of useful patterns.

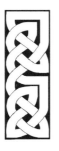

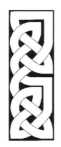

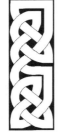

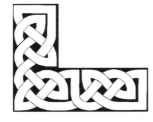

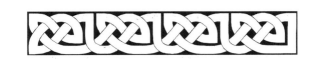

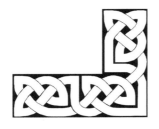

fig. 117: Border breakline plan

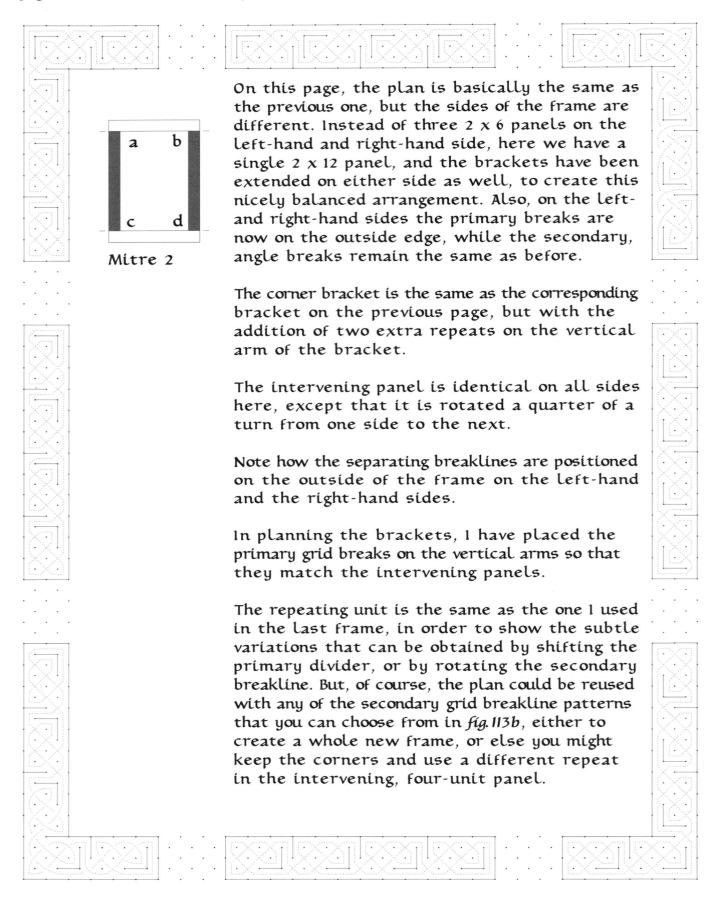

Mitre 2

On this page, the plan is basically the same as the previous one, but the sides of the frame are different. Instead of three 2 x 6 panels on the left-hand and right-hand side, here we have a single 2 x 12 panel, and the brackets have been extended on either side as well, to create this nicely balanced arrangement. Also, on the left- and right-hand sides the primary breaks are now on the outside edge, while the secondary, angle breaks remain the same as before.

The corner bracket is the same as the corresponding bracket on the previous page, but with the addition of two extra repeats on the vertical arm of the bracket.

The intervening panel is identical on all sides here, except that it is rotated a quarter of a turn from one side to the next.

Note how the separating breaklines are positioned on the outside of the frame on the left-hand and the right-hand sides.

In planning the brackets, I have placed the primary grid breaks on the vertical arms so that they match the intervening panels.

The repeating unit is the same as the one I used in the last frame, in order to show the subtle variations that can be obtained by shifting the primary divider, or by rotating the secondary breakline. But, of course, the plan could be reused with any of the secondary grid breakline patterns that you can choose from in fig. 113b, either to create a whole new frame, or else you might keep the corners and use a different repeat in the intervening, four-unit panel.

fig. 118a: Modular frame

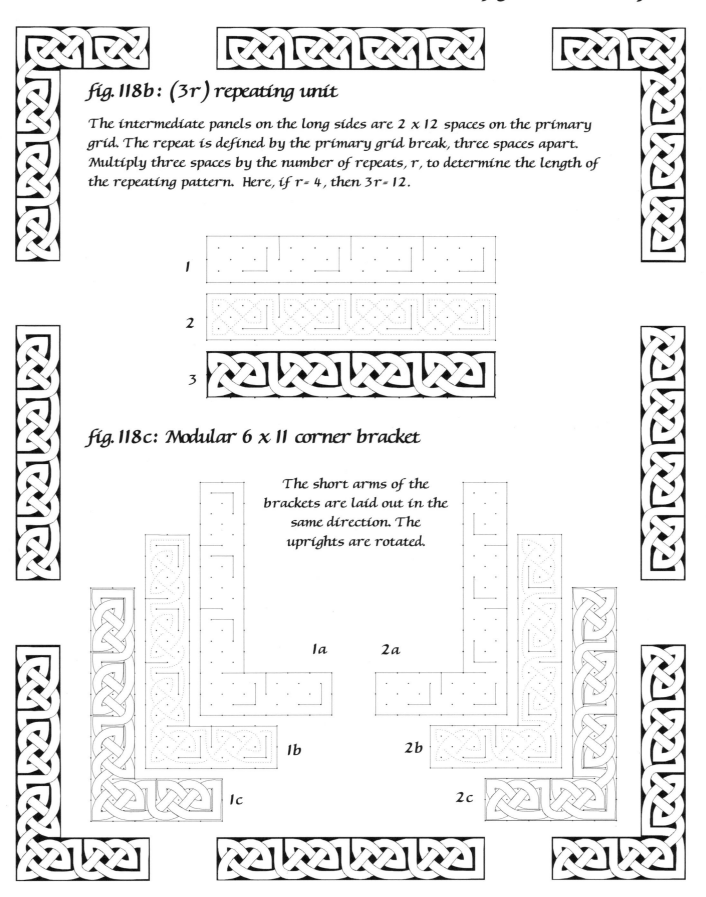

fig. 118b: (3r) repeating unit

The intermediate panels on the long sides are 2 x 12 spaces on the primary grid. The repeat is defined by the primary grid break, three spaces apart. Multiply three spaces by the number of repeats, r, to determine the length of the repeating pattern. Here, if r= 4, then 3r= 12.

fig. 118c: Modular 6 x 11 corner bracket

The short arms of the brackets are laid out in the same direction. The uprights are rotated.

fig. 119a: Border breakline plan

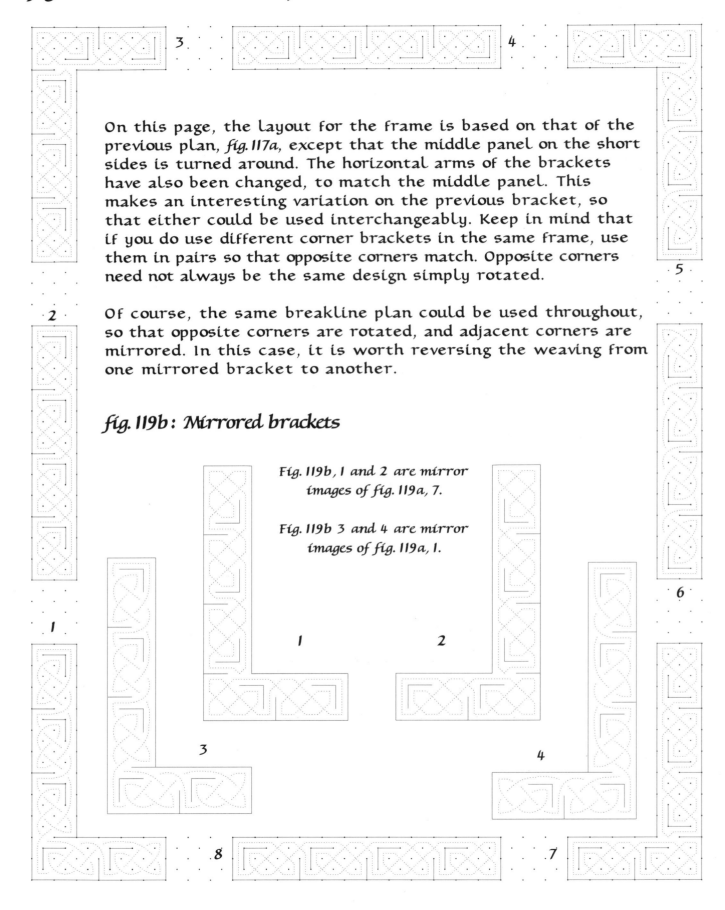

On this page, the layout for the frame is based on that of the previous plan, *fig. 117a*, except that the middle panel on the short sides is turned around. The horizontal arms of the brackets have also been changed, to match the middle panel. This makes an interesting variation on the previous bracket, so that either could be used interchangeably. Keep in mind that if you do use different corner brackets in the same frame, use them in pairs so that opposite corners match. Opposite corners need not always be the same design simply rotated.

Of course, the same breakline plan could be used throughout, so that opposite corners are rotated, and adjacent corners are mirrored. In this case, it is worth reversing the weaving from one mirrored bracket to another.

fig. 119b: Mirrored brackets

Fig. 119b, 1 and 2 are mirror images of fig. 119a, 7.

Fig. 119b 3 and 4 are mirror images of fig. 119a, 1.

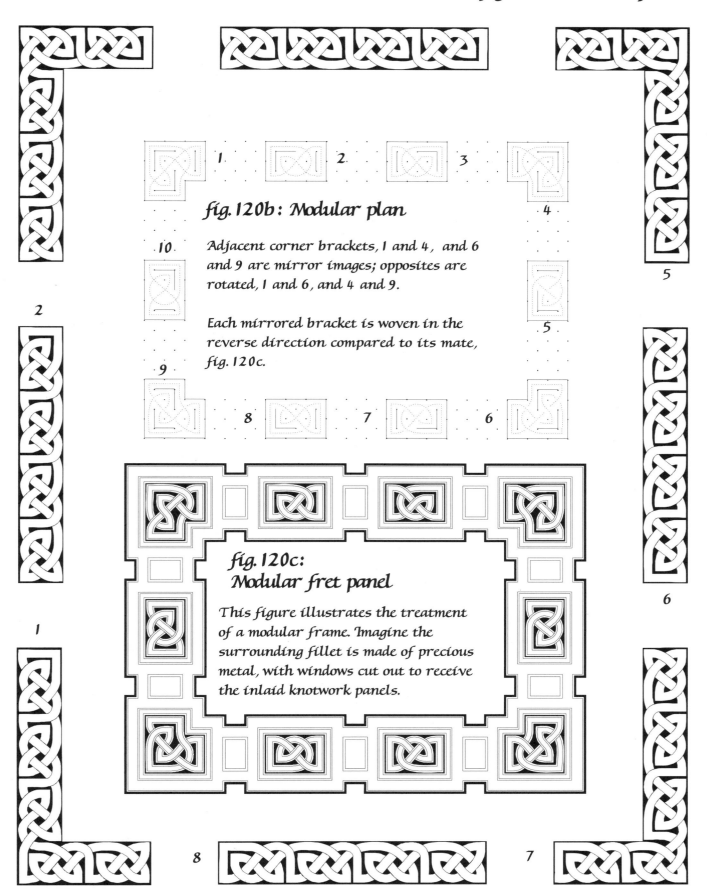

fig. 120a: Modular frame

fig. 120b: Modular plan

Adjacent corner brackets, 1 and 4, and 6 and 9 are mirror images; opposites are rotated, 1 and 6, and 4 and 9.

Each mirrored bracket is woven in the reverse direction compared to its mate, fig. 120c.

fig. 120c: Modular fret panel

This figure illustrates the treatment of a modular frame. Imagine the surrounding fillet is made of precious metal, with windows cut out to receive the inlaid knotwork panels.

EXERCISES

Mitre 3

1 Lay out a border two cells wide, with a primary grid cell of either a quarter inch or five mm, to fit a rectangle thirty spaces wide and forty spaces high.

2 Draw a solid line around the inside of the border, with a dip pen and Chinese ink, and another ink line around the inside edge of the frame.

3 Mark the dots for the primary grid in ink, so that the dots are equal or smaller than the thickness of your pen line.

4 Place the dots for the secondary grid in the middle of each primary grid cell.

5 Place primary grid breaklines on the inner edge of the frame at the corners, according to mitre variation 3.

6 Divide the twenty-six primary cells of the short sides into groups of three spaces, using secondary grid breaklines, starting with the first space next to the corner.

7 Divide the forty cells of the longer sides into groups of three, using secondary grid breaklines, starting with the first space next to the outer edge at the top or bottom of the frame.

8 Pencil in the straight-line skeleton of the path.

9 Go over the skeleton, smoothing all angles into curves, except for right-angled bends.

10 Weave the curved midline with a pencil. Check that the weaving is correct, and make any changes that need to be made.

11 Outline either side of the midline, to make a regular, woven triline knotwork border, all in pencil.

12 Draw over the lines of the triline knotwork in brown ink, with a dip pen and Chinese ink.

13 Fill in the background with brown ink using a finely pointed brush.

14 Outline the background cells with a fine nib and Chinese ink.

Unit 17: Fifteen 3 x 2 knot repeats

fig. 121a: Plan for (3r + 1) repeat

Fig. 121, below, is a border strip in which three repeating units are laid out with space for a bar at each end.

The unit is three spaces across, on the secondary grid. The bar occupies a half space. Therefore the space required for the whole is ten spaces across by two spaces down.

To apply such a repeat to a border strip, you calculate how many spaces you will need.

First, let the number of repeats required be called r.

Add half a space for the bar at the beginning, and another for the bar at the end, ½ + ½ = 1.

Then the number of spaces for the length of the desired pattern will be the width of the repeat - 3 - multiplied by the number of repeats required - 3 - plus one space.

fig. 121 b: Knotwork strip based on (3r+1) repeat

(3r+1) = x, where x is the number of spaces required to lay out the border with three repeats.

fig. 122a: Border plan

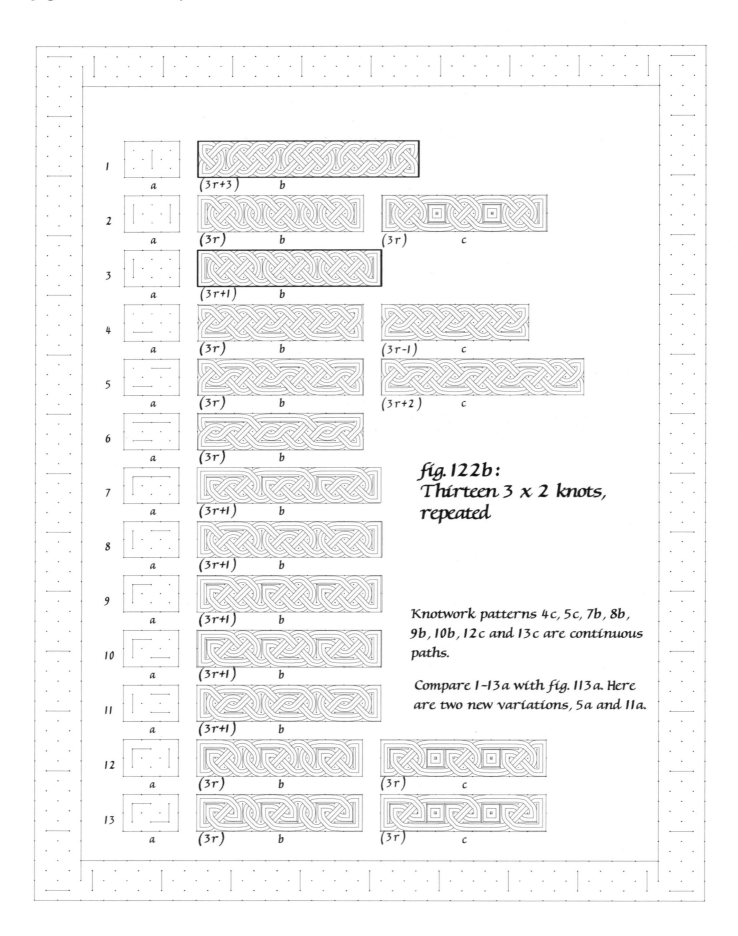

1 a (3r+3) b

2 a (3r) b (3r) c

3 a (3r+1) b

4 a (3r) b (3r-1) c

5 a (3r) b (3r+2) c

6 a (3r) b

7 a (3r+1) b

8 a (3r+1) b

9 a (3r+1) b

10 a (3r+1) b

11 a (3r+1) b

12 a (3r) b (3r) c

13 a (3r) b (3r) c

fig. 122b:
Thirteen 3 x 2 knots, repeated

Knotwork patterns 4c, 5c, 7b, 8b, 9b, 10b, 12c and 13c are continuous paths.

Compare 1–13a with fig. 113a. Here are two new variations, 5a and 11a.

fig. 123a: Border, 3 x 2 repeat

This border is based on the plan shown in fig. 122a.

The mitre plan is mitre 3, right.

On a quarter-inch grid, this border will fit an A4-sized page.

a–b is 25 spaces
a–c is 43 spaces

fig. 123b: Corner modules

1 Corner a: breaklines and skeleton knot.
2 Skeleton converted to curved midline.
3 Curved midline woven.
4 Corner b: midline thickened to form inner band, filled black.
5 Corner a: band woven and contoured, with contour defined by edges of broad midline.

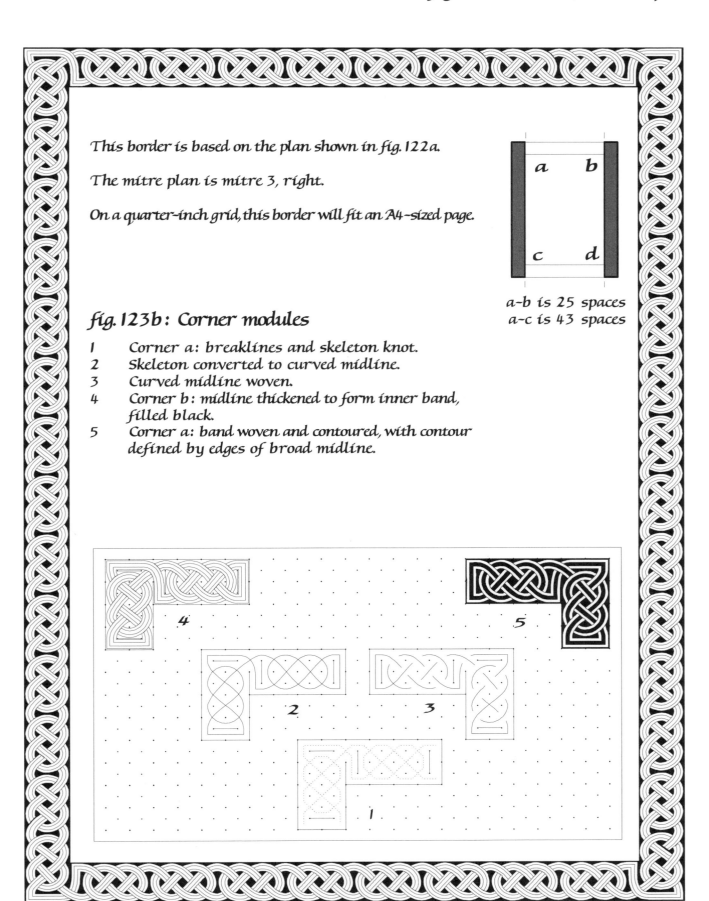

fig. 124a: Border breakline plan, (3r + 1) repeat

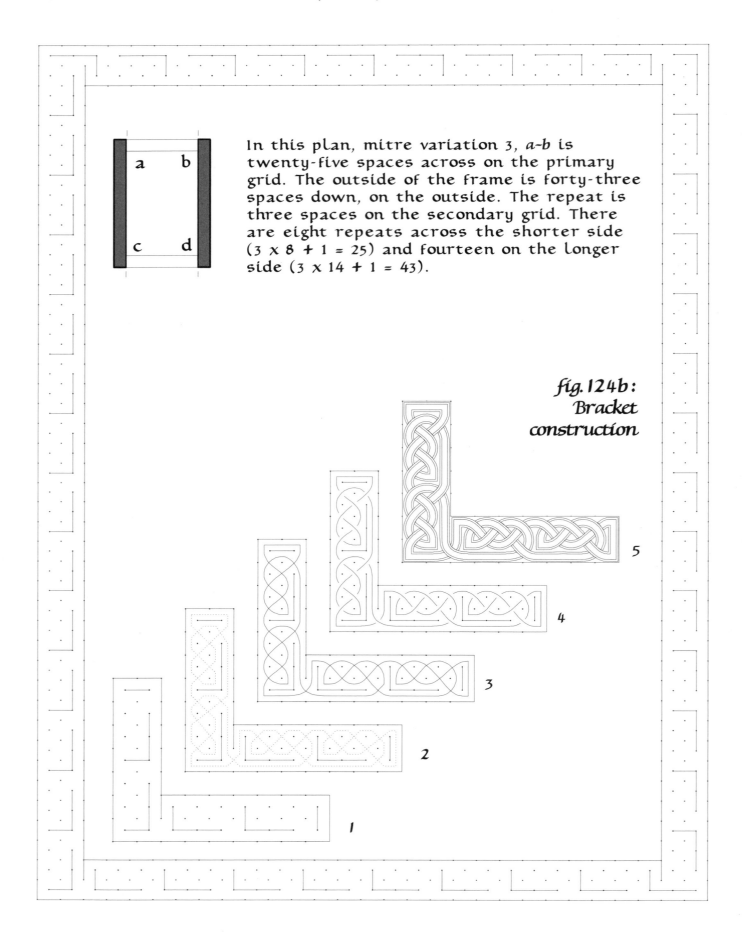

In this plan, mitre variation 3, *a-b* is twenty-five spaces across on the primary grid. The outside of the frame is forty-three spaces down, on the outside. The repeat is three spaces on the secondary grid. There are eight repeats across the shorter side (3 × 8 + 1 = 25) and fourteen on the longer side (3 × 14 + 1 = 43).

fig. 124b: Bracket construction

5

4

3

2

1

The borders in this unit are designed to fit an A4 page, rather than a standard letter size. The letter size border is 30 x 40 on a quarter-inch square grid, while the A4 border is 29 x 43, to the nearest quarter inch.

I have adapted the border to fit the proportion of the pages in this book, by distorting the grid. However, if you intend to apply this border, you should draft it on a quarter-inch grid, and then you will be able to reproduce the design to the intended proportion.

fig. 125b:
Bracket
construction

fig. 126a: Modular frame plan

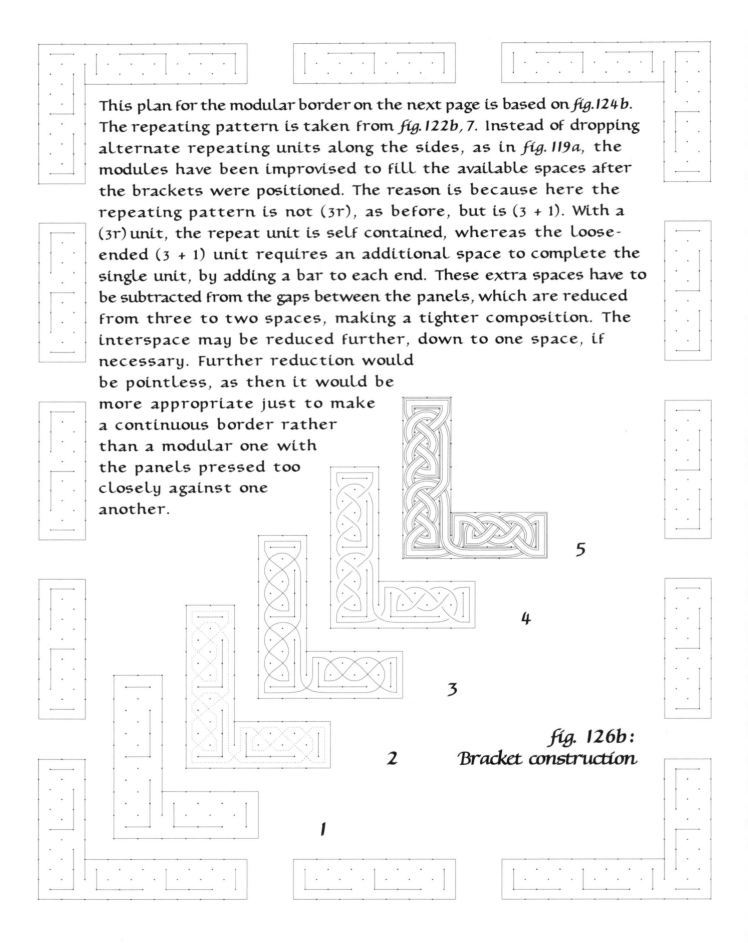

This plan for the modular border on the next page is based on *fig. 124 b*. The repeating pattern is taken from *fig. 122b, 7*. Instead of dropping alternate repeating units along the sides, as in *fig. 119a*, the modules have been improvised to fill the available spaces after the brackets were positioned. The reason is because here the repeating pattern is not (3r), as before, but is (3 + 1). With a (3r) unit, the repeat unit is self contained, whereas the loose-ended (3 + 1) unit requires an additional space to complete the single unit, by adding a bar to each end. These extra spaces have to be subtracted from the gaps between the panels, which are reduced from three to two spaces, making a tighter composition. The interspace may be reduced further, down to one space, if necessary. Further reduction would be pointless, as then it would be more appropriate just to make a continuous border rather than a modular one with the panels pressed too closely against one another.

5

4

3

fig. 126b: Bracket construction

2

1

fig. 127a: Modular frame

Compare the top and the bottom of the border on this page with the corresponding sides on the previous page. The repeating knots flow in the same direction. Now compare the knotwork on the long sides. In this border, the three intervening panels have been rotated. Because weaving does not reverse with a simple rotation, the effect is that the knots look different, although they are the same. The rotation could be taken one step further, especially with an arrangement such as this where the middle panel in the longer side might well be rotated in relation to the panels on either side of it, which would make an alternating, flipped design. In that case, the middle panels on the top and bottom should also be flipped, to be consistent.

These brackets are a further development of those in fig. 125b. Where those were made of two repeating units down and two across, these are two down and one unit across.

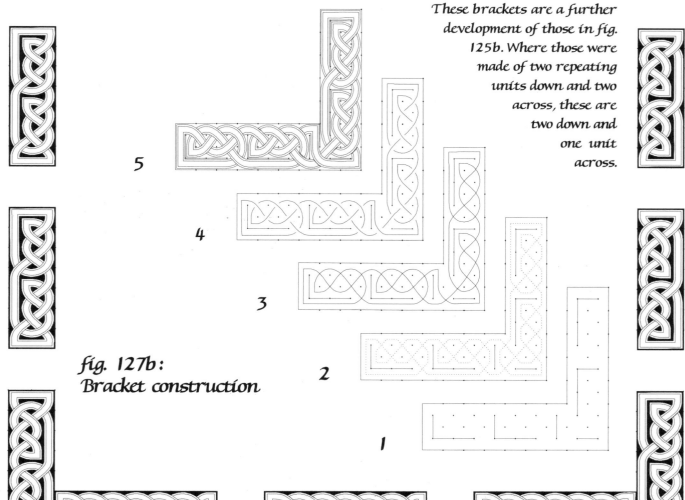

5

4

3

2

1

fig. 127b:
Bracket construction

fig. 128a: Modular breakline plan

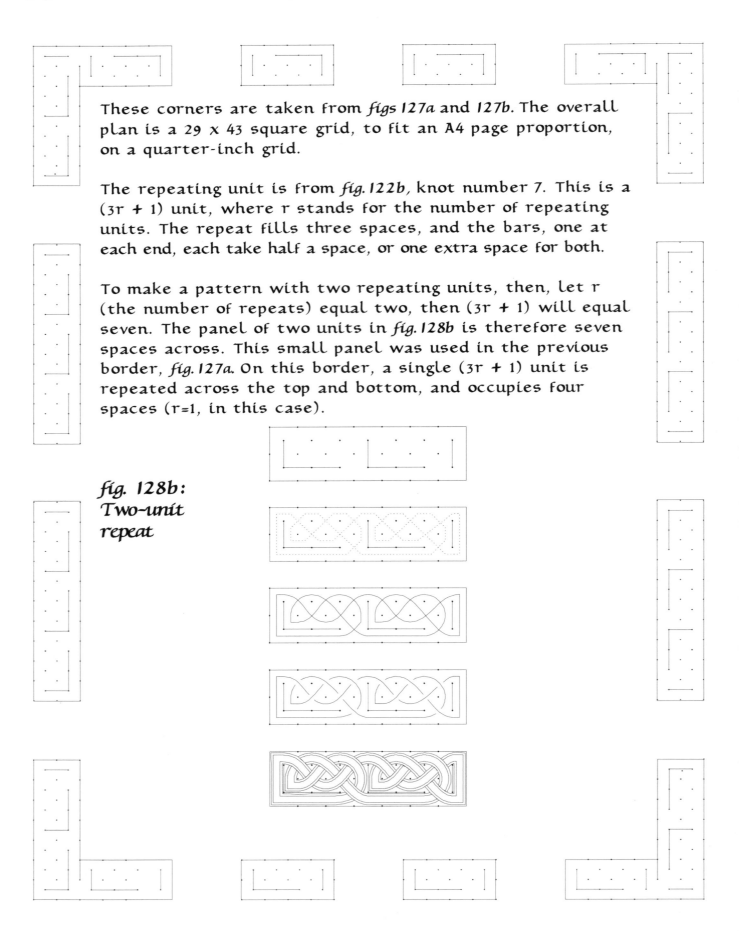

These corners are taken from *figs 127a* and *127b*. The overall plan is a 29 x 43 square grid, to fit an A4 page proportion, on a quarter-inch grid.

The repeating unit is from *fig. 122b*, knot number 7. This is a $(3r + 1)$ unit, where r stands for the number of repeating units. The repeat fills three spaces, and the bars, one at each end, each take half a space, or one extra space for both.

To make a pattern with two repeating units, then, let r (the number of repeats) equal two, then $(3r + 1)$ will equal seven. The panel of two units in *fig. 128b* is therefore seven spaces across. This small panel was used in the previous border, *fig. 127a*. On this border, a single $(3r + 1)$ unit is repeated across the top and bottom, and occupies four spaces (r=1, in this case).

fig. 128b:
Two-unit
repeat

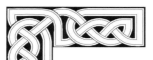

On the longer sides, the panel consists of three repeating units. The construction of this panel is shown below, *fig. 129b*. The calculation for the length of the panel is easy to work out using the formula, (3r + 1), as follows.

The whole pattern is ten spaces long, where the length is (3r + 1), and the number of repeats is three: r=3, therefore (3r + 1) = 10 spaces.

The length of the repeating unit, in this case, is measured on the secondary grid, from the shorter arm of one angled breakline to the next. The overall length is measured in terms of spaces on the primary square grid. There are three spaces between each part of the border. Regular spacing is very important in this sort of border.

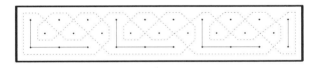

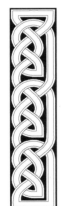

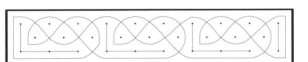

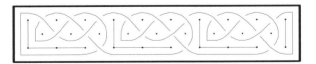

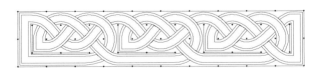

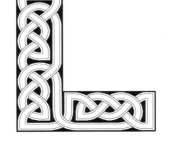
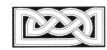
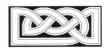
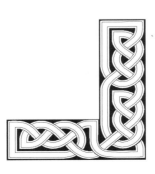

EXERCISES

1 Lay out a border two square cells wide, with a primary grid cell of a quarter-inch or 5mm, to fit a rectangle twenty-nine cells wide and forty-three cells high (A4 page proportion).

2 Draw a solid line around the inside of the border with a dip pen and Chinese ink, and another ink line around the inside edge of the frame.

3 Mark the dots for the primary grid in ink, and place the dots for the secondary grid in the middle of each primary grid cell, so that the dots are smaller than the line surrounding the border.

4 Place primary grid breaklines on the inner edge of the frame at the corners, according to mitre variation 3.

5 Divide the secondary grid cells into groups of three spaces, allowing room for bars at the end of each side of the strips on all four sides.

6 Modify the breakline for the repeating unit, using a $(3r+1)$ breakline arrangement from fig. 122b.

7 Pencil the straight-line skeleton of the path. Smooth all angles into curves, except for right-angled bends.

8 Weave the curved midline with a pencil. Check that the weaving is correct, and make any changes that need to be made.

9 Outline either side of the midline, to make a regular, woven triline knotwork border, all in pencil.

10 Convert the middle line into a bar by outlining it once more. The middle bar should be just slightly narrower than the whole band.

11 Draw over the lines of the barred band in brown ink, with a super-fine nib and Chinese ink. Allow the ink to dry, then erase the central line with a plastic eraser.

12 Fill in the background with black Chinese ink using a fine-point drawing nib.

In *fig. 130a* the continuous border is based on a simple knot pattern consisting of a circle crossed by diagonals, or a ring knot.

In previous examples, we have tried to avoid rings, so why use them here? This is the exception to the rule of avoiding rings. The ring - as a circle - arises naturally in a four-cord braid (that is, any border two spaces deep and more than two spaces wide), where the breaklines in the secondary grid are placed two spaces apart. This border design exploits the ring knot to the full.

As you can tell from *fig. 132b*, this pattern may be applied as a stand-alone module, a single unit being three spaces wide, where the formula for the number of spaces required for a given number of repeats may be written as (2r + 1). A double unit will need five spaces, and three units will need seven spaces.

The corner unit here has been given a twist, by introducing an angle break. This, as shown in *figs 133b* and *134b*, is the result of overlapping two identical units, which produce the angle.

From this continuous border, the plan of which is on the next page, we can extract a modular frame quite easily, by rotating the corner bracket and inserting double and triple repeats along the sides, *figs 133a* and *134a*.

fig. 130b:
Ring-knot bracket

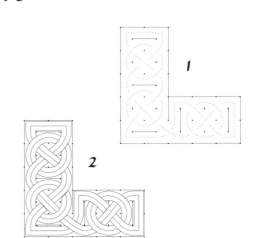

Two knots, fig. 132b (b and c) combine to make this ring-knot bracket, which is an alternative to the spiral-knot bracket which I have used here, the construction of which is shown overleaf, fig. 131b.

fig. 131a: Plan

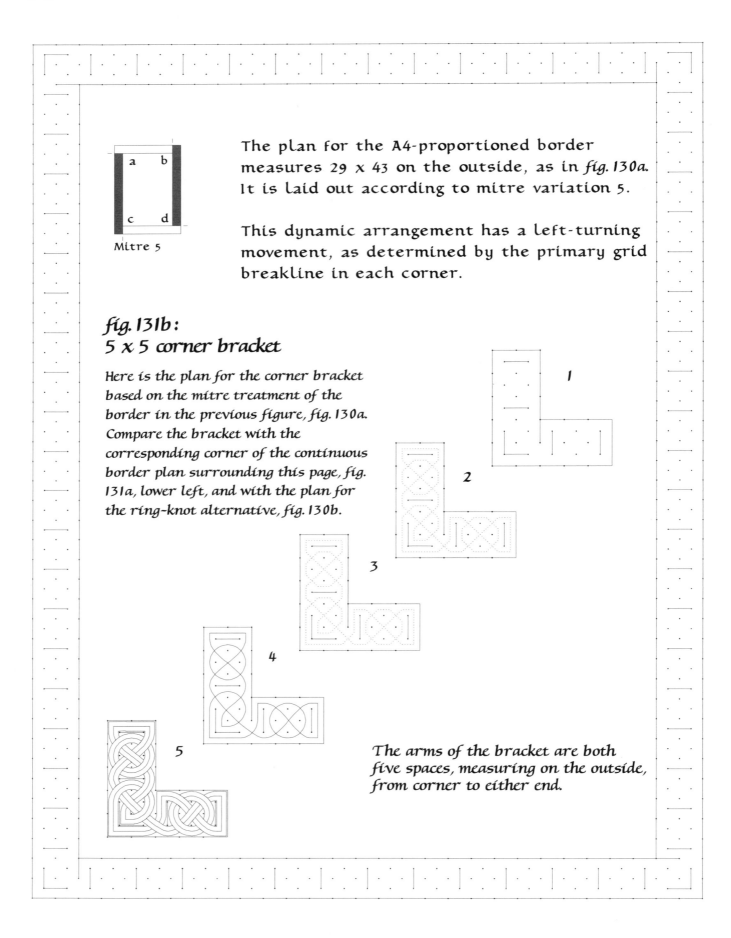

The plan for the A4-proportioned border measures 29 x 43 on the outside, as in *fig. 130a.* It is laid out according to mitre variation 5.

This dynamic arrangement has a left-turning movement, as determined by the primary grid breakline in each corner.

Mitre 5

a b

c d

fig. 131b:
5 x 5 corner bracket

Here is the plan for the corner bracket based on the mitre treatment of the border in the previous figure, fig. 130a. Compare the bracket with the corresponding corner of the continuous border plan surrounding this page, fig. 131a, lower left, and with the plan for the ring-knot alternative, fig. 130b.

1

2

3

4

5

The arms of the bracket are both five spaces, measuring on the outside, from corner to either end.

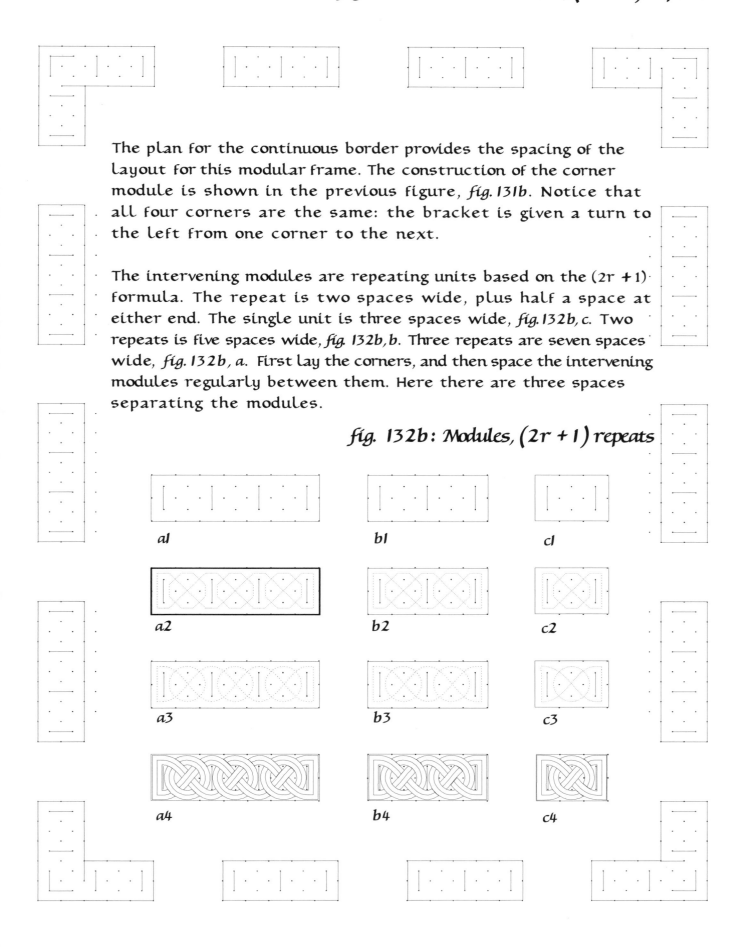

The plan for the continuous border provides the spacing of the layout for this modular frame. The construction of the corner module is shown in the previous figure, *fig. 131b*. Notice that all four corners are the same: the bracket is given a turn to the left from one corner to the next.

The intervening modules are repeating units based on the (2r + 1) formula. The repeat is two spaces wide, plus half a space at either end. The single unit is three spaces wide, *fig. 132b, c*. Two repeats is five spaces wide, *fig. 132b, b*. Three repeats are seven spaces wide, *fig. 132b, a*. First lay the corners, and then space the intervening modules regularly between them. Here there are three spaces separating the modules.

fig. 132b: Modules, (2r + 1) repeats

al

bl

cl

a2

b2

c2

a3

b3

c3

a4

b4

c4

fig. 133a: Modular frame, (2r + 1) repeat

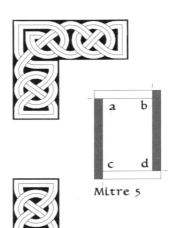

Mitre 5

In this plan, mitre variation 5, a-b is twenty-five spaces across on the primary grid. The outside of the frame is forty-three spaces down, on the outside. The repeat is three spaces on the secondary grid. There are eight repeats across the shorter side, (3 x 8 + 1 = 25) and fourteen on the longer side (3 x 14 + 1 = 43).

The panels in the middle of each side here are repeated on the next page, but the corner brackets are different. By keeping some elements the same, while changing some others, the result is a pair of borders that are subtly varied, while keeping a close similarity to each other - useful if you require a matching pair of decorative frames.

fig. 133b: Corner module construction

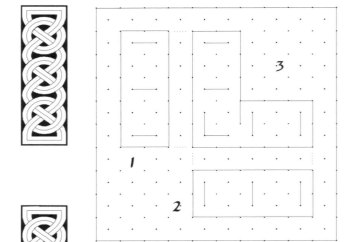

This bracket module is a combination of two units, each with a secondary grid break pattern, as in fig. 132b, b1. The bracket is mitred with a primary grid breakline, dropped from the internal concave corner. The units are superimposed on each other. One secondary break from each combines to make an angle breakline on the secondary grid.

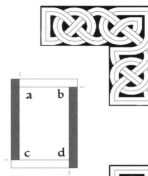

This modular frame matches that on the previous page, except that the direction of the mitre is reversed. The corner is mitred according to mitre variation 4, as illustrated in the placement of the primary grid breakline in *fig. 134b, 3.*

Mitre 4

This bracket is woven in reverse to the preceding one, as you can see by comparing it with the bottom right-hand corner on the previous page. Although the breaklines are mirror opposites, the woven knots are not simply mirrored. The corner module is re-woven on this page, to maintain the direction of the weave throughout.

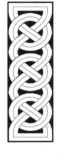

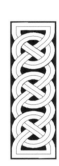

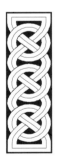

fig. 134b: Corner module variation

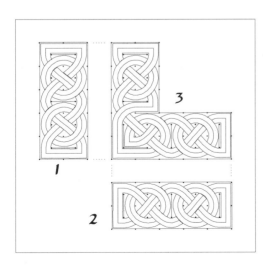

The bracket module used in the next figure, *fig. 135a,* is a combination of two units, each with a secondary grid break pattern, as shown here, *fig. 134b, 1 and 2,* left. The corner is mitred with a primary grid breakline, running from the inside corner to the left. Compare with *fig. 133b,* which shows the plan of the lower left-hand corner on this page.

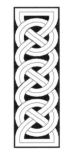

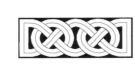

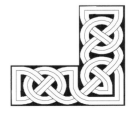

fig. 135a: Plan

This plan is based on the same primary grid layout as the previous ones.

Instead of rotating the same corner bracket four times, this border uses two corner brackets, *figs 133b* and *134b* (rotated). These brackets, lower left and right on this page, are mirror images. However, in applying them, the weaving is not mirrored, but reversed, so that the direction of the weaving is maintained, as you can see by comparing the corresponding corners of the finished border on the next page, *fig. 136a.*

The corners are mitred according to variation 3, above left - opposite corners are the same.

fig. 135b: (2r + 1) variations

a1 b1

a2 b2

a3 b3

a4 b4

a5 b5

In the previous frames, the intervening modules were based on a (2r + 1) repeating unit. Here the units are different – they are angle breaks instead of straight-line breaks, producing spiral knots instead of rings. The construction for the two- and three-repeat modules is shown here.

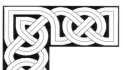

fig. 136a: Modular frame

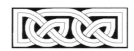

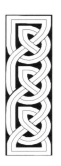

Here we see the variations on the (2r + 1) repeating unit, applied as intervening modules between the corners. The constructions for these are laid out in *fig. 135b*.

A further development of this modular frame may be made by converting the rings in the corner bracket to spirals. Although these bracket designs are acceptable on their own, the justification for the rings is hard to make once all the intervening blocks have been changed to spiral knots instead. When the intervening modules were also ring knots, the rings were appropriate in the corner brackets, *fig. 130a*. So, in keeping with the spiral knot patterns which dominate this design, here is the construction of a spiral-knot bracket to match, *fig. 136b*.

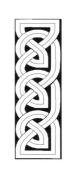

fig. 136b:
Spiral-knot bracket

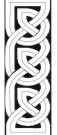

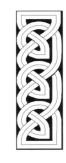

fig. 137: Plan

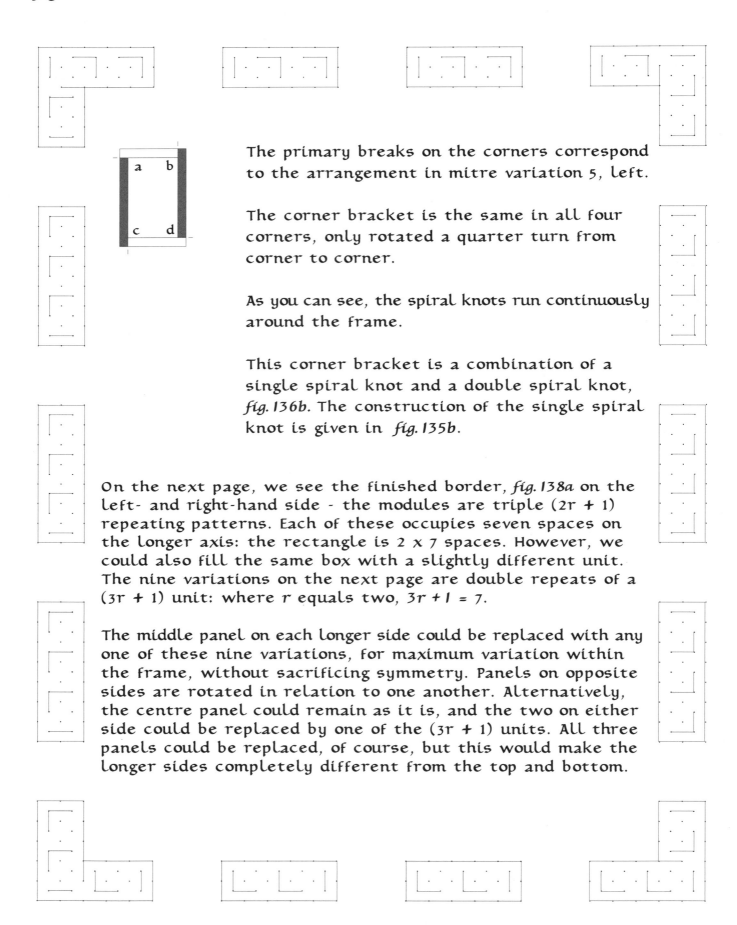

The primary breaks on the corners correspond to the arrangement in mitre variation 5, left.

The corner bracket is the same in all four corners, only rotated a quarter turn from corner to corner.

As you can see, the spiral knots run continuously around the frame.

This corner bracket is a combination of a single spiral knot and a double spiral knot, *fig. 136b*. The construction of the single spiral knot is given in *fig. 135b*.

On the next page, we see the finished border, *fig. 138a* on the left- and right-hand side - the modules are triple (2r + 1) repeating patterns. Each of these occupies seven spaces on the longer axis: the rectangle is 2 x 7 spaces. However, we could also fill the same box with a slightly different unit. The nine variations on the next page are double repeats of a (3r + 1) unit: where r equals two, 3r + 1 = 7.

The middle panel on each longer side could be replaced with any one of these nine variations, for maximum variation within the frame, without sacrificing symmetry. Panels on opposite sides are rotated in relation to one another. Alternatively, the centre panel could remain as it is, and the two on either side could be replaced by one of the (3r + 1) units. All three panels could be replaced, of course, but this would make the longer sides completely different from the top and bottom.

fig. 138a: Modular border

fig. 138b: (3r + 1) double units

1a 1b 1c

2a 2b 2c

3a 3b 3c

4a 4b 4c

5a 5b 5c

6a 6b 6c

7a 7b 7c

8a 8b 8c

9a 9b 9c

1 Pencil a rectangular border two square cells wide, twenty-nine cells wide and forty-three cells high (A4 page proportion).

2 Ink a solid line to define a corner bracket extending five spaces on the outside of the grid on two adjacent sides. Repeat the corner bracket in all four corners.

EXERCISES

3 With ink, draw the bounding lines of the 5 x 2 boxes on the top and bottom sides, leaving three spaces between each box, and between the box and the edge of the corner bracket, as in fig. 132a.

4 Likewise, draw the 2 x 7 boxes up each of the longer sides, leaving three spaces between each module.

5 Inside each modular corner bracket and intermediate panel, place dots of ink for the primary and secondary grids.

6 Place primary grid breaklines on the inner corner of the bracket, according to mitre variation 5.

7 Divide the secondary grid cells into groups of two spaces, allowing room for bars at the end of each module.

8 Use the $(2r + 1)$ breakline arrangement from fig. 132b for the 5 x 2, and for the two 2 x 7s next to the brackets on each side.

9 Use the bracket plan from fig. 130b.

10 Use the $(3r + 1)$ for the middle panel on the longer sides, as in fig. 138b, 1.

11 Pencil the straight-line skeleton of the path. Smooth all angles into curves, except for right-angled bends.

12 Weave the curved midline with a pencil. Check that the weaving is correct, and make any changes that need to be made.

13 Outline either side of the midline, to make a regular, woven triline knotwork border, all in pencil.

14 Draw over the three-line band in brown ink, with a super-fine nib and Chinese ink. Allow the ink to dry.

15 Paint the background with black Chinese ink using a fine-point drawing nib.

The plan for this border is shown on the following two pages. The three-cord plait or triple braid is the simplest plait, after the basic two-cord twist. The twist is even numbered, and is laid out on a row of squares. Each square of the primary grid is occupied by two cords. Thus a four-cord pattern, such as we have been dealing with so far, is two spaces deep, each space allowing two cords. A three-cord braid is therefore 1½ spaces deep.

Although the triple braid looks quite simple, the fact that it uses a half space is why I prefer to introduce the even-numbered, four-cord patterns first. Once you are used to drawing the grid for the four-cord braid, it is easy to adapt the grid for a triple braid. Instead of connecting the inner edge of the frame on the primary grid, we connect the corners on the secondary grid points to reduce the depth of the grid by one half, to one and a half units deep instead of two. As the secondary dots are the mid-points of the squares, this means the dot grid for the triple braid is a row of squares on the primary grid on one edge, and a row of squares on the secondary grid on the other edge, fig. 139b.

fig. 139b: Three-cord spacing

2 spaces

4 cords

1½ spaces

3 cords

fig. 140a: Triple-braid border, dot grid

The plan for the A4-proportioned border measures 29 x 43 on the outside, and 26 x 40 on the inside.

The dotted line represents the inner boundary of a border two spaces deep. This is the number of spaces needed to lay out a four-cord braid. To lay out a three-cord braid, we need to reduce this measure by half a space, or one cord width. The distance between the two solid lines is 1½ spaces, or three cords wide.

It is easier to subtract than to add a row of dots. In order to set off the half space, it is convenient to lay out the border to the nearest whole number of spaces, larger than the required odd number.

If measuring from the outside, then rule the inner edge 1½ spaces in from the outer edge.

fig. 140b: Triple-braid square frame

fig. 141a: Triple-braid border, construction

Notice that instead of the corner bracket construction, I have given a complete mini border in *fig. 140b*. That is because the odd-numbered plaits cannot be used in stand-alone modules, because the braid can only be closed by joining pairs of cords, and so there is always a loose cord that cannot be joined, and loose ends are not allowed in Celtic knot patterns. For this reason, odd-numbered knots can only be applied in continuous borders, whether rectangular, or curved, such as a circular or oval border.

None the less, there are a surprising number of variations that can be obtained by the usual placement of breaklines, either on the primary or the secondary grid. As mentioned above, the grid may be read from either edge, but for the sake of clarity I shall refer to the outermost edge as defining the primary grid, and the inner edge as the secondary grid.

fig. 141b: Continuous three-cord knots

1

Without any breaklines, these grids produce three-cord braids. The knots are formed by breaklines on the upper edge, primary grid, or lower edge, secondary grid.

2a

2b

In these knots, the path is discontinuous where the width of the repeating unit is a multiple of 1½, for example, 3, 4½, 6, 7½, etc. For practical purposes, we only need to use the variations shown here.

3a

3b

1: *(2r) knot*

4a

2a, 2b: *(2½r) knot*

3a, 3b: *(3½r) knot*

4a, 4b: *(4r) knot*

4b

fig. 142a: Three-cord braid, (2r) repeat

Mitre 4

In this plan, based on *fig. 64b, mitre variation 4*, a-b is twenty-nine spaces across on the primary grid, on the outside. b-d is forty-three spaces down, on the outside. Obviously, a two-space repeat will not fit either of these odd numbers. However, if we allow three spaces at one end, the remainder will divide equally.

The repeat is two spaces on the primary grid. There are thirteen repeats across the top, from right to left, plus three spaces on the far left. There are twenty repeats up the right-hand side plus three spaces at the upper end.

fig. 142b: 2 x 2 corner construction

In the three-cord layout, a 2 x 2 corner requires a break in order to avoid the diagonal ring that would otherwise fall between the primary grid breaklines on the outer edge.

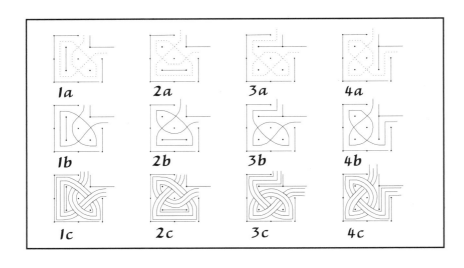

1a 2a 3a 4a

1b 2b 3b 4b

1c 2c 3c 4c

fig. 143a: Triple-braid border, (2r) repeat

The four 2 x 2 corner designs will work with a border with an even number on each side. But in an odd-numbered layout, such as this one, the choice is either to use an odd-numbered repeat in the middle of each side, or to use an odd-numbered unit in one corner.

If we were to use an odd-numbered unit in the middle of each side, the choice would be either a three-space unit, or a five-space unit. However, the three-space unit is not a valid option in a three-cord braid pattern, as it would contain a twisted loop, and this should be avoided. The five-space unit, on the other hand, would arguably spoil the appearance of the repeating pattern of the two-space units that we have chosen for the rest of the border. A subtler alternative is shown below, *fig. 143b*, which may be inserted at one end of each side, and rotated from corner to corner.

fig. 143b: 2 x 3 corner construction

The corner used on this page is two spaces on the horizontal and three on the vertical. The same knot is applied four times, and rotated a quarter turn in each corner. The remainder on each side is then an even number, and can be filled with the simple two-space repeat.

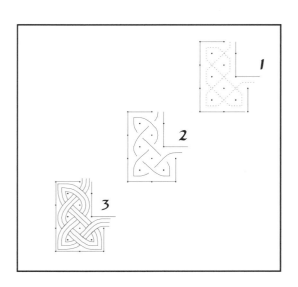

fig. 144a: Plan

The border plan on this page, and as finished on the next, is contained in a rectangle of 30 x 40 spaces (as you may recall, this proportion will fit a letter-sized page on a quarter-inch square grid, with a half-inch margin all round). Start by placing the 3 x 3 corners, leaving twenty-four spaces on the shorter sides and thirty-four spaces on the longer sides. The intervening spaces may conveniently be grouped in pairs by placing primary grid breaks on the outer edge.

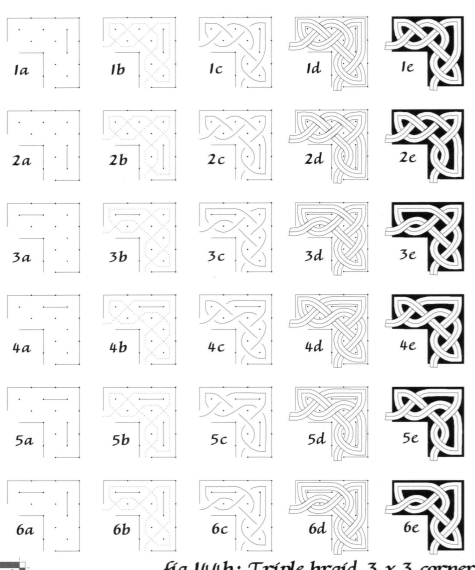

fig. 144b: Triple braid, 3 x 3 corners

These corners - extended equally on two sides - lend themselves to a layout based on mitre variation 1, fig. 64b.

Mitre 1

fig. 145a: Modular frame

The corners on this border are from the square frame, fig. 145b, 1b. The path is continuous in each of these corners, because of the continuous path repeat between corners. A continuous path is not at all the rule in Celtic knotwork, as is sometimes claimed. But, in the triple braid, discontinuity sticks out too much. In this case, the continuous path may be better.

fig. 145b: 3 x 3 corners, square frames

These frames are made by combining various corner pieces from fig. 144b.

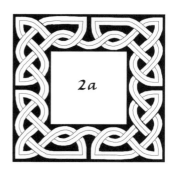

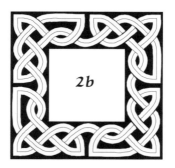

The three frames in the left-hand column are symmetrical on both axes, that is, adjacent corners mirror each other.

The three frames on the right hand are the result of rotating a single border a quarter turn from one corner to the next, which is symmetrical on the diagonal axes only.

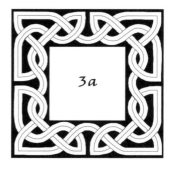

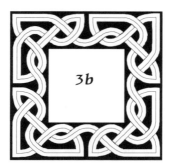

The rotating corner is dynamic, the mirrored corner is static, or more restful to the eye.

fig. 146a: Three-cord knotwork border plan

Mitre 1

The primary breaks between the corners correspond to the arrangement in mitre variation 1.

The corners are two continuous path 4 x 3 units, for each pair of adjacent corners.

The intervening knots on the top and bottom are each 3½ x 1½ spaces on the primary grid; the intervening units on the longer sides are 1½ x 4 spaces on the primary grid. The resulting knots will be continuous so long as their length is not a multiple of 1½.

fig. 146b: (3r + 1) double units

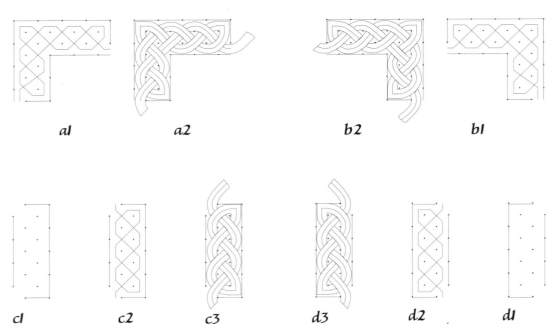

al a2 b2 bl

cl c2 c3 d3 d2 dl

In corners a and b the plans are mirror images, but the direction of the weaving in one corner is the same as in the other, as opposed to being reversed, as would be the case if the corner was simply reversed. On the left-hand and right-hand side, the unit is the same, just rotated 180°.

fig. 147a: Three-cord knotwork border

The repeating unit used on the top and bottom edges here is
a double unit, seven spaces wide, divided in two. Each of the
two parts is 3½ spaces wide. The two parts are mirror images
on the primary grid dot and breakline plan, but the direction
of the weaving is maintained from one half to the other.
This illustrates a basic principle of knot design. When using
two identical units in mirror symmetry, the direction of the
weaving must be maintained, or else the weaving will be
disrupted, causing a segment of the path to cross over-over
or under-under where the two units are joined. This mistake
most often results when part of a pattern is mirrored, and
the reversed copy is pasted down next to the original, without
altering the actual weaving. When building a symmetrical
pattern, it is important to lay out the plan first, and then
weave the knot all together, maintaining the direction of the
weaving throughout.

fig. 147b: Mirrored three-cord units

a The seven-space strip is divided equally.

b Each half reflects the other in this plan.

c The direction of the weaving is the same throughout
both halves of the strip.

d Here the same knot is simply mirrored from one half
to the other. Although it is perfectly symmetrical, in fact
the weaving is wrong. Since the direction of the weaving is
mirrored between one half and the other, the weaving changes
direction on the cross-over between the two halves. The
result is an under-under segment in the middle of the
lower edge. One solution is to lay out the plan first, then
weave the knot all at the same time, keeping the same
direction of weave throughout.

a

b

c

d

1 With a pencil, rule a 30 x 40 square grid, and draw a rectangle two spaces in from the outside edge. Ink a solid line around the inner edge, and ink an outer frame 1½ spaces all around it, to produce an outer frame measuring 29 x 39.

2 Ink the primary and secondary dot on top of the pencilled grid.

EXERCISES

3 Place the primary grid breaks to establish the corners, according to the layout described in fig. 146a.

4 Divide the intervening sections of the left-hand and right-hand sides into groups of four spaces, placing the primary grid breaks as in fig. 146a.

5 Divide the intervening twenty-one spaces of the top and bottom sides into three groups of seven spaces, placing the primary grid breaks on the outside edge.

6 Subdivide the seven-space sections of the top and bottom into groups of 3½ spaces, placing the primary grid breaks on the inner edge.

7 Pencil the straight-line skeleton of the path. Smooth all angles into curves, except for right-angled bends.

8 Weave the curved midline with a pencil. Check that the weaving is correct, and make any changes that need to be made.

9 Outline either side of the midline, to make a regular, woven triline knotwork border, all in pencil.

10 Draw over the three-line band in brown ink, with a super-fine nib and Chinese ink. Allow the ink to dry.

11 Paint the background with black Chinese ink using a fine-point drawing nib.

12 Rule a fine ink line surrounding the whole border, set half a space from the outside rectangle. Let this dry, and then rule a fine inked line around the inside, half a space inside the inner edge of the knot border.

Unit 20 : Five-cord borders

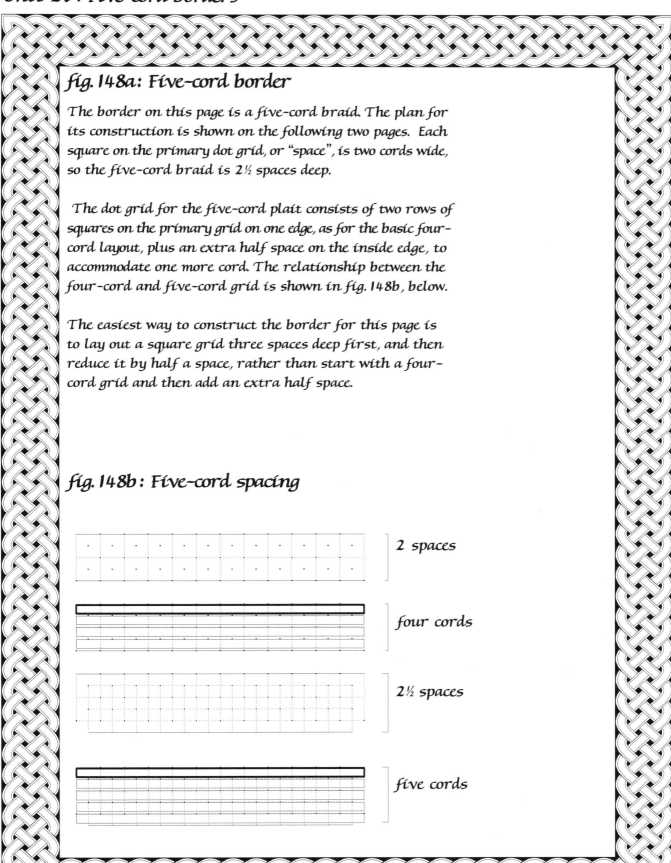

fig. 148a: Five-cord border

The border on this page is a five-cord braid. The plan for its construction is shown on the following two pages. Each square on the primary dot grid, or "space", is two cords wide, so the five-cord braid is 2½ spaces deep.

The dot grid for the five-cord plait consists of two rows of squares on the primary grid on one edge, as for the basic four-cord layout, plus an extra half space on the inside edge, to accommodate one more cord. The relationship between the four-cord and five-cord grid is shown in fig. 148b, below.

The easiest way to construct the border for this page is to lay out a square grid three spaces deep first, and then reduce it by half a space, rather than start with a four-cord grid and then add an extra half space.

fig. 148b: Five-cord spacing

2 spaces

four cords

2½ spaces

five cords

fig. 149a: Five-cord border, dot grid

The plan for the A4-proportioned border measures 29 x 43 on the outside, and 26 x 40 on the inside.

The solid lines define the edges of a border two spaces deep. This is the layout for a four-cord braid: remember, there are two cords per space.

The solid lines lie on the primary grid. The innermost dotted line is on the secondary grid. The inner dotted line adds half a space to the width, and this makes room for one more cord.

The width of the five-cord border plan is two spaces in from the outer edge on the primary grid, plus an extra half space, so that the inner edge falls on the secondary grid. The whole border layout is 2½ spaces deep from inside to outside.

fig. 149b: Five-cord braid, corner construction

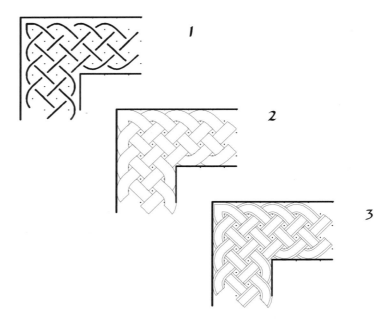

fig. 150b : Five-cord braid, construction

step 1

step 2

step 3

step 4

step 5

step 6

fig. 151a: Five-cord braid, (2r) repeat

Mitre 5

This plan follows the corner arrangement as illustrated in mitre variation 5, left. The proportion is A4 paper size, 29 x 43. Beginning from the top left, the upper edge is divided by primary breaks two spaces apart. These stop one space short, at the right-hand end. The secondary grid break is centred between these primary breaklines, and extends half a space into the right-hand corner. This completes the layout for the top edge. The bottom edge is similar, only rotated upside down, starting lower right. The longer sides follow the same pattern, beginning in the upper right-hand corner and ending 1½ spaces short of the lower edge, for the right-hand side. The same plan is rotated for the left side, starting from the bottom.

fig. 151b: 5 x 5 corner construction

Compare this corner treatment with the alternatives in fig. 154b, below.

In this border, the pattern repeats every two spaces, according to the plan in *fig. 151a.* You can count the spaces on either the primary grid, on the outer edge, or on the secondary grid (inner edge).

The corners of the border on this page are mitred according to the treatment in *fig. 151b.* Below are some suggested variations on the border treatment.

In each of the two variations here, above, there is an extra breakline, which leads the path of the knot directly on round the corner, instead of doubling back on itself.

fig. 152b: 5 x 5 corners

a1

b1

a2

b2

fig. 153a: Five-cord border plan

Mitre 4

The pattern fits a 29 x 43 grid (A4). These are odd numbers, so there is an extra space left at the end, which is worked into the corner.

The border plan on this page is finished on the next, and is adapted to an A4-page proportion, or 29 x 43 spaces. Start by placing the primary breaklines on the outer edge, from left to right along the top edge. Leave three spaces in the top right-hand corner. Do the same in reverse along the bottom, from right to left. On the sides, I have used a different pattern, from fig. 153b, 2a. The left-hand side begins at the bottom and ascends, the right-hand side begins at the top and descends, leaving three spaces at the end in each case.

fig. 153b: Five-cord, (2r) repeat

These two patterns are both based on the five-cord grid, 2½ spaces deep.

The repeat (r) is 2 spaces, in both.

1a

1b

The first has primary grid breaklines, one space long. The second has primary grid breaklines, two spaces long.

2a

2b

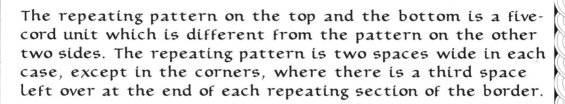

The repeating pattern on the top and the bottom is a five-cord unit which is different from the pattern on the other two sides. The repeating pattern is two spaces wide in each case, except in the corners, where there is a third space left over at the end of each repeating section of the border.

The repeating pattern is a (2r) pattern, where (r) equals the number of repeats, and the number of spaces required for each repeat is two. Although this particular border requires an extra space in the corner, the pattern repeats in multiples of two spaces. The extra space is allowed here because we are applying the even numbered repeat to an odd-numbered frame.

fig. 154b: Five-cord corners

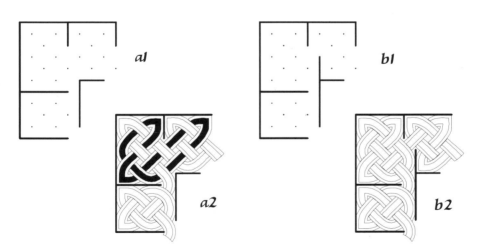

This border uses two patterns, one on the longer sides, another on the shorter. These two corner variations show two different methods of mitring the corner. The second, b2, above, uses a primary grid break according to the plan for mitre variation 4 (see inset, at the top of the previous page).

fig. 155a: Five-cord (3r) repeat border plan

Mitre 4

The primary breaks between the corners correspond to the arrangement in mitre variation 4.

The corners are two continuous path 4 x 3 units, for each pair of adjacent corners.

The intervening knots on the top and bottom are each 3 x 2½ spaces on the primary grid; the intervening units on the longer sides are 2½ x 3 spaces.

fig. 155b: Five-cord (3r) repeat

This is the knotwork unit that is applied to the longer sides of the border. The shorter sides are filled with variation 1, fig. 156b.

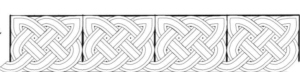

fig. 155c: Five-cord corner treatment

These corners are improvised to fill the remaining spaces after laying out the three-space repeating unit. The first corner is 2 x 3, the second corner is 3 x 4.

1a 1b 2a 2b

fig. 156a: Five-cord (3r) repeat border

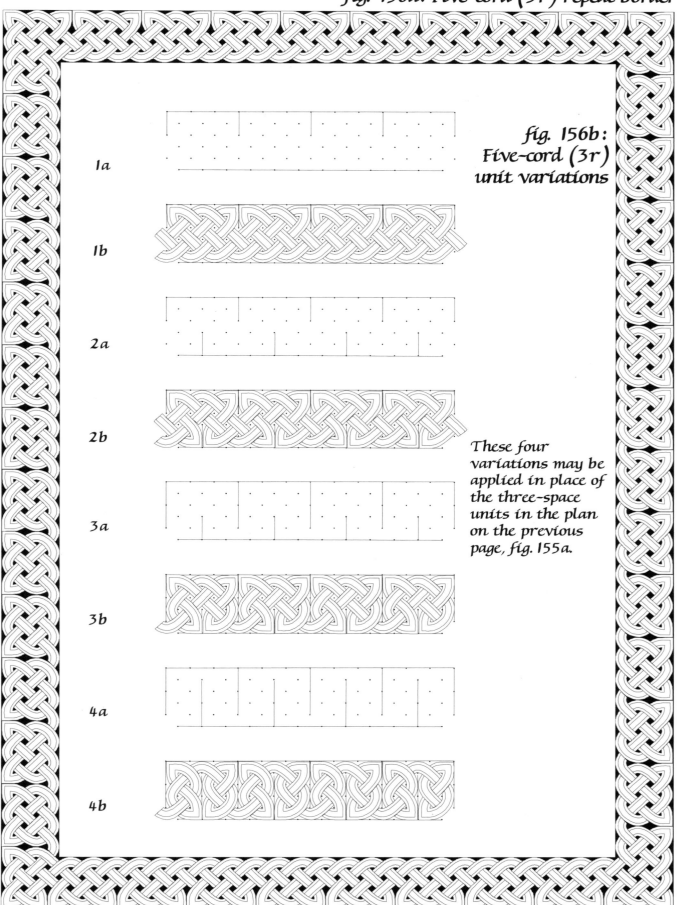

1a

1b

fig. 156b: Five-cord (3r) unit variations

2a

2b

3a

These four variations may be applied in place of the three-space units in the plan on the previous page, fig. 155a.

3b

4a

4b

EXERCISES

1 With a pencil, rule a 30 x 40 square grid, and draw a border measuring 2½ squares in from the outer edge.

2 Ink the primary and secondary dots on top of the pencilled grid.

3 Place the primary grid breaks according to the layout in fig. 155a, but select a variation of the (3r) repeating unit from fig. 156b.

4 Pencil the straight-line skeleton of the path. Smooth all angles into curves, except for right-angled bends.

5 Weave the curved midline with a pencil. Check that the weaving is correct, and make any changes that need to be made.

6 Outline either side of the midline, to make a regular, woven triline knotwork border, all in pencil.

7 Create a second pair of lines parallel to the central one, to define a narrow contour inside the edge of the band.

8 Draw over the four outermost lines of each segment of band in brown ink, with a super-fine nib and Chinese ink. Allow the ink to dry.

9 Paint the background with black Chinese ink using a fine-point drawing nib. Allow the ink to dry before proceeding.

10 Erase the central line with a soft pencil eraser, taking care not to smudge the lines that you have inked already.

11 Rule a fine ink line surrounding the whole border, set half a space from the outside rectangle. Let this dry, and then rule a fine inked line around the inside, half a space inside the inner edge of the knot border.

Congratulations!